LIGHTING
PHOTO WORKSHOP

Chris Bucher

BICENTENNIAL
1807
WILEY
2007
BICENTENNIAL

Wiley Publishing, Inc.

Lighting Photo Workshop

Published by
Wiley Publishing, Inc.
111 River Street
Hoboken, N.J. 07030
www.wiley.com

Copyright © 2007 by Wiley Publishing, Inc., Indianapolis, Indiana

Published simultaneously in Canada

ISBN: 978-0-470-11433-9
Manufactured in the United States of America

10 9 8 7 6 5 4 3 2 1

For general information on our other products and services or to obtain technical support, please contact our Customer Care Department within the U.S. at (800) 762-2974, outside the U.S. at (317) 572-3993 or fax (317) 572-4002.

Wiley also publishes its books in a variety of electronic formats. Some content that appears in print may not be available in electronic books.

Library of Congress Control Number: 2007926007

About the Author

Chris Bucher is a freelance commercial photographer who has contributed to a number of award-winning projects in the dozen-plus years he's been creating beautiful, marketable images. Although a resident of Indiana, he began his career in Arizona and retains an affinity for the desert Southwest, where his fascination with natural light is fed by the harsh but striking landscapes. His commercial images have appeared in countless national and regional magazines. On his own time, Chris loves racing mountain bikes and serving the Humane Society as a foster parent. But his favorite pastime, bar none, is watching the interaction of light with his favorite subject, his wife, Jennifer.

Credits

Acquisitions Editor
Kim Spilker

Senior Project Editor
Cricket Krengel

Project Editor
Kelly Dobbs Henthorne

Technical Editor
J. Dennis Thomas

Editorial Manager
Robyn Siesky

Vice President & Group Executive Publisher
Richard Swadley

Vice President & Publisher
Barry Pruett

Business Manager
Amy Knies

Book Designers
LeAndra Hosier
Tina Hovanessian

Project Coordinator
Adrienne Martinez

Graphics and Production Specialists
Brooke Graczyk
Jennifer Mayberry
Shelley Norris
Amanda Spagnuolo

Quality Control Technician
Todd Lothery

Cover Design
Daniella Richardson
Larry Vigon

Proofreading and Indexing
Debbye Butler
Rebecca R. Plunkett

Wiley Bicentennial Logo
Richard J. Pacifico

ACKNOWLEDGMENTS

As with so many things, so much credit goes to so many people, and thanks to those who helped immeasurably to make this book happen. This book was made so much better with the contributions of these photographers: Jarod Trow, Holly Jordan, Lynne Stacey, Dave Edelstein, Marcos Dominguez, and Jonathon Juillerat. Their input and offerings were beyond helpful.

Thanks to the team of Kelly, Kelly, Laura, Cricket, and Denny for your insight and immense help in working with this hopeless writer on his first book, and I will never be able to thank Kim Spilker enough for her constant encouragement and faith in me throughout this process.

I need to acknowledge Sharlie Douglas Hall and Nikon Inc. for much help over many years and for gear that just plain works. The calls, e-mails, and support that I got from Erik, Jarod, Angie, Lisa, David, Matt, Tim, and Eric meant more than they'll ever know.

A very special thank you goes to my parents and my siblings for their constant love and backing.

I also have the blessing to know that whenever I am in doubt or in need, that I always have the guidance of Butch Hall, Tom Casalini, and my Dad, Wes Bucher, for counsel and direction.

Finally, thank you to my wife and partner, Jennifer, for her patience and encouragement throughout this entire process.

For my wife, Jennifer

Foreword

After 10 years of helping photographers hone their skills on photoworkshop.com, I'm thrilled to present this new line of books in partnership with Wiley Publishing.

© Photo by Jay Maisel

I believe that photography is for everyone, and books are a new extension of the site's commitment to providing an education in photography, where the quest for knowledge is fueled by inspiration. To take great images is a matter of learning some basic techniques and "finding your eye." I hope this book teaches you the basic skills you need to explore the kind of photography that excites you.

You may notice another unique approach we've taken with the Photo Workshop series: The learning experience does not stop with the books. I hope you complete the assignments at the end of each chapter and upload your best photos to photoworkshop.com to share with others and receive feedback. By participating, you can help build a new community of beginning photographers who inspire each other, share techniques, and foster innovation and creativity.

Robert Farber

Contents

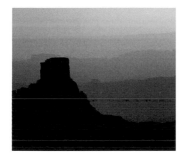

CHAPTER 4 Working with Interior Light **93**

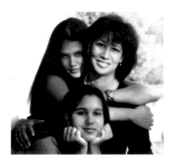

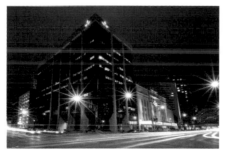

CHAPTER **7** Lighting Scenarios in Landscape Photography **171**

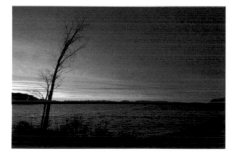

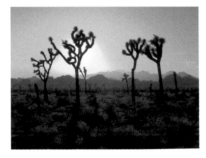

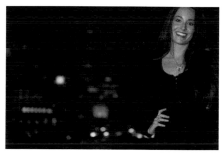

Introduction

To say that light is integral to photography is just scratching the surface. This book is just scratching the surface of all the angles and colors and direction that light can present to you in the viewfinder. As a photographer, you need light on the subject to create an image, but to create a great image, you need to get the best light you can on the subject.

Great light can come in many ways. Sometimes it just happens, and other times it takes time and patience to create or shape the light in your photographs. Take the time to wait for a few minutes to see whether the light changes, and savor the moments that you are shooting or waiting to shoot because you are not just seeing things through the camera, you are experiencing life happening before your eyes. Then you can take that slice of life home with you.

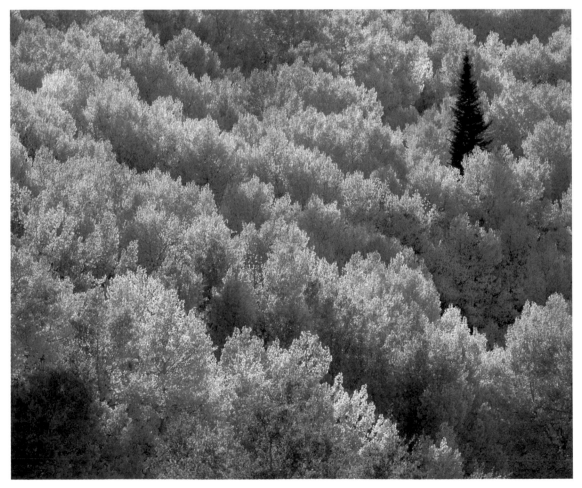

ABOUT THIS PHOTO *The backlight in this image is what creates the yellow glow as the sunlight passes through the fall Aspen leaves, and the lone pine creates a focus for the image. 1/160 sec. at f/9 at ISO 200.*

I hope that the images inspire you, if nothing more than to just take your camera with you or to keep it close to you for when the light is happening. Even more, I hope the images inspire you to try new things. Use the images here as guides and signposts so that you can recognize the things happening in your own images and better know how to capture the images that you see in your mind.

One of the goals that I had for this book was to show how it is possible to create better photographs with light that is there, no matter whether it is great light or not. This entails some testing and practice and trying new things, but that discovery is so exciting. When you begin to realize the skills that you are developing because you can better see and work with light, your photography becomes like second nature.

ELEMENTS OF LIGHT

UNDERSTANDING THE THREE ELEMENTS OF EXPOSURE

DEALING WITH COLOR TEMPERATURE

SETTING WHITE BALANCE

USING CONTRAST TO CREATE MOOD

WORKING WITH THE QUALITY OF LIGHT

In some ways, photography is analogous to cooking: a certain temperature for a certain amount of time. So how is that like photography? If you substitute light for temperature, you have your answer. In this chapter, I tell you how light affects your camera and images.

UNDERSTANDING THE THREE ELEMENTS OF EXPOSURE

Exposure is the balance of the amount of light allowed to fall on the photographic medium (digital sensor, film, glass plate, and so on). I use the word *balance* because you use many things to capture the correct exposure. You use three variables to create your exposure:

- **ISO.** The light sensitivity of the film or digital sensor.

- **Aperture.** A moving diaphragm within the lens that controls the amount of light passing through the lens and into the camera. F-stops are the numeric designations referring to the size of the aperture.

- **Shutter.** A mechanical device that opens and closes very quickly, letting light into the camera and in contact with the digital sensor (or film). The length of time the shutter is open is known as *shutter speed.*

Each incremental change in the exposure of any of these three things is measured in f-stops. A 1 stop difference in any of these three things either halves or doubles the amount of light for the exposure. For example, if you change your ISO from 100 to 200, you have increased your sensitivity 1 stop. If you adjust your shutter speed from 1/125 to 1/250, that is a 1 stop difference as well. Changing your aperture from f/8 to f/11 is also a change of 1 stop.

Read on to learn about these three aspects of exposure in greater detail and discover how changing things 1 stop or more affects your photographs.

ISO

ISO (International Organization for Standardization) is a body that sets international and commercial standards. In digital photography, the ISO is the measure of the digital sensor's light sensitivity. Digital sensitivity correlates to film speed in traditional cameras. Digital cameras can have ISO settings from 50 through 3200. The standard ISO settings that you use most of the time are 100, 200, and 400. A lower number and sensitivity, 50 to 200, requires more light and, thus, is called slow, but an ISO that is larger, 400 to 1600, needs less light, can shoot the same scene with a faster exposure, and is considered a faster ISO. Adjusting the ISO higher increases the sensitivity when subjects are in lower light situations like shade, as in 1-1.

With each 1 f-stop change higher in the ISO, you effectively double the sensitivity of the film or digital sensor. As you raise the ISO sensitivity each stop, 100 to 200 to 400, the sensor becomes more light-sensitive, and you need less light to get your exposure.

The lower the number, the *less* light sensitive the digital sensor is. Less light sensitivity means that you need *more* light to achieve the correct exposure. At the lower ISOs, 50 and 100, you achieve the highest image quality in both film and digital. For example, assuming that the amount of light does not change, if you go from 100 to 200, you need to either use 1 f-stop smaller of an aperture or 1 f-stop faster of a shutter speed. As you use faster films or turn the ISO up on your digital camera, you increase its light sensitivity, but you also see increases in *grain* in film and *noise* in your digital photos.

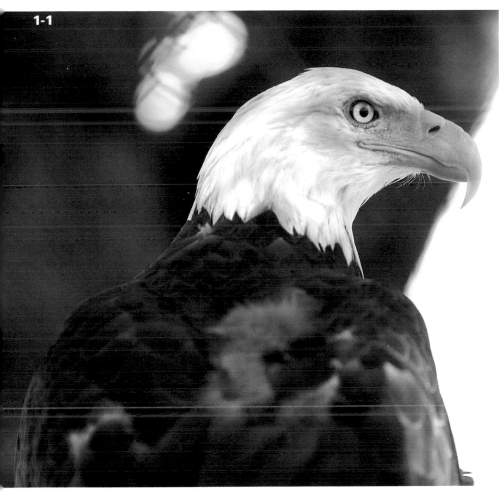

1-1

ABOUT THIS PHOTO
Because this Bald Eagle was in deep shade, I set the ISO to 200, so that the digital sensor captured enough light on this beautiful bird. 1/90 sec. at f/2.8, using a Nikon 80-200mm f/2.8 zoom lens.

 x-ref

See Chapter 2 for a detailed explanation of grain and noise.

Even though you need less light to achieve the correct exposure, higher ISOs increase digital noise and decrease contrast. As the light level begins to drop, or as the speed of the action increases, you can increase your ISO to stop the action and avoid blurring the image.

With the high quality of digital sensors and film today, going to 200 or as high as 400 only increases the noise and grain minimally, but I still recommend using the lowest possible ISO for the situation at hand.

If the highest image quality is achieved at ISO 100, why wouldn't you just use that setting all the time? This is where the other factors in exposure, such as grain and noise, start to weigh in.

THE APERTURE

The lens aperture is a moving diaphragm within the barrel of the lens; it determines how much light passes through the lens and into the camera. The designation for each step in the aperture is called the *f-stop*. A smaller f-stop or f number means that the actual opening of the aperture is larger, and the higher numbered f-stops designate smaller apertures, letting in less light. The f number is the ratio of focal length to effective aperture diameter. The relative size of the changing aperture and corresponding f-stops are shown in 1-2.

Your lenses' f-stops were traditionally changed by a ring around the outside of the lens that would change the diameter of the diaphragm. On today's cameras, especially digital cameras, the f-stop is usually changed with a turn of the thumb wheel or forefinger dial. The diaphragm's diameter changes in the same manner as it always did; it is now controlled electronically rather than manually. In 1-3 you can see the aperture blades moving in and out.

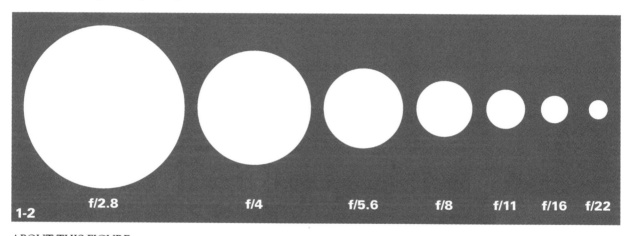

| f/2.8 | f/4 | f/5.6 | f/8 | f/11 | f/16 | f/22 |

1-2

ABOUT THIS FIGURE *Each aperture decreases in full 1 f-stop increments. The corresponding f-stops get higher in number. Notice each aperture opening is half as large as the preceding, letting in half as much light.*

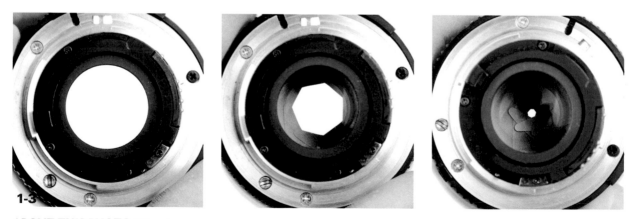

1-3

ABOUT THIS PHOTO *This series of photos shows the aperture blades and how they open and close. From the left, f/1.8, f/8, and f/22.*

Besides determining the amount of light that passes through to the camera, the aperture has one very important function and photographic effect. The size of the aperture determines the *depth of field* for the photograph. The easiest way to describe depth of field is as the amount of a photograph that is in focus. A smaller f-stop and larger aperture, such as 2.8, has less depth of field than a larger f-stop and smaller aperture, such as f/22, which has more depth of field. Using smaller apertures creates larger depths of field; images with greater depth of field have more sharpness from the front to the back. Smaller apertures and larger depths of field are used more for subjects like landscapes, when you want to see sharpness in an entire scene, than for portraits, when you focus on just the subject of an image.

It isn't as complicated as it seems. An easy way to remember this is to think "the higher the f-stop numbers, the higher the depth of field" and "the lower the numbers, the lower the depth of field." So at f/22 nearly everything in the photograph is sharp and in focus, but at f/2.8, only the subject is in focus, and the background and foreground are blurry. Your eyes work the same way. In the middle of the day, nearly everything that you see is in focus because the aperture of your iris is effectively *stopped down* and its aperture is very small, but when you are driving at night in low light, it takes a moment to change your focus from the road to the speedometer because your irises are dilated, giving you less depth of field.

How does depth of field really affect your photographs? In 1-4, you can see shallow depth of field as the microphone is sharp and in focus, the saxophone is slightly out of focus, and the trumpet player is totally out of focus, but still discernable.

ABOUT THIS PHOTO
The shallow depth of field of the f/2.8 lens puts importance on the microphone, and as the other parts of the image fall more out of focus, it gives the photo a layered effect. Tamron 28-105mm lens f/2.8 at 1/125 sec. at f/2.8.

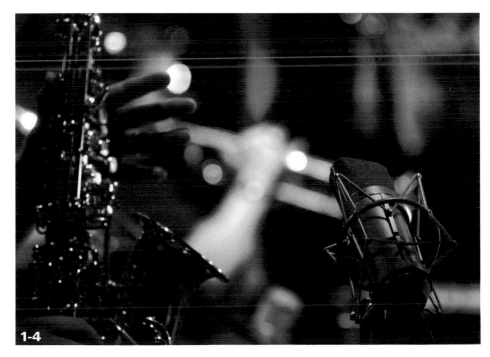

1-4

When placing a foreground subject in front of a deep landscape scene, you need substantial depth of field to maintain sharpness throughout the photograph as seen in 1-5. As you get more comfortable with your camera and lenses, visualizing depth of field becomes second nature.

THE SHUTTER

Stopping action or avoiding blurry subjects is generally a desired quality of a photograph. Choosing an appropriate shutter speed greatly determines your success in achieving this. In most cases, a camera's shutter consists of small thin pieces of metal that move very quickly, opening and closing. Two types of shutters exist, focal plane shutters and leaf shutters. A focal plane shutter is found in most digital single lens reflex (dSLR) cameras and is located right in front of the digital sensor, just behind the lens. As you can see in 1-6 and 1-7, the shutter is closed, and then open revealing the sensor. The horizontal blades of the shutter rise and fall rapidly to expose the sensor to light. Your camera's shutter opens and closes just in front of the digital sensor, allowing light in for only as much time as needed to create the exposure. In digital point-and-shoot cameras, the lens is built into the body of the camera, and the shutter is built into the lens. These shutters are

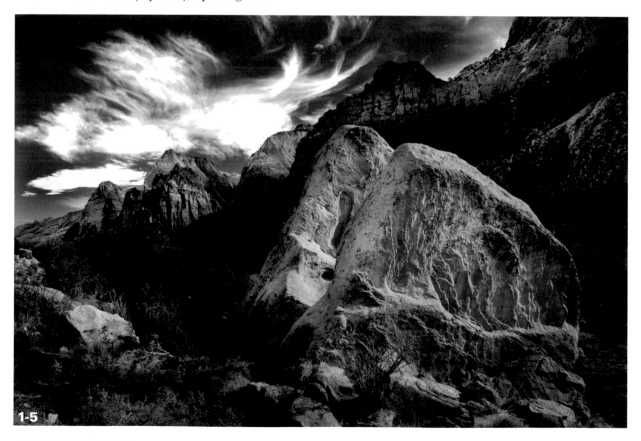

1-5

ABOUT THIS PHOTO *With sharp focus from the rocks in the foreground to the mountains at the back, this photo maintains substantial depth of field, even at f/9.5 at ISO 200.*

ABOUT THESE PHOTOS *Figure 1-6 shows the digital sensor ready to have its electrons excited by the light; figure 1-7 shows the mirror in place. The light reflects into the viewfinder until the exposure happens. The shutter is behind the mirror.*

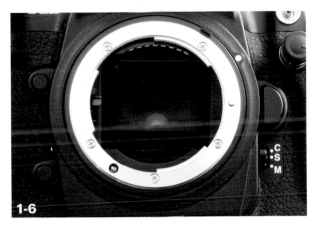

1-6

1-7

called *leaf shutters*, and they work much like the aperture in that the blades progressively dilate to the circular opening of the lens.

Shutter speed is changed with a turn of the shutter speed dial. This is different in many cameras: With some, it is a dial turned by the forefinger; on others the thumb wheel; and some cameras enable you to select which dial is the shutter speed dial. With each full change of the shutter dial, the shutter is open for twice as much, or half as much time. For example, if your camera is set at ISO 100, the f-stop at f/11, and shutter to 1/125, and you want to stop the action, changing the shutter to 1/250 reduces blurring, but it also makes the image 1 stop darker. To maintain the same exposure, you also have to change your f-stop to f/8 or change the ISO to 200.

Shutter speeds can be faster than 1/10,000 of a second or as slow as many hours, but in most real-world photography, the shutter is open for just a fraction of a second. For example, a standard daylight exposure might be 1/125 of a second at f/11 using ISO 100. Using a faster shutter speed stops motion, and a slower one can induce blur, and each has its place. In Table 1-1, you can see the stopping ability of many shutter speeds.

Just like the analogy at the beginning of this chapter, exposure is similar to the instructions in a recipe; the aperture controls the amount of light, which is like the thermostat on the oven, and the shutter speed is like the cooking time, so f/8 at 1/250 is similar to 350 degrees for 35 minutes.

Table 1-1

Shutter Speeds and What They Do

Shutter Speed	Effect
1/4000 to 1/2000	Stop a hummingbird's wings
1/1000 to 1/500	Freeze a human running and most athletes
1/250 to 1/60	Stop most daily movement and stop most blur from holding the camera
1/30 to 1/8	Blur motion (Camera should be on a tripod.)
1/2 to many seconds	Capture scenes in dim lighting, such as pre-dawn (Camera must be on sturdy tripod.)

DEALING WITH COLOR TEMPERATURE

What the eyes see and what the camera sees are often quite different. Sunlight has a different *color temperature* than shade, which has a different color temperature than regular light bulbs, fluorescent light, or flash. Your brain automatically changes your irises to let the needed amount of light in so you can see; your brain also interprets the color of the light so that what you see looks normal. Color temperature and *white balance* are integrally linked. In this section, you learn what color temperature is and how changing the white balance in your camera affects your photographs.

LEARNING ABOUT KELVIN

The color of light is measured in Kelvin (K), named after the nineteenth century physicist William Thomson, 1st Baron Kelvin. The Kelvin unit is based on energy absolutes; therefore, 0K is the temperature at which all energy is lost. To put this in perspective, 0K is the equivalent of −459.69°F. In the light spectrum, 5500K is white; higher color temperatures are blue and are cooler in appearance; and lower temperature colors, like yellow, orange, and red are warmer in appearance. This is opposite of how color is normally thought of, with reds being warmer. In Kelvin, reds have a cooler temperature than blues.

Every color can be put into the classifications of warm, neutral, and cool, whether it is paint on a house or car, fabric on clothing, or part of the earth and seas. The color of the light source corresponds to those same colors as shown in Table 1-2. Images can be all manner of warm, cool, or neutral, or they can be elements of all three as is seen in 1-9.

| 1800K | 4000K | 5500K | 8000K | 12000K | 16000K |

1-8

ABOUT THIS FIGURE *The progression of the color temperature scale.*

Table 1-2

Light Sources and Corresponding Color Temperatures

Light Source	Color Temperatures
Candle light/matches	1500K to 1900K
Incandescent bulbs	2500K to 3000K
Sunrise/sunset	3000K to 3500K
Photofloods/studio tungsten bulbs	3400K
Daylight (midday)	5000K to 5500K
Flash/strobe	5500K
Cloudy day/shade	6500K to 7500K

ABOUT THIS PHOTO
With the yellow colors of the leaves, the blue color of the blue sky, and the neutral of the snow-covered peaks, it is easy to see the differences in color temperatures. 1/500 sec. at f/11 at ISO 200.

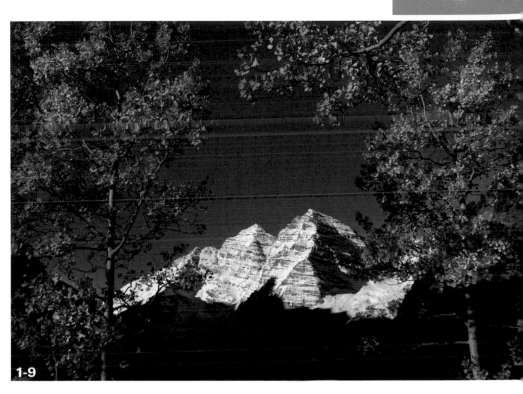

1-9

SEEING THE COLOR

Your eyes and brain automatically interpret the colors and energies of these different light sources so that what you see appears normal. For example, if you are outdoors on an overcast day, the color temperature of the light is around 7000K, and when you come inside to a room that is lit by incandescent lights, the light is around 3000K. Your eyes and brain adjust so that you see clearly in both instances.

DON'T OPEN YOUR SHUTTER NEEDLESSLY! Because of the nature of dSLR cameras and the electrical charge that powers the sensor, the sensor is extremely susceptible to dust. When small pieces of dust come into contact with a digital sensor, they create fuzzy dark spots on the image. Often these spots cannot be seen until the image is full screen on your camera monitor. Keep your lenses or caps on your camera at all times. Try to change lenses as quickly and carefully as possible. If your sensor becomes dirty, follow the manufacturer's recommendations on cleaning. It is difficult and expensive to repair a damaged sensor; I speak from experience.

The camera is affected by light temperature and energy changes. Photographs taken with different light sources and temperatures look very different. Training yourself to notice the differences in light makes it easier for you to create images in various lights.

The biggest differences in color temperature may not be the easiest to see, such as the difference between a cloudy day and a sunny day. One of the easiest ways to see light differences is to look at your subject in shade and then in sunlight. A fascinating time to see differences in lighting color is at night in a well-lit downtown area. Streetlights, car headlights, neon signs, and the lights from inside windows demonstrate a range of lighting situations, such as in 1-10.

note Because the camera sees all the different colors, you can create images that use the different colors of light to accentuate your photographs. You also can make changes in your camera settings to balance the light back to neutral or bring out the warmer or cooler tones in a photograph.

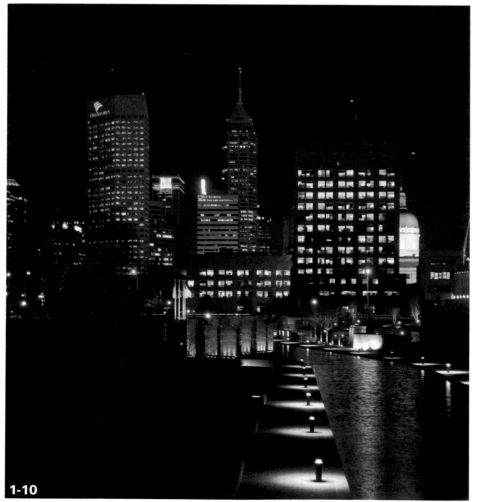

1-10

ABOUT THIS PHOTO
Each of the buildings has different colored interior lights. The streetlights are magenta-orange. Especially interesting are the lights on the foreground sidewalk: one is nearly white, the next amber, and the third green. 1/6 second, f/5.6, ISO 100.

Generally, warmer (which have a lower color temperature) appearing lights look more pleasing in photographs, whether in a landscape or a portrait. This is one of the reasons that you can look to sunrise and sunset as the best times to create photographs. Using the light of a sunset or sunrise helps to change a snapshot into a great photograph.

FLUORESCENT BULBS

Fluorescent bulbs and tubes are one of the best and worst light sources known to man. Fluorescents are extremely energy efficient and are cool to the touch. They cast broad, even light in a workspace. Photographically, though, fluorescents are a challenge. The color that they cast has a greenish tone, and in many cases is unflattering and unpleasant.

The light from fluorescent bulbs is inconsistent and changes over the course of their life spans. The differences are the result of different manufacturers, various batches, and even different bulb wattages. These differences can affect your photographs.

In recent years, fluorescents have made great strides with their color balance getting ever more neutral. With the advent of all the new compact fluorescents that replace regular household light bulbs, the color problem has gotten much better. Digital photography has also helped to solve some of these problems, either in the camera or on the computer. It is now easier to balance many of these different colors back to neutral.

SETTING WHITE BALANCE

The white balance function of the camera optimizes the color of a scene so that it records as the photographer wishes. The white balance of the camera works to balance the color temperature of the scene

to make sure that the colors that are recorded by the camera are the same as you see them.

Effectively matching the color balance of a scene to the white balance of the camera allows a photographer to save immeasurable time in front of the computer and in some cases enhances or perfects an image. Color casts are most easily seen on a white subject, like a wedding dress, so the adjustments are made to make "whites" look white.

HOW WHITE BALANCE AFFECTS COLOR TEMPERATURE

Sunlight and manmade light have different color temperatures that are seen by the camera in unique ways. As the color temperature goes up and the light in the scene becomes more bluish, to maintain the white balance, orange must be added. In a scene that is lit by very orange tungsten bulbs, a very warmly colored scene, blue must be added to create the proper color balance, and a scene that is primarily lit by fluorescents, which have a green cast, needs magenta. The white balance function effectively filters the light through the camera's software to correct for the imbalance in color temperature and shifts that color temperature so that the white in the scene is white on the picture. The light is filtered with the complementary color of the light color to balance the light color and change any color casts back to neutral. Figure 1-11 shows the complementary colors in very basic terms. Green balances magenta; red balances cyan; and blue balances yellow.

> *note* In film photography, color balance can be done with colored filters. The filters are manually added in front of either the lens of the camera, the light source, the enlarging lens, or even different film types specific to the light source. With digital, photographers now use the white balance function of their cameras to maintain the correct colors from different light sources.

ABOUT THIS FIGURE *Colors relate to each other. Looking at the colors opposite each other shows which colors balance with the others to create white.*

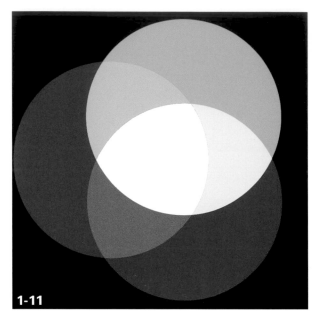

1-11

All digital cameras can change their white balance. The Auto White Balance (AWB) function can accurately get the correct white balance in most cases. Because human eyes automatically white balance the color temperature of the light, it is often hard to see these colors. To maintain control and consistency in your photographs, you might want to stay away from the automatic settings and set your own white balance. To do that, just look at the white balance icons on the camera and match them to the visible light source.

The Auto White Balance can be fooled by both color casts or overwhelming amounts of a single color in an image. The AWB can change every image if more or fewer colors are introduced into the scene. Setting the white balance according to the light source makes every shot the same. There is more discussion on setting the white balance coming up later in this chapter.

WHAT DO THE WHITE BALANCE ICONS MEAN?

Learning how to use the items in the White Balance menu properly helps your photography immensely. Table 1-3 shows icons and their functions — while these may not be exactly what you see on your camera, these icons tend to be similar from camera to camera.

Table 1-3

White Balance Menu Options

Setting	Function
A/AWB	Auto white balance
(light bulb icon)	Tungsten white balance
(fluorescent tube icon)	Fluorescent white balance
(sun icon)	Standard daylight white balance
(lightning bolt)	Electronic flash white balance
(cloud icon)	Cloudy white balance
(shaded house icon)	Shade white balance

The icons are fairly self-explanatory. For example, the cloud setting is appropriate if your subject is underneath hazy or overcast skies or other situations. When shooting a children's program, most spotlights and stage lights are tungsten, and the best setting for this situation would be the light bulb icon white balance setting. In the case of a concert, colored gels are often used instead.

HOW DOES CHANGING THE WHITE BALANCE AFFECT THE IMAGE?

In simple terms, changing the white balance warms up or cools down the basic color tones of the image to ensure that the whites are white (instead of dull grey or peachy pinks). Because warmer tones are generally more pleasing to the eye, you get the most benefit by making sure that your white balance is properly set in a cloudy or shady situation.

As you can see in 1-12, the image of this woman is taken on a bright sunny day, but her face is almost completely in shadow. With the white balance set to daylight, the picture is just fine, although because her face is in shadow, her skin appears to be slightly bluish. In 1-13 with the white balance set to shade, the image really starts to pop as her skin warms up nicely, and the sunlight hitting her hair becomes far more golden and lustrous.

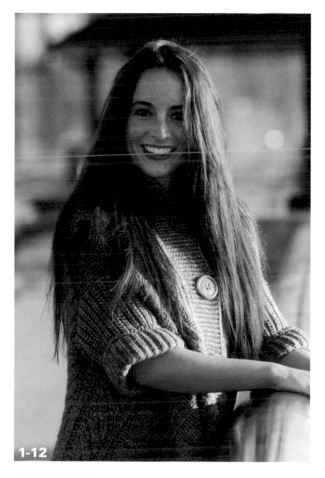

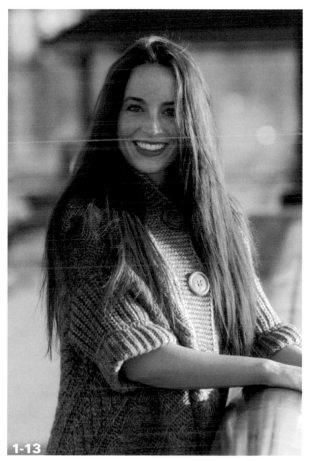

ABOUT THESE PHOTOS *Figure 1-12 was taken with the white balance set to daylight; figure 1-13 to shade. Notice the shallow depth of field separating the subject from the background. ISO 100 at 1/90 sec. at f/6.3.*

USING FLASH

When using strobe flash, you also need to have the proper white balance. With the color temperature of strobe being similar color temperature to daylight, setting the white balance to flash is very important. When photographing people with a strobe, you are usually introducing a different, slightly cooler color into a scene, and the proper flash white balance helps to make sure that skin tones stay neutral.

Most manufacturers' dedicated on-camera flash units actually transmit color temperature data to the camera. Using Auto White Balance when using a strobe is also a good option because the color temperature of a strobe is variable according to the output of the flash.

To change the amount of light that an on-camera flash puts out, the light actually fires for a variable amount of time. This amount of time is called the *flash duration* and the more light is needed, the longer the flash duration. However, even the longest flash duration is still a very short period of time, about 1/200 of a second.

USING AUTO WHITE BALANCE

Like most things automatic, Auto White Balance can adequately select the correct white balance for most scenes. When you are uncertain as to

how to set your white balance manually, AWB is a great starting point. However, two common problems are encountered with AWB:

- ■ **AWB can be fooled**

- ■ **AWB might not produce the image that was envisioned by the photographer**

The fact that the Auto White Balance can be tricked is a problem caused by color cast. The AWB works by measuring the overall color of the entire scene and determining what the ambient light temperature is. If the scene has a predominant color, or a color cast, that might be enough for the AWB to be fooled into thinking that the color temperature is different than it really is. In a scene such as 1-14, the overall blue cast of the water could easily trick the AWB, telling the camera that the entire scene is lit with a blue light, adding warm tones such as red and yellow, which could make the water look dull and grey.

CHANGING THE WHITE BALANCE IN THE COMPUTER

Although changing the white balance when the photograph is taken seems simple and obvious, white balance is often overlooked. But, unlike exposure or focus, white balance is easily correctable after the image gets to the computer. Fine tuning the white balance in your image might be the difference between a snapshot and a great photograph.

Digital cameras are usually quite capable of achieving proper white balance. However, it is common for photographers to use some version of Photoshop or other image editing software to manipulate white balance.

ABOUT THIS PHOTO
Using a 12-24mm f/4 lens, the entire wide scene is filled with blue, which has the potential to throw the white balance off. The exposure here was 1/125 sec. at f/4 using ISO 800.

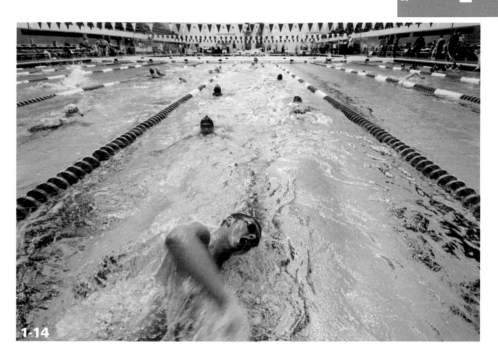

1-14

When a digital file is captured in RAW format, the image must be *converted* before it can be tweaked in any image editing software. Because all of the data is available in RAW format, it is relatively simple to just select the correct white balance in the RAW converter that comes with Photoshop Elements. You can also fine tune the white balance using a slider tool that adjusts for warmer or cooler images.

If your camera doesn't shoot RAW, or if you have chosen not to shoot RAW, the image is likely already a JPEG file. You can correct the white balance by choosing Enhance ⇨ Adjust Color and then choosing from these options: Remove Color Cast, Adjust Color for Skin Tones, or Color Variations as seen in 1-15. Each of these options in Photoshop Elements can adequately correct for incorrect white balance. (You see other options here, but they aren't specifically for fixing the white balance.)

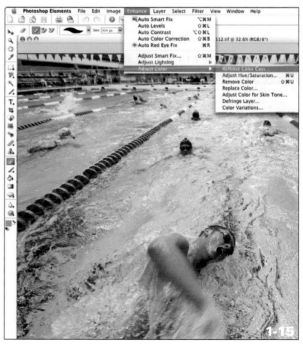

1-15

ABOUT THIS FIGURE *This image shows the path needed to correct color casts or white balance in Photoshop Elements.*

RAW OR JPEG

Whether you use a Nikon, Canon, Leica, Panasonic, Sony, or another brand of camera, the question of whether you should use RAW or JPEG files often comes up. RAW files are the proprietary files of each camera manufacturer, and they contain *all* of the data of the image photographed. JPEG (labeled as .jpg) stands for Joint Photographic Experts Group, which is the name of the committee that wrote the standard. JPEGs are compressed image files and are considered *lossy* in that they get rid of some of the image data, according to specific parameters when they are compressed and use advanced algorithms to decompress or open them.

Every camera generates a RAW file when it initially creates the image, but if the JPEG file is the only file format selected or if the camera does not have a RAW setting, the RAW file is discarded after the camera converts the RAW file into a JPEG. Numerous advantages exist to using a RAW file. Because they are large and uncompressed, RAW files create high-quality images. The RAW file can be manipulated with a computer to enhance exposure, color, white balance, sharpness, tint, and precision. Many of these changes go beyond what can be done by the camera's software.

Unfortunately, RAW files take up large amounts of memory. Because they are so big, they might take a longer time to write to the memory card, preventing you from taking multiple pictures in quick succession. RAW files also take up a lot of space, not only on your memory card, but also on your hard drive. A RAW file can take up two to three times as much space as a high-resolution/low-compression JPEG. Keep in mind that some image processing software may not be able to accommodate RAW files.

 t i p If you do use JPEG, save them as a TIF right away and do any editing in the TIF file — TIFs are *lossless,* meaning they do not lose data with each subsequent save.

RAW versus JPEG has recently become a controversial issue among photographers. Some argue that with the quality of digital cameras and software today, only JPEGs are necessary, and others believe the RAW file creates the best possible image. Ultimately, it is up to each photographer to do his own research and testing and determine what is best for his images.

USING CONTRAST TO CREATE MOOD

Contrast is paramount in creating drama, mood, and emotion in a photograph. An image that has high contrast generally has a lot of blacks and whites or darks and lights, and an image lower in contrast has more shades of grey or middle tone color. Both exposure and light quality affect the contrast in the image.

Softer light, such as the light of an overcast day, creates a lower contrast image, such as in 1-16.

CONTRAST RANGE

The ratio between the darkness of shadows and the white of the highlights is known as the *contrast range*. The human eye has a huge dynamic contrast range and can see the difference between brightly lit areas and areas that have deep shadows. Conversely, the digital sensor has a narrow range of contrast, and if the difference between light and dark is too great, the variation cannot be recorded correctly in the image.

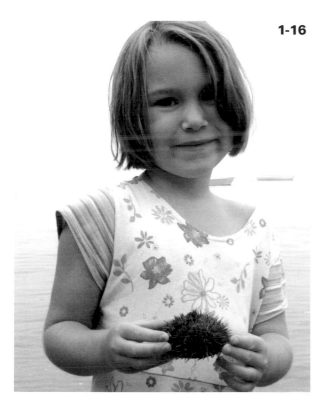

1-16

ABOUT THIS PHOTO *The directionless light on the girl makes for very soft contrast. The changes in tone are subtle and dreamlike. 1/80 sec. at f/8 at ISO 100.*

WORKING WITH CONTRAST

Take stock of where the light and shadows are in your scene. If the foreground of your image is in shadow and the background is sunlit, no matter how good the meter in your camera is, the foreground will be too dark, and the background too light. One of the easiest ways to avoid this is to get everything into or everything out of the light. If the background is in sunlight, get the foreground in sun, and if the background is in shadow, move the subject into shadow, changing the exposure as needed.

A photograph of a person might have the same problem — a lot of light coming from the side or above, casting harsh, unattractive shadows across the face or into the eyes. Have the subject move her face so that it is more evenly in sun or shade to create a better photograph. Although these are basic solutions to difficult situations, they can help you build a better understanding of dealing with contrast.

Because the meter in your camera is going to average the highs and lows in a high contrast scene, dealing with the contrast range becomes second nature the more you begin to really see what the light is doing.

When you are working with unfiltered sunlight, the images you create are almost always high in contrast. The difference between the light that hits the subject and the shadows created is very large. It is also possible to use a reflector or a flash to increase the light on a dark subject, which better balances the contrast of the scene.

For those used to shooting images on film, the contrast range of digital images is similar to the contrast range of slide film. This is particularly the same when it comes to highlights and overexposure, as digital has no tolerance for overexposure, although it can take several f/stops of underexposure, and slide film would largely be ruined.

Even with simple direct sunlight, if the sunlight subject is exposed correctly, the sunny area looks perfect, and the parts of the image that are shadowed become entirely black, as in 1-17. If the exposure is set to see detail in the shadow, the bright sunlight areas become too light and washed out.

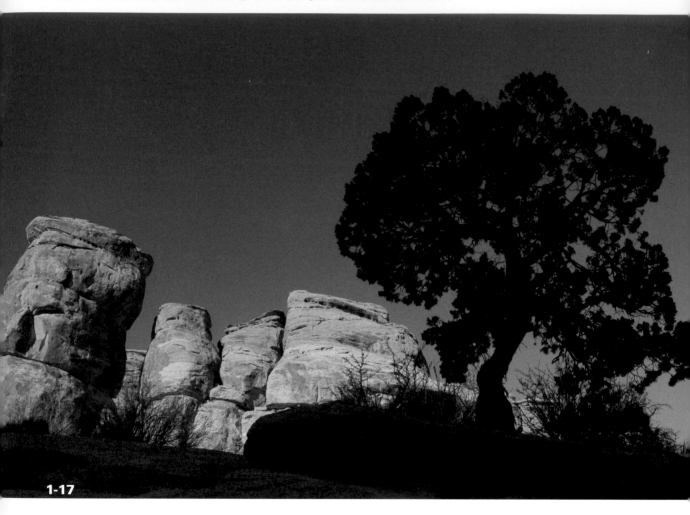

1-17

HIGH AND LOW CONTRAST

High contrast images tend to be bolder, stronger, dynamic, and dramatic; low contrast images appear softer, moodier, and subtle. This is not always the case and often the difference between high and low contrast is as simple as a quarter turn of a face or to wait for a few minutes for a cloud. Neither high contrast nor low contrast is better than the other, and either can make for exciting, beautiful photographs. A very high contrast image is shown in 1-18, as the light and the dark areas of the image come together at the hard line of the shadows. A low contrast image uses an easier transition between the light and shadow, and the tones of grey are more remarkable than bright highlights and dark shadows as seen in 1-19.

On a clear day, the sun is a very hard, direct light, and it can create very high contrast in a photograph. The exposure was set at ISO 200, 1/90 sec. at f/9.5.

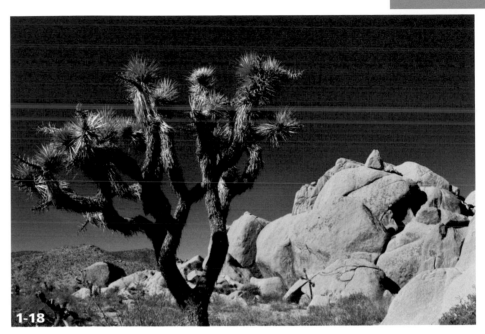

1-18

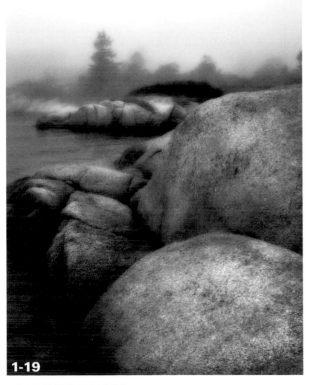

1-19

ABOUT THIS PHOTO *On a foggy day, a wide range of contrast exists throughout the grey tones but no whites and no hard lined shadows are seen. ISO 200 at 1/250 sec. at f/5.6.*

WORKING WITH THE QUALITY OF LIGHT

Light quality is something that is hard to define, yet easy to see. Light quality has to do with contrast and color, but also with texture. These elements work along with the angle and direction of the light to create light quality.

DEFINING DIFFERENT KINDS OF LIGHT

A single, bare light bulb is a small light source. Even a frosted, soft light bulb casts severe shadows. This is why you put shades on your light bulbs. The lampshades cover and soften the harshest light of the bulb and direct the light toward the ceiling and the floor, making the light more useful. Light that goes up, lights the ceiling and brightens the whole room as in 1-20. Light that goes down is useful for reading, and light going through the shade is nice and soft and fills in the shadows. Soft light can also be called *diffused light* because most light sources can

21

be diffused to make them softer—sunlight can be diffused by clouds just like a light bulb's light can be diffused by a lampshade.

Even though the sun is a huge light source, because it is so far away, it is still a point of light. The smaller and farther away a light source is to the subject, the *harder* the light appears. The larger and closer the light source is, the *softer* the light gets. Harder and softer are in some ways related to contrast.

The direction of the light to the subject also is a factor of light quality. From landscapes to portraits, light coming from the side, called *sidelight* or *crosslight,* is optimal in many situations. The effect of the highlights and shadows created by the sidelight is that texture is created in the

image, whether on a mountainside or someone's face.

Even though the sun is a hard light source, when it is low in the horizon, either in the morning or evening, it is a great light source for photographs for two reasons: when it is low, the sun can create the most sidelight, and because the light has to go through significantly more atmosphere, the light is filtered and becomes much softer and warmer in tone. As can be seen in 1-21, the light has a nice warm tone to it; the shadows across her face are pleasing and help to define the shape of her face. The sun is extremely low on the horizon, nearly at sunset. If this photograph had been taken just one hour earlier, the light would have been too harsh, and those soft shadows would have been totally black.

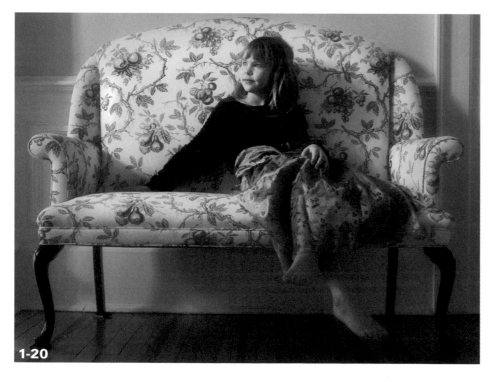

1-20

ABOUT THIS PHOTO
The soft light of a couple of standard floor lamps allow the light to wrap around the different textures and fabrics in the girl's outfit. ISO 400 at 1/60 sec. at f/4.

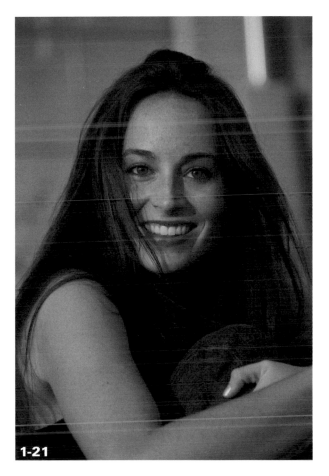

ABOUT THIS PHOTO *The light is much warmer and softer closer to dusk, making the shadows softer. By setting the white balance to shade, it further warms the scene. 80-200mm f/2.8 lens with an exposure of ISO 100 at 1/90 sec. at f/5.6.*

HARD LIGHT

Hard light works with many types of images, but is especially complementary with high contrast and bold colors. Hard light almost always makes the viewer think that the scene is shot in bright daylight. Hard light can evoke drama and strength in an image, but it can also be harsh and hot looking, such as light from a camera flash or midday sunshine.

Hard light is great light for mountains, beaches, and the city, making those scenes beautiful and bright, like days full of life. In 1-22, the texture of the trees is accentuated by the hard light.

Because of the inherent contrast of hard light, it casts deep shadows and bright sparkling highlights. These things can trick the meter of the camera; too much of those deep shadows causes the meter to tell the camera to overexpose the image, keeping detail in the shadow. Having bright highlights, such as sunlight reflecting off water, causes the meter to underexpose; this could make your scene so dark that the subject might become a silhouette. As discussed earlier in this chapter, make sure that you meter correctly in hard light because overexposure can easily wash out the entire image, while the meter was just trying to keep it average.

To get the right exposure for your subject, point the camera directly at something of medium tone in the image to get the exposure and then recompose to include the deep shadows or highlights.

SOFT LIGHT

Soft light occurs when the light is more diffused: a hazy, cloudy, or overcast day; in the shade; or when the strobe is bounced. Soft light can come from large light sources such as a *softbox* attached to a strobe or window from the shade side of a building. Soft light often works better for people photos, and soft light can give photos more of a moody look because it can be more subtle than hard light. Soft light wraps around shapes and can appear to have less contrast in photographs.

x-ref More on softboxes and other equipment in Chapter 5.

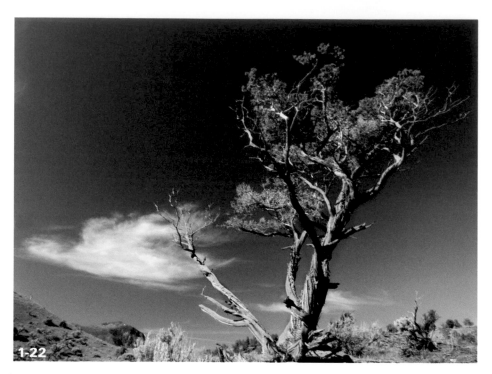

In many cases, a mix of soft and hard light sources is used in an image. It is common to affect light quality with reflectors, placing the subject in a soft light situation and leaving the rest of the scene to hard light. This might happen when shooting in open shade with a sunlit background.

The light in 1-23 is soft, yet it still has bold lines and nice contrast. The white of the aspen trees and the color of the leaves all over make this a perfect candidate for soft light. In harder light, this image would be almost impossible to manage with the huge contrast range between the white trees and the dark underbrush.

note Sunlight that reaches the Earth has been scattered by all the particles in the air. That is why you can use a polarizing filter to darken skies — the polarizing filter gets all the scattered light going in the same direction as it comes into the camera.

COLOR IN THE LIGHT

The colors of light that are produced by the sun vary widely throughout the course of the day as the light passes through different levels of atmospheric density. For example, at midday, the sun is higher in the sky and the light rays go through less atmosphere than at dusk when the light travels through a thicker layer of atmosphere to reach our eyes, which causes what is called *Rayleigh scattering*. And, not to get too scientific, it basically has to do with the wavelengths of various colors and how the particles in the atmosphere affect them.

In the morning and the evening, the light is diffused and scattered and less of the blue wavelengths reach our eyes, which is called the *Rayleigh effect*, allowing your eyes to see more red light. Thus the warmer tones in color at sunrise and sunset.

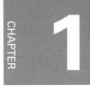

ABOUT THIS PHOTO *Shooting a forest scene is great with diffused light because it shows the entire scene. Hard light would cast shadows or leave bright sunlit areas that would be out of the exposure range. ISO 200, 1 sec., f/11.*

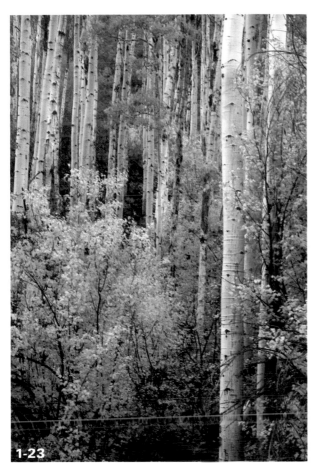

1-23

tendency to be a little harder, and the light definitely has more reddish and deeper colors.

The big bold sunsets happen when it is clear enough for the sun's last rays to shine through the atmosphere onto the underside of the clouds, but clouds are needed to capture that dramatic red light such as in 1-24.

1-24

ABOUT THIS PHOTO *This sunset was photographed with a 17-35mm f/2.8 lens at ISO 100, 1/30 sec. at f/9. The sun really lights up the bottoms of those clouds, creating great texture and color.*

Photographers often call the light that happens right around sunrise and sunset the golden hour. The light at this time is full of much more color, with light that can have hints of pink, orange, red, magenta, and gold. The light quality at this time is really fantastic and is different every day. In the morning, the light might look a little softer and gentler; this is also the time that some of those pink tones show up. This is largely due to the cooler overnight temperatures and the tendency in the mornings to have a little bit of mist or fog in many situations. The evening light has a

Assignment

The Right Light (for You)

I covered a lot of ground quickly in this chapter to get you familiar with all the kinds of light that affect the color and contrast in your images. For this assignment, you get to pick the light for your subject. You can take a high- or low-contrast photo. You can take the picture indoors or outdoors, in full light or low light. It's up to you. The only instruction is to make note of all the elements that go into the photo that you choose to upload to photoworkshop.com. What kind of light are you dealing with? Do you need to adjust the white balance? What are your shutter speed, ISO, and aperture settings? Do you have to adjust any of them to accommodate the amount of light? When you upload the photo, share with everyone all that you can about how you took your image.

I really like working with light as a reflection. So, to complete this assignment, I decided to photograph the graphic shape of the St. Louis Arch. It becomes totally different when you get a different angle and use the light and shadow to maximize the color. In this case, the Arch is in its own shadow, so it is blue, and the sky on this bright sunny day is also blue. The sun behind the arch gives a glow that separates the subject from the background. Using a wide angle lens on a compact digital camera, the exposure was ISO 200 at 1/640 second at f/7.1 with the exposure compensation set to −1/3 to really get the blue nice and rich in color.

Don't forget to go to www.pwsbooks.com when you complete this assignment so you can share your best photo and see what other readers have come up with for this assignment. You can also post and read comments, encouraging suggestions, and feedback.

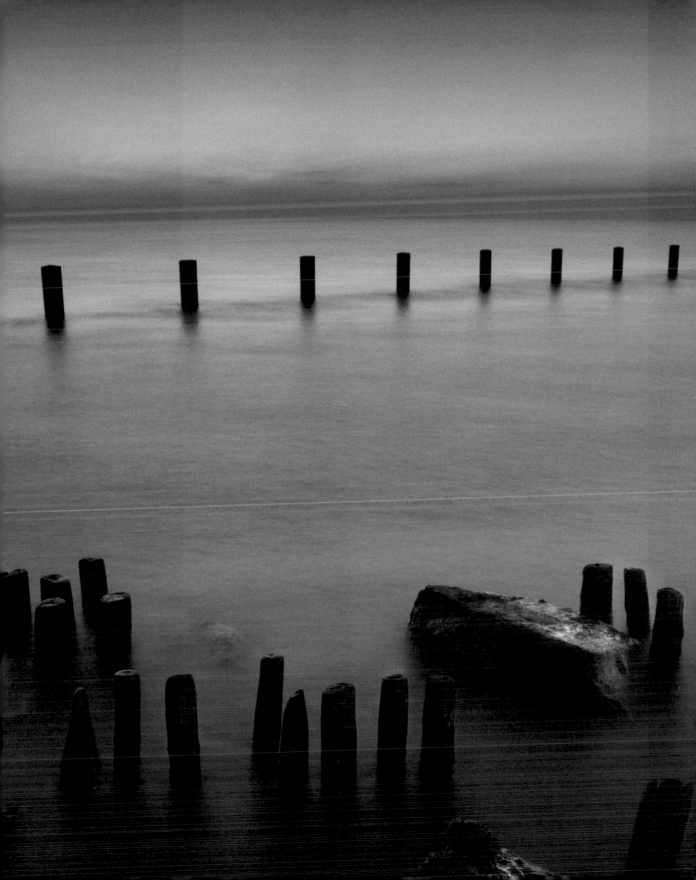

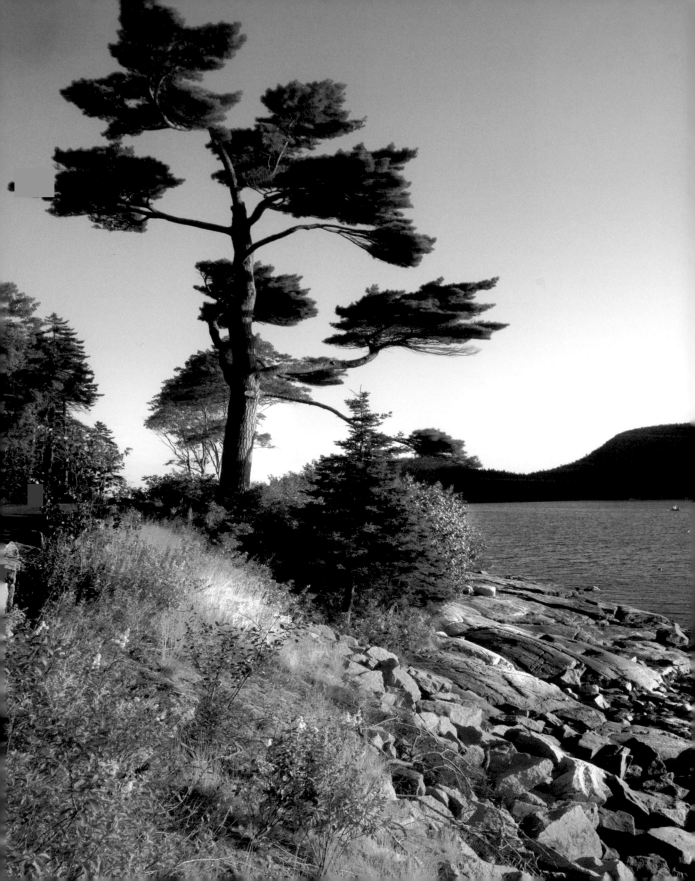

UNDERSTANDING YOUR EQUIPMENT'S ROLE IN LIGHTING

Only a few years ago, some said that digital photography would never surpass film; they said the cameras were too expensive and the quality was never going to be good enough. Obviously, things have changed, and digital photography has grown so big and so fast that many camera manufacturers make only digital cameras now.

The accessibility of digital cameras along with the advance of computer technology has led to a revival in photography. The cameras are so good and have so many automatic features that taking good photos is easier than ever before, but being able to take great pictures still takes a good eye and knowledge of how the equipment works with light to get the most out of the digital camera.

COMPACT DIGITAL CAMERAS

Compact cameras have long been popular with photographers. Starting decades ago with Leica

and 35mm, camera manufacturers have worked long and hard at delivering ever-smaller cameras. With the restrictions created by the size of the film roll and take-up roll, there was a definite limit to how small, and especially how thin, compact cameras could be.

A compact camera can be placed inside a pocket or purse so easily, and many people keep these small cameras with them at all times. There are plenty of times when a full size digital SLR camera would be unwieldy and unwelcome, but bringing along a compact digital camera would be no problem. Having them as close and accessible as your pocket also adds to your photography because a photo like 2-1 might be taken and be back in your pocket before a dSLR is even out of the bag, if you even remembered to bring it on your walk to breakfast.

Digital cameras can be much smaller, limited only by the size of batteries, computer chips,

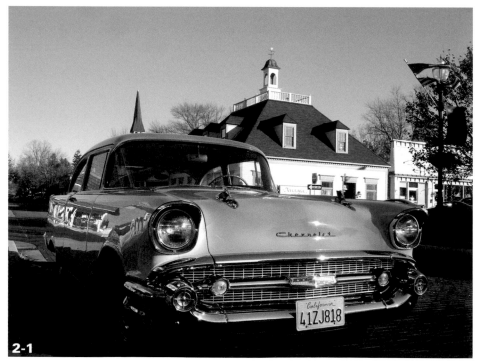

2-1

ABOUT THIS PHOTO
The size of compact digital cameras and their quality let photographers capture scenes that otherwise might be missed because of their portability. Using the black and white mode gives the scene a period feel. f/8 at ISO 200.

retractable lenses, and flash memory cards the size of a quarter that hold hundreds of photos. This enables you to walk out the door with only a single camera in your pocket, loaded with only a full battery charge and an empty memory card to photograph all day. The small size of many cameras is indeed amazing, almost to the point that some may be too small for larger hands.

Most of today's compact digital cameras have auto focus, auto exposure, auto ISO, and even auto scene modes that set you free to explore lighting, color, and composition without worrying about whether an image will come out. The ability to look at the rear LCD to check out whether the scene looks right or whether Grandma blinked is a great advantage to photographers.

Compact digitals have some of the same pitfalls that all cameras have when it comes to tricky lighting situations, but do not have many of the manual controls to change your exposure.

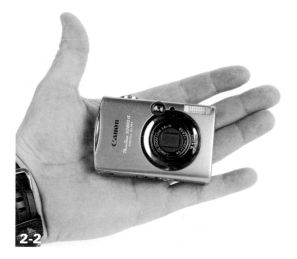

2-2

ABOUT THIS PHOTO *This digital camera is slightly bigger than a deck of cards. This book is peppered with photos from small digitals such as this as they are great for taking pictures anytime, anywhere.*

Reading your manual, becoming familiar with the scene modes and camera controls, and practicing with your compact digital camera are important to get the most out of it. Practicing and testing the camera when you first get it, by taking photographs and then looking at them on your computer, helps you to evaluate whether you should always do some things, never do them, or do those things in certain situations. For example, in testing a compact digital camera recently, I found that virtually all the photos were too bright and slightly overexposed. After looking at them on the monitor and doing some adjustments in Photoshop Elements, I came up with the best plan for this camera — to set the exposure compensation to -2/3 for general shooting.

Exposure compensation is a way in which you can control how dark or light your image will be while still using one of the automatic exposure modes. Using + exposure compensation, you can lighten the image, but using - exposure compensation, you can darken the photograph. For example, when shooting a bright scene like a beach or snow scene, you should use an exposure compensation setting of about +2/3 meaning overexposed 2/3 of an f-stop from the automatic meter setting. In 2-3, the exposure compensation is set to underexpose –1/3, and in 2-4 you can see a different camera's exposure setting at +1.0, overexposing the image 1 f-stop.

> **ⓟ** *tip* Look for where the light is hitting your subject. Even though the meter says that you have a good exposure, that might not mean that the scene is well lit. Is the light coming from across, above, or around your subject? What light is hitting your subject? Are there large areas of dark or light in the background that might affect the light? Take a moment to look at the light all around your subject.

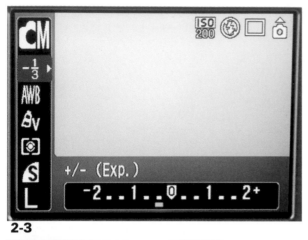

2-3

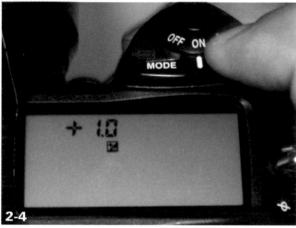

2-4

ABOUT THESE PHOTOS *These are the exposure compensation settings on different digital cameras. Notice that although each one has a different way to do it, the process is the same, making the auto exposure lighter or darker in small steps.*

Most photographers use one of the automatic exposure modes at least occasionally, and automatic might be all that is available with the compact digitals. Exposure compensation enables you to use automatic exposure and still make the image lighter or darker as needed. This technique is great for ski and beach scenes by dialing in +1/3 to +1. A dark moody scene with just a small amount of light, however, might trick the auto exposure into washing out the scene; you can compensate –1 1/3 to make subjects like this

yellow window frame in 2-5 really pop out of a black wall or background. Exposure compensation is an invaluable tool and learning to use it and practicing where to use it go far in making your pictures better. Virtually every digital camera offers exposure compensation.

Activating exposure compensation is usually a two-step process. This means you press a button and then you press a second button or move a dial to actually change the exposure compensation. This process is in place to prevent accidents

2-5

ABOUT THIS PHOTO *The outside light brightens the yellow windowsill, and the lack of light inside makes the wall black. In standard automatic mode, this photo was washed out. An exposure compensation of –1 1/3 makes this far more dramatic.*

in which exposure compensation is turned on and changed, which can potentially ruin some photos.

Being able to evaluate what the light is doing in the scene helps immensely. In 2-6, the ends of these lodge poles coming out of the adobe building is very interesting, along with the complementary blue and the cloud splitting the scene into a diagonal. The light raking across the adobe helps to create its texture against the rich blue of the sky. Try to visualize what the end photograph will be and make certain that adequate light is hitting your subject.

Most compact digital cameras also have a number of scene modes, which provide easy ways to achieve better results while remaining fully automatic. For example, the landscape mode, which is generally denoted by a mountain icon, sets the f-stop to a small aperture to maximize depth of field. On the other hand, the portrait mode sets the camera for a much larger aperture, for a shallow depth of field, attempting to blur any distracting background. Check with your camera's manual or Web site for more in-depth information on the many scene modes that your compact digital has. A sample scene mode screen is shown in 2-7.

 x-ref Starting in Chapter 3, light quality and direction are discussed in more detail.

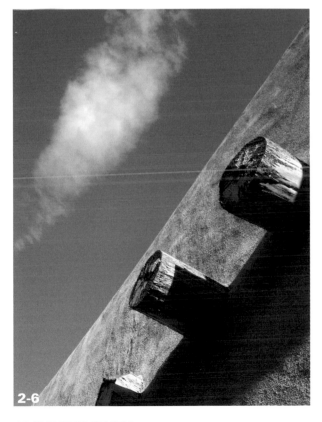

2-6

ABOUT THIS PHOTO *The image appeared a bit too flat; the shadows a little too grey; and the blue a little too pale at the auto setting. This photo was taken at ISO 100 at f/8 with –2/3 exposure compensation.*

2-7

ABOUT THIS PHOTO *This image displays just one of the large variety of different scene modes that many compact digital cameras have.*

33

DIGITAL SLR CAMERAS

The digital SLR cameras allow the photographer a tremendous amount of flexibility when it comes to exposure, white balance, speed of use, lens choice, and incredible image quality. *Single Lens Reflex* means that the light from the image comes through the lens and bounces off a mirror in front of the shutter into the viewfinder until the shutter release is pressed. At that time, the mirror flips up; the shutter opens, exposes the digital sensor, and then closes; and the mirror flips back down. This all happens in a click. The digital SLR is the twenty-first century 35mm camera, because most of them have removable lenses, large megapixel sensors, and auto everything, along with a full complement of manual controls. Figure 2-8 shows an image shot with a professional level digital SLR.

The basics of the digital SLR are mostly similar to the film SLRs, except that instead of film being the medium of light capture, it is a digital sensor. This sensor is a light-sensitive computer chip with microscopic sensor points called *pixels*. The chips, with names like CCD, CMOS, LBCAST, or Fovoen, have the pixels laid out in an array of rows and columns. To determine the size of the chip, the horizontal and vertical pixels are counted and multiplied together; for example, if a chip has 3,872 horizontal pixels and 2,592 vertical pixels, it has a total of 10,036,224 pixels, which means this camera has a 10-megapixel chip.

Generally, the more pixels that a chip has, the better it can resolve fine detail or create large prints. I say generally because with the available technology today, as pixels get smaller, the chips get noisier. *Noise* are the color speckles in a digital photograph that come from the inconsistencies in the sensor and are exacerbated at higher ISOs. Noise is very similar to seeing a lot of film grain in high-speed film. The technology is

2-8

moving faster than ever today, and much as computer storage used to be measured in kilobytes for storage that filled a room, now hundreds of gigabytes of storage use the space of a deck of cards. Soon digital cameras will have gigapixels of resolution, and the quality of those sensors continually goes up. As the quality of the sensors goes up, the amount of noise inevitably goes down, and the amount of sharpness and resolution continue to go up, and the prices go down.

MEGAPIXELS

Having more megapixels does not make you a better photographer. Virtually all modern digital

cameras have enough resolution and quality to
create great looking prints from snapshots to
good-sized enlargements, like 8 × 10, 11 × 14,
and even larger. You don't need to rush out and
get the newest best camera available every time
something new comes out to get great photos.
Digital camera advancements are usually evolu-
tionary, not revolutionary, so think about a cam-
era with more megapixels when you need to
make larger prints.

Until then, you have consumer digital cameras,
the point-and-shoot style with 6 to 8 megapixel
sensors and professional dSLR digital cameras
with sensors that run from 8 to 16 megapixels,
like the sensor shown in 2-9.

The light of the image comes through the lens
and shutter and then passes through an array of
red, green, and blue filters and microlenses for
each pixel on the sensor. The light excites the
electrons on the sensor, and the image becomes
an electronic signal. This signal runs through a
series of electronic filters for color, white balance,
and the like, and finally, the light becomes your
digital image. The image is then stored on a small
digital memory cards.

Digital SLRs, like a point-and-shoot camera,
have automatic settings that can make them easy

2-9

ABOUT THIS PHOTO *This is a photograph of a digital sensor
from a digital SLR camera with 10-megapixel resolution. It is amazing
to think about all the technology that goes into that little chip.*

to use, or these cameras can be partially or totally
manually operated. Manual operation is done via
the aperture and shutter selection wheels on the
front and back of the camera. In most digital
SLRs, those exposure wheels fall nicely under the
forefinger and thumb of the right hand, and most
cameras give the photographer options of which
wheel controls aperture and shutter and even the
direction choice for those wheels.

Having this amount of control and customization
of the camera lets the photographer control the

MEMORY CARDS Most digital SLRs use compact flash or CF as their digital storage
media. These are about 1 × 1 1/4 inch and have memory capacity from 256 megabytes of data
up to 16 gigabytes, with the most common cards being 1, 2, and 4 gigabytes. This size allows
for hundreds of photos on one card, even at the highest resolution. Larger cards are great
because they allow for so many photos between changing, which might mean you can leave
the house with less stuff. On the other hand, larger cards are more than proportionally more
expensive, meaning that twice as much storage is often far more than twice the price. Many
professionals also prefer cards that are smaller, because in the case of a damaged or lost
card, fewer images are lost. Compact digital cameras use smaller storage, generally either
SD (Secure Digital) or Sony Memory Stick (which comes in several different iterations on
its own).

light that creates the image easily. It also makes the camera operate quickly and in a manner that is most comfortable for you.

CONTROLLING YOUR EXPOSURE

The digital SLR also gives photographers their choice of exposure mode. Of course, some sort of fully automatic exposure is available, in many cases called P or Program, and in some cases is even set via some sort of an icon. For example, one camera manufacturer uses a green box to denote the simplest most automated setting. Here are the different exposure modes available:

- **P, Program, Auto.** This fully automatic exposure lets the camera totally decide what the exposure should be and sets the shutter speed and aperture according to the in-camera meter.

- **M.** This setting is for full manual, in which the photographer selects both the aperture and shutter speed and is in complete control of the exposure.

- **A or Av.** In Aperture Priority or Aperture Value, the photographer selects the aperture desired, and the camera sets the shutter speed as needed. This allows for the photographer to select the depth of field needed for the shot, and the shutter speed is selected by the camera to match.

- **S or Tv.** Shutter Priority or Time value allows the photographer to select a shutter speed, and the camera matches the exposure to the aperture. Shutter Priority lets the photographer decide whether the shutter should be fast or slow depending on the scene, while the aperture just follows along.

- **Aperture Priority, Shutter Priority, and Program.** All allow the photographer to override the camera's decision through the use of the exposure compensation wheel. Aperture

Priority is useful in many cases because it allows the photographer the quick control over depth of field of a photograph, especially when shutter speed is less important, such as an outdoor portrait or a landscape when the camera is already on a tripod when there is a low amount of light such as in 2-10. Shutter Priority is great for times when the light is such that a faster shutter speed is needed to stop motion or slow the motion down to induce blur, and because that is more important than depth of field, as in 2-11.

ABOUT THIS PHOTO *Because only a small part of the image needs to be in focus, shallow depth of field, Aperture Priority was selected. The exposure here was 1/80 sec. at f2.8 at ISO 200. Exposure compensation was set at +1.*

2-11

ABOUT THIS PHOTO *To stop the flag in this image, Shutter
Priority was used, and the shutter speed selected was 1/250 with an
aperture of f/5.6 at ISO 200. 1/250 sec. was chosen to stop the action
and depth of field.*

IN-CAMERA METERING

All digital cameras have built-in light meters. In
digital SLR cameras, the light is metered *through
the lens*, or TTL. These meters are a very accurate
way for the camera to get the correct exposure.
Three types of TTL metering are available in
most digital SLR cameras and in many compact
digitals.

Depending on the camera maker, the first type
of TTL meter might be called Evaluative,
Segmented, Pattern, or Matrix. This meter takes

different parts of the scene, measures each
one, and computes or averages the exposure of
the scene. This type of meter is very accurate
for most situations and is the default for most
cameras.

The *center-weighted* meter measures the light from
a central circular portion of the viewfinder and
averages those tones from this smaller area. This
meter lets the photographer take a reading from
that central area, such as when taking a tight por-
trait and largely disregards the light from the rest
of the scene.

A *spotmeter* is similar to the center-weighted
meter, with more focused measurement, usually
about 5 percent of the viewfinder. The spotmeter
is designed for the photographer to be able to
take a reading from a very small area in the scene,
such as a face in very difficult lighting situations
as in 2-12.

Each camera's spotmeter is a little bit different.
The spotmeter does exactly what it sounds like, it
takes a reading from exactly where you select to
measure. The spotmeter reading is usually taken
with the central focus sensor, and the area that is
measured is about the size of the focus sensor.
Some cameras' spotmeters follow along with the
focus sensors. The spotmeter is great for times
when very dramatic contrast or small parts of
light and dark would otherwise fool a broader-
based meter.

Spotmeters are difficult to use because it is impor-
tant to find the right place to point the meter so
that you can meter the correct tone. It is also
important to take the reading with a spotmeter
and then to set your exposure properly, usually in
manual or by using the Auto Exposure Lock
before you recompose your scene. You need to
recompose after setting the exposure because you
almost never find the proper tone exactly where
the spotmeter is.

2-12

What does the meter actually tell the camera? The job of any light meter is to tell the camera what the average grey is. This *middle grey* or *average grey* is 12-percent grey on the scale of tones between white and black. The meter is looking for the average tone or luminance value, and not the color. No matter what the scene is, the meter looks at the scene and tells the camera, "Use this exposure to get to middle grey."

You use a *grey card* (a card that is 17-percent gray) by placing it in the scene with the light on it; then you take a reading by either getting close to it or using the spotmeter to get the exposure. This method takes out the variations of brightness in the scene and just focuses on the light that makes the card grey. A light meter tries to average the scene, so when you have a scene like 2-13, the camera tends to make this photo too dark because it sees the snow as grey. Taking a meter reading off of the flexible grey card lets you be more accurate with your exposure, as in 2-14.

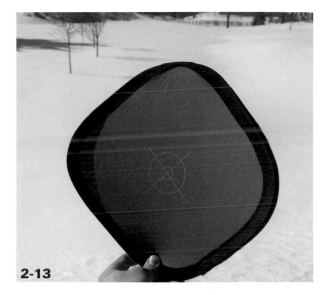

ABOUT THIS PHOTO
*Make sure that you get the
same light hitting on the grey
card as you are shooting to
get the exposure correct.
Turning the grey card into the
shade causes the exposure to
be even darker.*

2-13

ABOUT THIS PHOTO
*Especially when shooting difficult
lighting situations, like snow on a
sunny day, using a grey card can
help you nail your exposure.
1/400 sec., f/7.1 at ISO 100.*

2-14

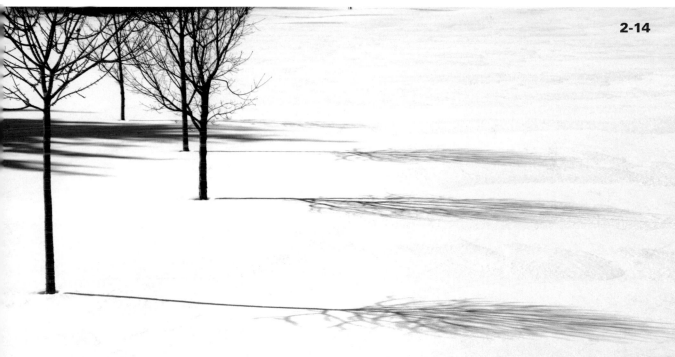

ON-CAMERA FLASH

It wasn't too many years ago that photographer's flashes amounted to disposable flash bulbs, and even before that, flash powder was used to help light a photograph. Photography has come a long way, and now virtually all digital cameras have flashes built in or have accessory *hot shoe* mounts to place a larger flash on top; some have both.

BUILT-IN FLASH

The compact digital camera usually has a small built-in electronic strobe somewhere along the top, front of the camera, hopefully, where the photographer's fingers won't block it. These strobes are small and generally not very powerful. Because they are small, they are *point* light sources, which means that they have very hard light quality. Because they aren't very powerful, they only give out adequate light for 15 feet or so. The lack of power of these compact strobes is usually forgivable because most photography that needs flash can be done up close, as shown in 2-15, but when shooting a large family group, these small strobes often leave much to desire.

The flashes on compact digital cameras have their own sets of features, including their own

2-15

ABOUT THIS PHOTO *This photo was taken in full auto with a compact digital, 1/60 sec. at f/5.8 at ISO 400. This touching image of grandfather and grandson would never have happened without the light of the strobe.*

white balance to make sure that the bluish light of the strobe is properly balanced. You can also use the slow sync or night flash, which fires the strobe as well as leaves the shutter open for a longer period of time to expose for the ambient light in a scene. This makes for some unpredictable and exciting effects, even though it also often causes blur in the photographs, as in 2-16.

The small flashes on compact digital cameras can be further altered, as in flash exposure compensation. The flash exposure compensation button

REDEYE The dreaded phenomenon of *redeye* has become even worse as compact digital cameras have gotten smaller. Redeye happens when light from the strobe comes through the iris and reflects off the back of the eyeball, which is totally covered with blood vessels, thus, the reflection is red. This happens when the angle of the flash to the lens is very tight. Although some cameras have various redeye reduction programs, such as the pre-flash and the bright spotlight intended to decrease the size of the iris, their results are questionable. Fixing redeye using software is also a good option, but it is often time-consuming and sometimes looks unreal. The only tried and true way to eliminate redeye is to get the flash away from the lens, so if redeye is a huge problem for you, moving to a digital SLR and a larger shoe-mounted strobe unit pays dividends.

2-16

ABOUT THIS PHOTO *This happy couple was taken using a long shutter time and slow sync, a feature of many digital cameras that helps to balance the flash and the ambient light. 1/3 sec. at f/4.5 at ISO 500.*

looks like the regular exposure compensation icon, but with the addition of the lightning bolt/flash icon. This feature lets the exposure remain the same but turns the power of the flash up or down as the photographer sees fit. In 2-17, the sun is near dusk and the light level is low, so

the strobe is too bright in automatic. The strobe's color temperature is also too blue to match the warmth of the setting sun. By turning the strobe's exposure compensation down to -2/3 and placing a small square of warm gel filter over the strobe, a much more pleasing result is obtained.

2-17

ACCESSORY FLASH UNITS

A few differences exist between a built-in flash in a compact digital camera or dSLR and an external on-camera flash on a dSLR. The on-camera flash is used in the same manner as the built-in flashes but has the advantages of being larger, which means that the flash can be both more powerful and also farther away from the camera. These accessory off-camera strobes, which are small electronic flash units that approximate the color temperature of daylight, are also more flexible.

Their flexibility comes from their ability to tilt and swivel. This enables you to point the strobe other places than directly forward. In doing this, you can bounce the light coming from the flash. This is directly related to the flashes being more powerful, because it takes more power to make

enough light to travel all the way to the ceiling and back down to the subject and still get a good exposure. The additional power also lets the flash expose subjects farther away.

Digital SLRs can use larger flash units, which they attach together via the hot shoe on the top of the camera. The hot shoe plays a number of roles: It holds the flash to the camera; it has the connection that fires the strobe at the precise moment the shutter opens; and it makes other connections, which allow the camera and flash to talk to each other to further aid in correct exposure. These connections aid the camera and flash in deciding exactly how much light is needed for an exposure while measuring the light from the strobe and the ambient light already present in the scene.

TTL metering, which I mentioned earlier, happens like this: The shutter release is pressed; the shutter opens; the lens stops down to the proper aperture; the flash fires; as the light from the flash hits the subject and bounces back into the camera and onto the sensor, it makes the exposure. When the sensor knows that enough light has hit the subject, it cuts the power off from the strobe, and the shutter closes. All this happens in milliseconds and gives fantastic results most of the time, but because the sensor is evaluating all these things, sometimes the results aren't perfect.

These large flash units that attach to a dSLR are simply more precise, allow for easier control, more control, have more power, and give the photographer even more options for light quality. On a compact digital, if the photographer wants to turn the strobe power up or down, it usually means a series of button pushes or menu selections. On a dSLR's accessory strobe, with a quick press of the up or down button, you can affect the power output of the strobe. Using that same strobe's Manual function, the photographer can have the same output come out of the strobe consistently. This function would be used when a subject might be moving in such a manner as to change the light in the background in each frame. By keeping the strobe's power the same, the exposure on the subject remains the same, even though the light might otherwise cause a different exposure, such as in 2-18. If the subject moves closer or farther from the strobe in Manual mode, the subject gets more or less light.

These accessory strobe units also have the ability to turn and tilt. This is an advantage over in-camera strobes because the light can be bounced

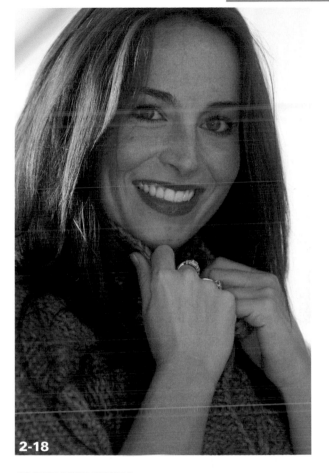

2-18

ABOUT THIS PHOTO *Because the sunlight behind this woman is very strong, using the TTL mode might give varying amounts of power in each, changing the exposure. Changing to Manual strobe at –1 1/3 power makes every frame the correct exposure.*

off walls or ceilings, allowing for far more natural-looking light than the blast from directly over the camera. By tilting the head of the strobe upward at an angle, the light hits the ceiling, lighting the entire room as opposed to just the subject, as shown in 2-19, which is know as *bounce flash*.

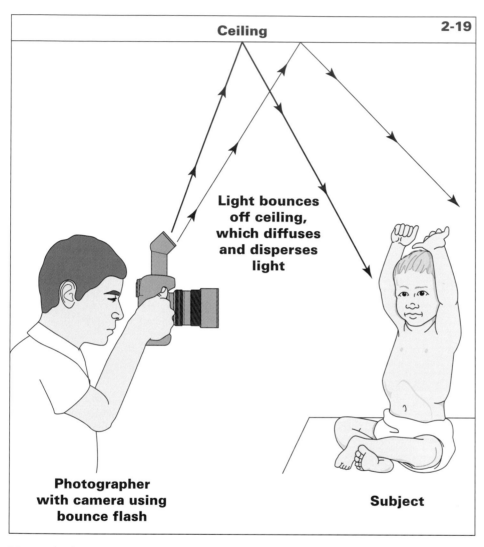

Ceiling

2-19

Light bounces off ceiling, which diffuses and disperses light

Photographer with camera using bounce flash

Subject

ABOUT THIS FIGURE
The light from the flash bounces against the ceiling, creating much more natural light coming from above. You can also attach a small card or reflector to the strobe to push some of the light forward.

Using the bounce flash on your camera strobe to light a ceiling or wall is a great and easy way to light a room so that your images appear as though natural light is used. Not only is it more natural, but also because the light is bouncing off of something else, it becomes a larger, softer light source as opposed to the hard, point light source provided by an on-camera flash. In 2-20, you can see how the bounced light wraps around the subject.

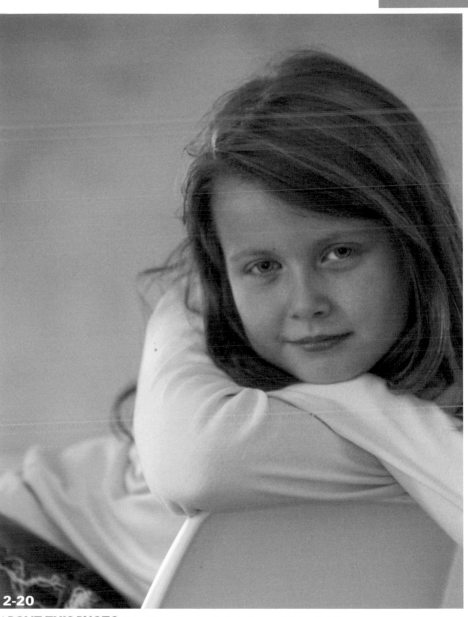

2-20

ABOUT THIS PHOTO *Using the on-camera strobe to bounce light against the
wall in front of this girl creates even and soft light. 1/50 sec. at f/2.8 at ISO 400.*

STUDIO LIGHTING AND ACCESSORIES

Studio lighting takes many forms. Photographers have used all manner of lighting to create their images, everything from window light, to open light bulbs, halogen lamps, pieces of poster board or foam core, and even candles. These light sources are different and effective, but the most powerful and flexible light source are strobe units.

Many other accessories are available to help photographers with the lighting in their images. Things that add, subtract, and even direct or reflect light all can be used to create better images, and most of these things can be made or purchased inexpensively. Lighting accessories can be used with many kinds of light.

STUDIO STROBES

Lighting in the studio is the next step up from mastering the on-camera strobe unit. Although *studio strobes* are exactly that, strobe units made for a studio scenario, on-location use is common. Studio strobes are several times more powerful as compared to even the largest of on-camera units, and they are built specifically to have *light shapers* attached to them. Light shapers are things like umbrellas, reflectors, and softboxes that alter the light quality of a studio strobe. Some of these units are compact enough to allow several units to fit into a small case, and others are very heavy, large, and rarely leave the studio. Most studio strobes are powered like any other electrical equipment, although some are able to use battery power. A small set of studio strobes are shown in 2-21.

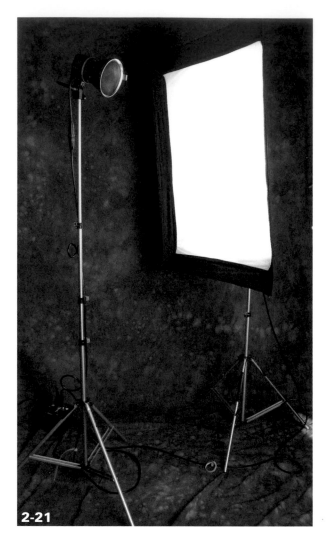

2-21

ABOUT THIS PHOTO *The light on the left has a reflector with a grid that creates a direct spot light. A soft box is attached to the light on the right, which gives out a soft, wrapping light.*

The biggest reason to use studio strobes is the ability to change the light quality. By using different accessories and the direction that the light comes from, the photographer can drastically change the photographs. When compared to

continuous light sources, strobes help to stop
blur, because they fire very quickly, stopping the
action, and with the additional power, studio
strobes add so much more light to your image
that the exposure is much greater. For example,
an exposure using a window light or a large
tungsten light bulb might be ISO 400, 1/30 sec.
at f/4 such as in 2-22, and a similar situation
using a strobe might be ISO 200, 1/125 sec. at
f/8 shown in 2-23. The difference is 8 f-stops

worth of light, yet the difference in the look of
the light quality on the subjects is similar.

Not only do studio strobes help stop action, but
also they are instrumental in getting enough
depth of field when shooting inside. Shooting
inside can be limiting because the light often is
not exactly where you need it when you need it.
The strobes can help to create an image when
there is no available light.

2-22

ABOUT THIS PHOTO *This portrait was taken with an 80-200mm
f/2.8 telephoto zoom lens, with the exposure set at ISO 400, 1/30 sec. at
f/4. A large sliding door let soft light in on an overcast day.*

2-23

ABOUT THIS PHOTO
An exposure of ISO 200 at f/8 at 1/125 sec. was used for this image. A soft box was attached to the strobe unit in order to create a window light effect.

LIGHTING ACCESSORIES

Light shapers, such as umbrellas, soft boxes, reflectors, and the like, come in all shapes and sizes depending on the desired effects. They all change the quality of light in different ways.

■ **Umbrellas.** An *umbrella* attached to a strobe can create a number of lighting effects.

Umbrellas can be large or small and white, silver, or gold. A large silver umbrella attached to the strobe, so that the light bounces into the umbrella, spreads the light. This light source is great for photographing a group of people and can be made even better with lights on either side of the group.

Some umbrellas have removable backs, meaning the strobe can be arranged so that the light comes through the umbrella. This arrangement creates more of a natural look, but is very inefficient, losing a lot of light through the fabric of the umbrella with much of it bouncing back toward the strobe.

Other advantages of umbrellas are that they are small and easily portable. Umbrellas are also relatively inexpensive, so testing the different effects of what different umbrellas do won't break the bank. Adapters are available that hold an umbrella and an on-camera strobe, which can be triggered in a number of ways; these adapters use the umbrella effect without dealing with a larger studio strobe.

■ **Soft boxes.** A *soft box* is exactly what it says — a box of nylon fabric that holds its shape with a series of poles and is attached to the strobe using a *speed ring*. Speed rings come in different models that attach to different strobe units. They allow for the soft box to revolve around the flash tube so that the soft box can be oriented vertically or horizontally. Soft boxes create a soft pleasing light when attached to studio strobes. They have a large translucent panel in front of the flash, and the rest of the box is closed at the strobe, so the light bounces around inside, further softening the light and making them very efficient.

■ **Reflectors.** Two types of *reflectors* are available.

> **Circular.** Circular metal reflectors attach to studio strobes. These give the hardest, strongest light and begin to focus the light.

Attachments also are available that go onto these reflectors; these *honeycomb grids* and *snoots* make the light even tighter and more focused. This focused light is great for backgrounds and products and can be used when the subject calls for light with much more contrast, drama, and a hard edge, as in 2-24.

> **Fill.** The second type of reflector is used along with another light source to fill in where the shadows might be too strong. This reflector can be created from a piece of cardboard, a sheet, or a blank wall, or you can purchase specialty reflectors, some of which are collapsible, folding up for easy portability. These reflectors also come in a variety of textures and reflective ability, with many having multiple faces, each with different characteristics.

Different reflectors might be white, to just push the same color of light back into the subject, or silver, which is brighter and adds a little bit of sparkle to the light. Other types might be gold, which would also be a little harder, but would also reflect warmer, gold light back into the shadows.

Some reflectors are translucent, and those are called *diffusers* or *scrims*. A translucent diffuser could not only be a white reflector, but also would be great to let light through. You could place a strobe unit behind it, giving the subject a softer light, or you could place the diffuser between the sun and the subject, diffusing the light and cutting the harsh shadows from the scene, but maintaining its bright daylight look, as in 2-25.

ABOUT THIS PHOTO *This piano player was shot with just one reflector and grid spot, making for an image with a lot of contrast and a look approaching the light on stage. 1/125 sec. at f/4 at ISO 100.*

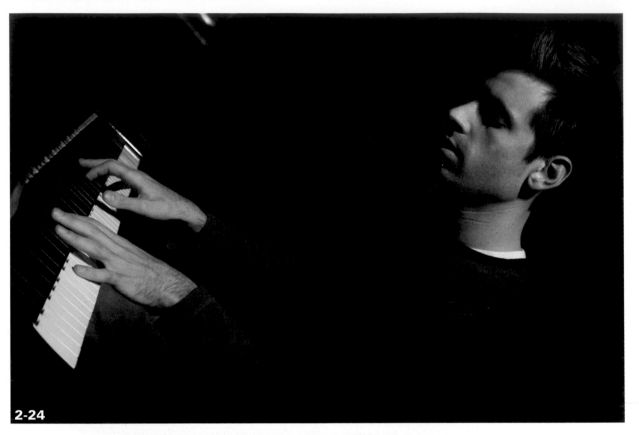

2-24

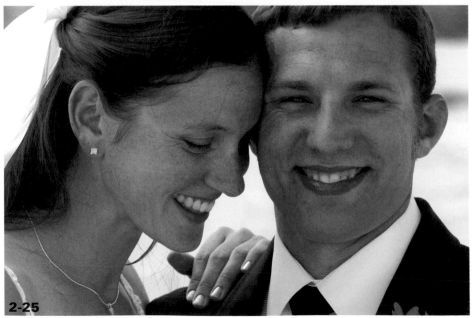

2-25

ABOUT THIS PHOTO
This photo was taken using an 80-200mm f/2.8 lens in Aperture Priority at f/7.1, 1/80 sec. at ISO 100. A scrim was placed above the couple to cut the harsh shadows in the midday light.

TRIPODS

Dealing with a tripod is difficult, cumbersome, and slows down the photographic process. Don't be caught without one! Obviously, sometimes a tripod is not needed, but having one around is like insurance, and so many images could be made better if photographers took the time to put their camera on a tripod and thought a little longer about the image they were trying to create.

Because of digital and the ability to quickly access faster ISOs, as well as new technology such as the new lenses that have Vibration Reduction or Image Stabilization, photographers can be lulled into the thought that they can hand-hold their cameras with a much slower shutter speed.

When motion brings excitement to an image, that may be the case, but if sharpness and image quality are paramount as in 2-26, getting your camera on a tripod and using the lowest possible ISO helps your images.

Some tripods cost less than $100, and some cost nearly $1,000. Certainly, that range is large, and many photographers have several. Spend time at your local camera dealer looking at all the options. Almost as important is the tripod head. This part connects the tripod to the camera and actually moves the camera angle. Many different kinds of tripods are available, and photographers are very particular to the different types. Take some time to try the many options available and how they operate before you buy.

ABOUT THIS PHOTO
This close on a subject makes a tripod a must; even at a fast shutter speed, a photographer's hand is rarely steady enough to keep focus on a subject this close. ISO 100 at 1/80 sec. at f/5.6.

2-26

If you are a traveler or you backpack quite a bit, one of the lightweight carbon fiber models might fit the bill. A couple of things to think about:

■ Does it extend high enough that you won't be stooped over while shooting?

■ Is it solid enough that it does not have excess vibration for long exposures?

■ Are the movements of the head logical and user friendly?

Professional photographers use their tripods almost as much as their cameras, so they must be sturdy, have user replaceable parts, and be built to last.

When longer exposures of several seconds come into play as in 2-27, you most definitely need to use a tripod. However, using a tripod is more than being able to keep the camera steady; it is far more about studying the image in the viewfinder and seeing the composition and what

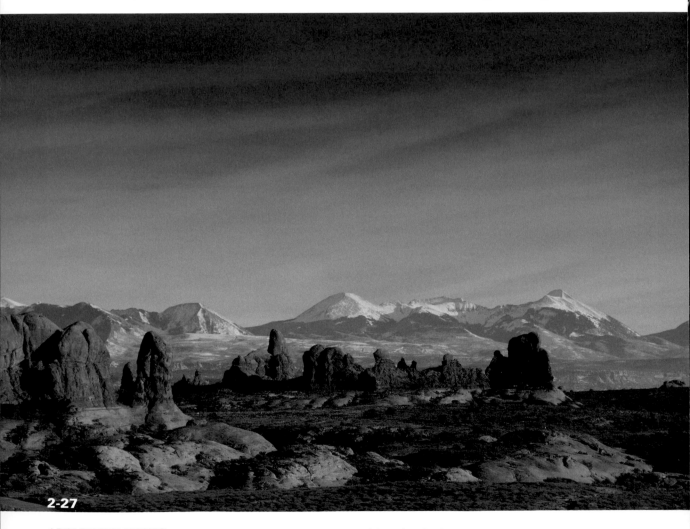

2-27

ABOUT THIS PHOTO Even at 1/250 second with a long telephoto lens (200mm), a tripod can help maximize depth of field and sharpness. At 200mm it can also be difficult to keep the horizon straight and maintain the composition without a tripod. Taken at f/7.1 with exposure compensation set to -1/3.

TIME FOR A TRIPOD? When the light level is getting low, you might start to wonder when is it time to start using a tripod. A good rule of thumb for the slowest shutter speed you can handhold is 1/focal length of the lens. So if you are using a 200mm lens, the slowest shutter speed you should use would be 1/200, and if you are using a 28mm, it should be 1/30. If you are particularly steady or you have something solid to lean on, maybe you can go 1 stop slower, and if your lens has some sort of vibration assistance, perhaps 1 stop slower yet.

the light and shadows are doing in the image. It is about taking your time making great images, not just taking pictures.

tip If you are trekking, traveling, hiking, or the like with others who aren't as excited about photography as you are, you might want to ditch the tripod. The additional time and burden of dealing with a tripod for the non-photographer is often unappreciated. These are times when higher ISOs and anti-shake lenses are great!

CABLE RELEASE

The cable release and the tripod are virtually synonymous, although not mutually exclusive, except you would rarely use a cable release without the camera being on a tripod. Having the release button connected to the camera by a flexible cable allows for virtually vibration-free photography, and it allows you the ability to take a step away from the camera, to get a child's attention, or get out of the way of a reflection.

In the digital world, cable releases are no longer just throwaway items; they are electronic releases, some with advanced timing mechanisms. Some

cameras have eschewed the cable release and have gone with an electronic remote. In case your camera does not have a release socket or you have misplaced your cable release, use the camera's self-timer. The timer does just as good of a job at keeping your camera steady as the cable release.

LENS HOODS

Lens flare happens when a direct light source, such as the sun or a strobe, strikes the front glass element of the lens. The resulting reflections created within the many pieces of glass cause either bright light spots within the image, or the light appears to fill in all the dark areas, making them dull and grey. Lens hoods, or lens shades, help to eliminate this problem. Most lenses for dSLR cameras now ship with lens hoods that are manufactured with a scalloped shape specifically to maximize the coverage that the hood gives, but even a rubber, aftermarket hood helps with lens flare.

Lens flare happens more often with wide angle lenses, and anytime that your light source is not behind you, flare can be a problem. When a lens

FILTERS Photographic filters have immeasurable uses, but in the digital world of traveling lighter and perfecting photographs in software, many filters have gone by the wayside. A few filter effects cannot be duplicated digitally. Before you put a filter in front of your lens, think about what effect it has on the image. Digital cameras and good lenses are well designed, and they are expensive. Placing a cheap piece of glass or plastic in front of the lens won't help the image quality, no matter how good the effect of the filter is. See Chapter 7 for more information about filters.

hood is not available or is not enough protection from the light, use your hand, a hat, a clipboard, and even your body to create a little bit of shade for the front of your lens. Obviously, using one of those methods of shading your lens is easier if your camera is on a tripod or you have an assistant to hold it for you. Make sure to check the LCD monitor after the shot to make sure that your hand, body, or hat is not seen along the edge of your image.

Assignment

Using Your Flash

After reading the owner's manual for your digital camera, take some time to learn how the flash works. Your camera's flash unit can make a huge difference in your photography, so learning its capabilities is important. If you are using a digital SLR with an accessory flash unit, create images bouncing the light into a wall or ceiling to see how that changes the light quality of your strobe. Or, if you don't have an accessory flash, use the flash's exposure compensation capability to just fire a tiny bit of light or blast a bunch of light into an already bright scene.

I really like to use flash as an augment to the natural light more than as the main light when I can. I also believe that more people should use flash outdoors as fill light. In the case of this image, the flash is used to add light into the shadows. Without the strobe, their faces would be very dark, or the sky and the colors would be very washed out. By keeping the girls' faces mostly in shade, the flash is able to fill in the shade pretty evenly, balancing the light without washing them out. Bounce light would not work because there is nothing for it to bounce off of at the beach. Not only does the flash fill in the shadows, but it also adds a little sparkle to their eyes. This image was taken at 1/800 second, f/6.3 at ISO 100.

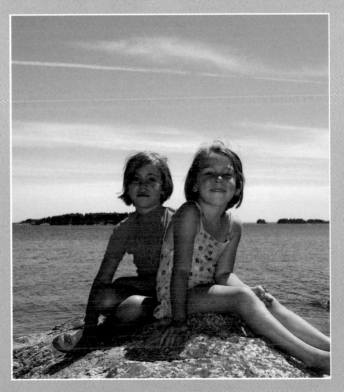

Don't forget to go to www.pwsbooks.com when you complete this assignment so you can share your best photo and see what other readers have come up with for this assignment. You can also post and read comments, encouraging suggestions, and feedback.

WORKING WITH OUTDOOR NATURAL LIGHT

Dealing with outdoor light might seem easy — and certainly plenty of rules of thumb are passed around regarding outdoor photography. Photographers might refer to the Sunny 16 Rule (see Table 3-1) or the saying "f/8 and be there." However, it is more important that you know how and why the light works in your photographs than what exposure to use.

The obvious problem with rules of thumb is that they only get you started. What about light underneath clouds or shade? What about times when the sun is just rising or setting? That is what this chapter is all about.

> **tip** The *Sunny 16 Rule* is a middle of the day exposure of f/16 at 1/ISO. This means that if you are using ISO 100, your exposure should be f/16 at 1/125 second. If you were to use ISO 400, the exposure is f/16 at 1/500 second. In most cases, the shutter speed won't exactly match the ISO but can be set as close as possible; just remember "shutter speed = ISO." With digital cameras and the ability to immediately check the photo on the LCD, this rule is mostly obsolete but still good to know.

LEARNING TO USE THE METER

A light meter is used to measure the amount of light that is available to make the exposure. All digital cameras measure the light that is reflected back toward the camera and are, thus, appropriately called *reflective meters*.

There are no good or bad exposures; the light measurement simply is what it is, and as the photographer, you can use the exposure information to help best create your image. Using what you already know about aperture, shutter speed, and ISO, start to visualize what you want the image to look like. That should help you with your initial settings of the camera as far as how much depth of field or motion you want to control.

The next step is to look at what the meter tells you. When you are using Manual exposure, most cameras have you adjust the shutter speed or aperture until you line up the correct bars or arrows to the correct exposure. Remember, the meter is telling you that what it sees is middle grey, so visually evaluate your scene to determine whether the tones and brightness appear as though they will average out to that middle tone. If you think that the scene should be brighter, as in 3-1, then you need to set the aperture or shutter to let more light through to the sensor, and if you think the scene should look darker, close the aperture or speed up the shutter to make the scene darker. An example of a scene that should look darker than the meter might tell you is shown as this chapter's opener. The meter would look at all those black rocks and overexpose them to make them grey, so underexposing the scene makes them darker.

Table 3-1

SUNNY 16 CHART

Aperture	Lighting Conditions	Shadow Detail
f/16	Sunny	Distinct
f/11	Slightly overcast	Soft around edges
f/8	Overcast	Barely visible
f/5.6	Heavy overcast	No shadows

HAND-HELD LIGHT METERS All sorts of hand-held meters are available, although with the ability to see your images immediately in digital photography, the demand for hand-held meters has diminished. Two types of hand-held meters exist: ambient meters and reflective. The *ambient* meter usually has a translucent dome, and light from the source actually gives you the exposure of the light hitting the subject. Ambient type meters are usually used for subjects in which you can actually measure the light hitting your subject, like portraits. Many ambient type meters today also incorporate the ability to measure the light of strobes. Because of the quality of the TTL meters in today's cameras, the reflective meter has mostly gone by the wayside, except for spotmeters. *Spotmeters* are reflective meters that measure the light from a very small part of the scene and are mostly used by landscape photographers.

3-1

ABOUT THIS PHOTO *The evaluative meter's reading is averaged over the entire scene. The glow of the flag is bright so exposure compensation is set to +2/3 to keep it bright. 1/320 sec., f/5.6, ISO 100.*

WORKING WITH SHAPE AND SHADOW

As light falls across your subject or scene, creating the exposure, the light wraps around the subject or is blocked by the subject, which creates interest. The interplay of light and shadow can create dynamic shapes and textures. In 3-2, the photograph is nothing but the shape of a shadow, yet the bride and groom are unmistakable.

Watching the interplay of the light with your subjects shows ever changing lines and textures with the light and shadow. Working around the different angles and seeing where the light and shadows move inside the camera can be fascinating. In 3-3, the camera was moved all around until the shadow of the barbed wire became just an extension of the rest of wire.

ABOUT THIS PHOTO *This shadow was captured just before sunset with the long shadows that are only available near dawn and dusk. 1/400 sec., f/7.1 at ISO 100.*

3-2

Without shadows, lighting can look flat and uninteresting even if the subject is beautiful or the scene is dramatic. Conversely, great light with exciting shadows can help make mundane subjects more interesting. Sometimes, a simple adjustment in your shooting position and, therefore, a change in the angle of the light increases the drama of the photo.

Although capturing shadows in your scene can create drama, you need to remember to adjust your camera setting in situations where the appearance of shadows changes. In outdoor photography, shadows lengthen while you watch during the waning moments of the day. As shadows increase in the scene and the amount of light in your scene decreases, the in-camera meters read that the light level is lower. Lower light levels give the scene more exposure to maintain an average, which makes your shadows grey.

If you want to keep the shadows in your scene black, you can make several different adjustments. If you are using an evaluative meter set to automatic exposure modes—A, S, or P—you can set your exposure compensation to a minus value starting at –1/2 or –2/3 to make sure the meter maintains enough black in the shadows, as in 3-4. Check the exposure on your LCD to make certain that it is having the desired effect. A value of –2/3 might not be enough; in that case, continue to turn down your exposure compensation. Although you want the shadows darker, maintaining the proper value on the subject is more important.

3-3

ABOUT THIS PHOTO *The shadow appears to continue the line of barbed wired. This image was photographed in macro mode. To keep the exposure bright enough +2/3 exposure compensation was used with an exposure of 1/500 sec. at f/7.1 at ISO 100.*

60

ABOUT THIS PHOTO
With the sun low in the horizon, the light comes across the rocks very dramatically. To maintain the darkness in the shadows and richness of the colors, –1.3 exposure compensation was used. 1/180 sec., f/7.1, ISO 100.

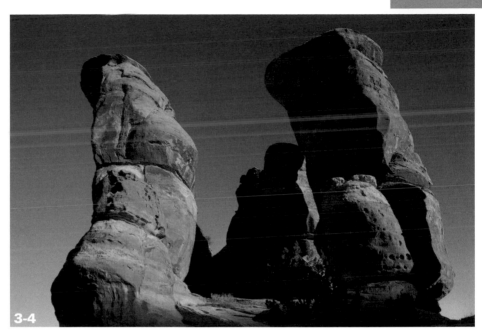

3-4

Maintaining the richness in a photograph full of shadows can be accomplished with a spotmeter. Evaluative meters are adequate in most situations, but they are not as accurate in tricky light situations because they average the scene out. Setting your camera to the spotmeter lets you precisely select your exposure by pointing the spotmeter, which is located in the center focus area of the viewfinder at the most important part of the scene. After you have gotten a reading with the spotmeter, you can maintain the proper exposure after the spotmeter reading by either setting your camera to that exposure in manual exposure mode or using the auto exposure lock button to keep the exposure before you recompose.

The spotmeter only reads exposure from that tiny area in the center of the viewfinder. It tells you what the exposure should be to make what is in

that area 18-percent grey, which is an average, middle grey and is close to an average skin tone. If you take the spotmeter reading on something too light or too dark, it can throw the rest of your exposure off by quite a bit. The spotmeter is a very powerful tool; using your spotmeter can help your photographs if you make the time to learn how to best use it.

tip

Auto exposure lock (AEL) is a button generally on the back of your SLR that allows you to take a meter reading in one direction and then maintain that reading while you recompose and take the photo in a different direction. The AEL can be used in any of the auto-exposure modes—A,S or P— as well as any of the metering modes—evaluative, center-weighted, or spot.

You can create a dynamic photograph by using a recognizable shape in the form of a shadow in front of an already interesting background. Subjects with shadows that create a silhouette in front of a scene give images a sense of scale and create layers within the image. In 3-5, the subject of the silhouetted juniper tree creates an interesting shape of shadow within the image. The darkness of the juniper's shadow is not large enough to cause substantial exposure change. A –1/3 stop lowering of the exposure darkens the shadow and maintains the richness of the color in the background. Using a slight underexposure along with a bright scene, you can make the silhouetted subject a rich black shape, complementing the rest of the scene.

The reverse effect can be used with a bright subject in front of a very dark background. This is a more difficult situation because a large dark area can trick the meter into overexposing the shadow area, which washes out the subject matter. An example of this is shown in 3-6. The tiny wildflowers are being hit by some bright sunlight, but the background is a nearly black, shadowed mountain. The background is so dark, and the small flowers are so slight, that substantial darkening of the exposure is needed to maintain the correct brightness of the flowers. Both the evaluative meter and center-weighted meter try to average the lights and darks in the scene, making the image too bright. By setting the exposure compensation to –1 1/3, you get the correct exposure, darkening the background and keeping the colors appropriately rich.

A bright subject in front of a dark background subject can be taken to an extreme. In 3-7, this spindly stark white tree, stuck deep in the shadows of a valley, gets just a tiny kiss of light. Using the evaluative meter, the tree barely registers as any sort of brightness, and the exposure is entirely one of the shadows of the valley. When

the meter sees such a dark scene, it still attempts to expose for middle grey, which in this case would wash out the tree and grasses that are getting sunlight.

Learning to see how the shadows work with the bright parts of the scene and learning how the meter responds to different situations helps you create better photographs. Seeing the light and learning how the camera sees the light is important. The ability to view your photographs immediately after you've taken them makes digital photography immensely advantageous.

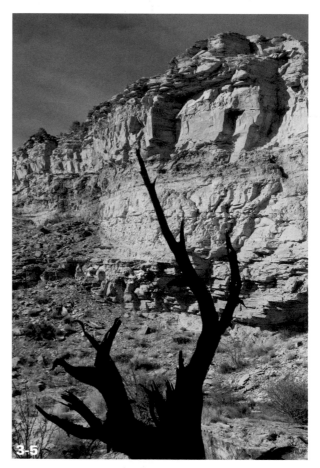

3-5

ABOUT THIS PHOTO *A polarizing filter and –1/3 exposure compensation with an exposure of 1/125 sec., f/5.6, ISO 100 let this shadow pop out of the scene. The exposure for the sunlit rocks and the tree in shadow create this contrast.*

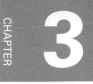

ABOUT THIS PHOTO
By underexposing –1 1/3 stop, you can keep the colors saturated and the shadow of the mountain properly dark. ISO 100 at 1/500 sec. at f/7.1.

3-6

By taking a photograph and reviewing the lighting and exposure, you can reshoot with more appropriate settings. Take the time to do this. If you keep the first and final images, you can review them at home and learn how changes in settings affect your photographs. You'll be ready the next time a similar situation arises.

Shadows also give shape and texture to images. *Dappled light* comes through leaves or branches, casting organic shaped shadows onto the subjects and scenes of your photographs. Dappled light can be beautiful, but it can also be hard to handle. In bright sunlight, the light is very bright, and the shadows are very dark.

ABOUT THIS PHOTO *The darkness of this image needs even more exposure to match what was seen. For the small tree to be properly exposed, –2 f-stops of exposure compensation makes the entire scene dark enough. 1/1000 sec., f/3.2, ISO 100.*

3-7

If the exposure is set for the bright areas, those are correctly exposed, while the shadows are very dark if not black; if the exposure is set to see much detail in the shadows, the bright areas are quickly washed out. In the case of 3-8, a middle ground is met by setting the exposure compensation to +1/3. Any more, and the impact of the dark shadows would be gone, and the red washed out.

If dappled shadows cover your entire scene, exposing for the shadows might be the only option. In 3-9, the light is coming from three quarters behind the trees, meaning that it is not completely *backlit* or completely *sidelit*. Nice white highlights are on the white trees, but a larger portion of the scene, the ground cover in the front, is in shadow. Set

the camera to Aperture Priority and use the evaluative, or Matrix, meter; this setting tells the camera that the scene is already in shadow. A small amount of highlights should not affect a scene too much, but if the meter doesn't recognize a large amount of shadows, setting the exposure compensation to +1/3 or +2/3 helps.

When evaluating how bright the exposure should be, take a look at the main subject of the photograph, in this case the fern at the bottom of the scene. Even though much of the scene is in shadow, the fern in the foreground has sunlight on it. Because the fern is such a prominent part of the image, maintaining a correct exposure is very important.

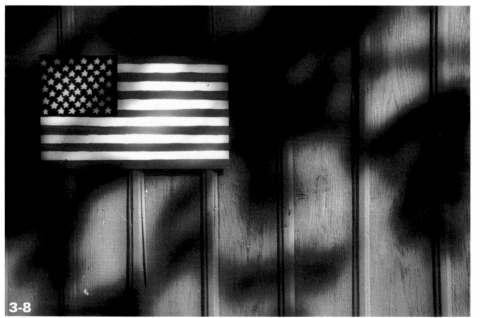

3-8

ABOUT THIS PHOTO *The aspen forest in this photo was taken in Aperture Priority at f/11, 1/125 sec. at ISO 200. Maintaining the detail in the highlights is important so that they don't wash out.*

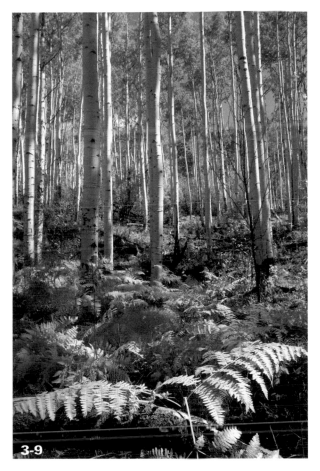

3-9

3-10

ABOUT THIS PHOTO *The shadow of one rock on another gives clear indication about where the light is coming from in this photo taken with a 17-35mm f/2.8 lens at ISO 200, 1/160 sec. at f.5.6.*

Sidelight and crosslight are interchangeable terms meaning that the light comes across the scene from right or left. Top light is when the light comes largely from directly above the subject, such as at noon. Backlight happens when the light is behind the subject, shining into the camera.

x-ref For more information on the meter go to Chapter 2 and read about in-camera metering.

DEALING WITH LIGHT DIRECTION

Any camera's meter gives an exposure that averages the light in the scene so that it averages a grey tone. Learning how to see where that light is actually going in the photograph, how it is affecting the subject, and where to take the proper exposure while photographing outdoors all has to do with light direction which is illustrated in 3-10.

In the preceding section, terms such as *backlight* and *sidelight* were used. These terms, along with *front light, top light,* and *crosslight,* are simple ways to talk about the direction from which light is happening in the scene or photograph. Front light is when light hits the subject or scene head on—the light comes from right behind the photographer.

FRONT LIGHT

The simplest type of light comes from the front of the scene. When photographing outdoors, keep the sun over your shoulder to take a photograph. On-camera flash is another example of front lighting. Front light allows for bright scenes and easy exposures, as shown in 3-11. The red in the rocks is rich, which complements the dark blue sky, and no complex shadows are available to

3-11

ABOUT THIS PHOTO
The rich red color of the iron-rich rocks and the deep blue are accentuated by a polarizing filter with a 17-35mm f/2.8 lens. ISO 100 at 1/45 sec. at f/8.

work with. Sometimes, you can have too much of a good thing. Strong front light can often appear too bright as there is little in the way of shadows, and the light comes straight back into the camera. In those cases, underexposing by −1/3 or 1/2 of a stop can help tone down such brightness.

In a portrait setting, front light is often best when slightly softer. The light coming from the front allows the eyes to be bright and the cheek bones to have a nice shape as in 3-12. Front light also

3-12

ABOUT THIS PHOTO *This image was photographed at ISO 100 at f/11 at 1/125 sec. with a 80-200mm f/2.8 lens. The lighting came from directly above the photographer's head with a studio strobe unit attached to a soft box.*

lets the entire face to be shown without shadows distracting the viewer's eye. Many fashion magazines use some version of front light to best showcase the models and their clothes.

SIDELIGHT

The light that comes across a scene is called *sidelight* or *crosslight*. Subjects and scenes that are sidelit usually show great texture by focusing on shadows and shape. The sidelight often accentuates the leading edge of the subject with the light fading on the opposite side. Sidelight in a portrait causes the shape of the face to fall into shadow such as in 3-13. The sunlight in this image is low, and the way it is coming across the woman's face, it is just beginning to soften. Measuring the exposure from the sunny side of the face using a spot-meter or center-weighted meter helps to maintain good skin tone.

Using the evaluative meter is the best meter for most things. Sometimes brightness or shadows in the background might skew the exposure of the face in a wider portrait. In those situations, you can zoom in tightly into the face or physically move closer and take the meter reading. At that point, you can either use the auto exposure lock or set the exposure manually when you move back or recompose. If the light on the face remains the same, the exposure continues to be the same.

Sidelight is where photographers have to begin really evaluating the light as it becomes part of their photographs. The difference in exposure from the bright side to the shadow side of the scene can either create great images or big problems. If there are equal parts light and shadow, then using an evaluative meter is easy, such as in 3-14.

3-13

3-14

More interesting light, in which the shadows play a bigger roll in the photograph, can challenge the meter and the auto settings. In 3-15 the sky is a dark blue, and the sidelight is creating deep shadows, both on the foreground rock and across the canyon wall and into the valley. Along with those dark shadows, the surfaces of the rocks are being brightly lit by the hard sidelight of the early sun. Setting the exposure compensation to –2/3 was necessary to get the drama desired out of the image; this also ensured that the colors of the rock remained rich.

BACKLIGHT

In many cases, light from behind the subject can be just as exciting and dramatic as when light is

directly on the scene. This backlight is difficult to deal with because, if you are not careful, lens flare can result. This light is also the most difficult for the camera's meter to deal with as exposure difference between the light and dark areas of the scene are far greater. When the scene is backlit, the subject is generally in shadow, so you must start thinking about what light is available in those shadows.

In 3-16, the main light in the scene is sunlight coming from behind the model. This bright sun lights her hair beautifully, but no part of her face directly. Her face is entirely in the shadow created by her head and body, and the light inside that shadow is still beautiful and has very soft texture, with gentle highlights in her eyes and

ABOUT THIS PHOTO
The light coming across the scene created great interplay of light and shadow. 1/320 sec. at f/7.1 at ISO 100 with an underexposure of –2/3 of a stop.

3-15

along her nose. Using the spotmeter, focused directly on her forehead, yields an exposure of 1/50 second at f/4.5 at ISO 100. Obviously, for being outside that is not a lot of light, but inside that shadow, there is great light.

Backlight can also create very interesting highlights because of angle of the light and the direction it hits the camera. These highlights are called *specular light* because they have properties similar to a mirror. In 3-17, specular highlights are all across the bow of the boat caused by the sun hitting the water droplets on the deck and the bright metal trim. The backlight also creates even more contrast with the highlights of the water and the shiny parts on the deck against the shadows created across the deck. Use the trick of squinting to see the highlights and shadows more clearly; the nearly equal amounts of bright and shadow make this an easy, normal exposure situation, even though it is a scene with very high contrast.

3-16

3-17

ABOUT THIS PHOTO *No exposure compensation was needed because of the spotmeter reading, but the white balance is set to shade to maintain the warmth of her skin tone in the blue light of the shadow. 80-200mm f/2.8 lens.*

ABOUT THIS PHOTO *This photo was taken using an exposure of 1/320 sec. at f/5.6 at ISO 200. The shade white balance makes sure that the dark shadows are not too blue and accentuates the warmth of the morning light.*

Extreme backlighting can also create layers within the image and silhouettes a subject. During the last moments of the day, the sun's rays create color as the light goes through the atmosphere. With each layer of canyon farther away from the mesa in the foreground in 3-18, the layers get brighter. Using a telephoto lens helps to visually compress the layers. A center-weighted meter allows you to select just the part of the mesa, but mostly the light filled shadows of the canyon. Metering in a backlight situation, such as 3-18, often gives an exposure that is too bright, so set your meter to –1 or –2 stops below the meter's selection to get the silhouette exposure.

FIGHTING FLARE

Anytime that the sun is out, you have the chance for flare. Today, lens manufacturers use both advanced computer design as well as coatings on the glass to minimize flare, but it can still happen. As discussed in Chapter 2, flare happens when a direct light source enters through the front of the lens and reflects on the many glass surfaces inside the lens.

Flare occurs mostly in backlit situations or times when the sidelight comes at the camera more at a diagonal than straight across. Flare can even happen near midday if the sun's rays hit the front of

ABOUT THIS PHOTO
This photo was created with a 300mm f/2.8 lens. Some flare was seen in the shadow of the mesa, and Photoshop Elements was used to darken the foreground, eliminating the flare. 1/500 sec. at f/11 at ISO 200.

3-18

the lens just right and can be seen in 3-19. The circular shaped light anomalies are lens flare, which is distracting and easily seen against a dark background. Luckily with digital photography, you have the opportunity to check on the back of the camera to see whether the flare affects the shot. In 3-20 the angle to the sun has not changed, but the flare is gone, after the judicious use of a ball cap held over the top of the lens. Even in an overcast scene, having a small bit of light in the wrong place can cause havoc in a photograph.

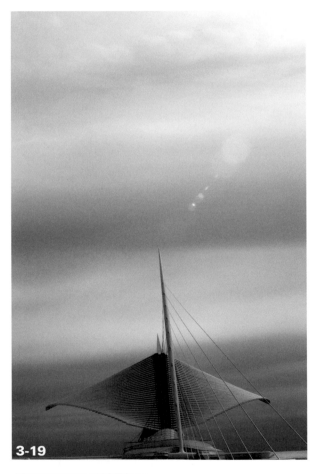

3-19

ABOUT THIS PHOTO *This photo was taken with a 28-105mm f/2.8 zoom lens. Obviously, the photographer left his lens hood in the car in his haste to capture this image and was too lazy to walk back and get it.*

ⓟ note | Longer lenses allow a photographer to control flare somewhat better because with the narrow angle of view, you can move to somewhere the lens doesn't flare or place more shade over it. When shooting with a wide angle lens, because the lens sees so much of the scene, sometimes there is nowhere you can turn that you don't get flare.

In some cases, flare is desired, and shooting into the sun is exactly what works for the image. Any time the sun, a powerful light source, enters the viewfinder, it darkens the rest of the exposure, creating great shape in the form of silhouettes. In 3-21, the red rock formation of Landscape Arch in Arches National Park provides the perfect foil for the sun's bright rays. Underexposing an additional -1/2 stop from the meter reading ensured that the shape of the silhouette is completely black and the blue of the sky is rich and saturated with the clouds making for a small measure of texture in the sky.

SUNRISE AND SUNSET

As discussed in Chapter 1, the light at sunrise and sunset is full of color and drama. Shooting at sunrise and sunset has its own challenges as well, but the challenges are not insurmountable, and the rewards of shooting at that time of day are great. Shooting sunrise and sunset takes some planning and forethought as well as good photographic skills. The light is so dramatic for only a small window of time, so being where you need to be, with the equipment that you need well before the light gets golden, will help immensely.

ABOUT THIS PHOTO
Turning the camera horizontally, which tilted the lens down, and placing a shade over the front of the lens eliminated the flare. 28-105mm f/2.8 zoom lens, ISO 200 at 1/640 sec. at f/7.1 with +2/3 exposure compensation.

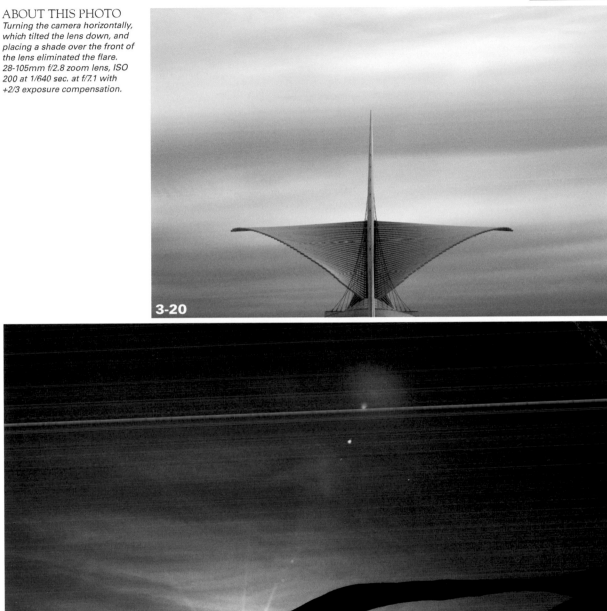

3-20

3-21

ABOUT THIS PHOTO *The exposure was made at ISO 200 with a 1/1250 shutter speed at f/9.5, using evaluative, matrix metering and using −1/2 stop of exposure compensation. 28-105mm f/2.8 zoom lens.*

THE GOLDEN HOURS OF LIGHT

This time should probably be labeled the golden *moments* of light. When the angle of the sun starts to get into those few degrees of sunlight just above the horizon, it takes only a few moments before everything starts to slip into shadow. Although the time is called golden, mostly because the light takes on a golden or amber tone, it also tends to have an almost mystical quality. The color and the low, long shadows make these golden moments such an exciting time to shoot.

In 3-22 the sun is very low in the sky, still probably a half of an hour before sunset. The shadows are growing longer, and the sky is becoming more infused with light. A normal evaluative meter setting in one of the auto exposure modes gives great results. In some situations, you might be tempted to underexpose by –1/3 of a stop to give the rocks some additional richness and saturation; this might cause the shadows on the back sides of the rocks to become too black. In this case, you can use a telephoto lens to bring all the layers of the rocks and mountains together.

3-22

ABOUT THIS PHOTO *80-200mm f/2.8 lens, exposed at ISO 100 at 1/180 sec. at f/7.1. Matrix meter, using Aperture Priority and –1/3 exposure compensation.*

Only moments later, the light becomes far more saturated with red, and the angle of the light is far lower. The clouds also begin to pick up some to of the colored light, giving the sky texture. Using up to –1 full stop in exposure compensation really gives the scene unreal richness. Moving in closer to use a wide-angle lens gives the scene even more of an otherworldly feel. The red and the blue also complement each other very well in 3-23.

In the golden moments of the morning, the light always seems so much softer than in the evening, but that is probably just perception. The subtle light of morning looks great with sidelight coming across a scene. Look for the pastels of the early morning light low on the horizon and in the water scene and watch the sidelight give texture to foreground elements such as in 3-24.

3-23

ABOUT THIS PHOTO *The light at this time is so exciting and dramatic in this place that great photos exist in every direction. ISO 80 with an exposure of 1/210 sec. at f/3.1.*

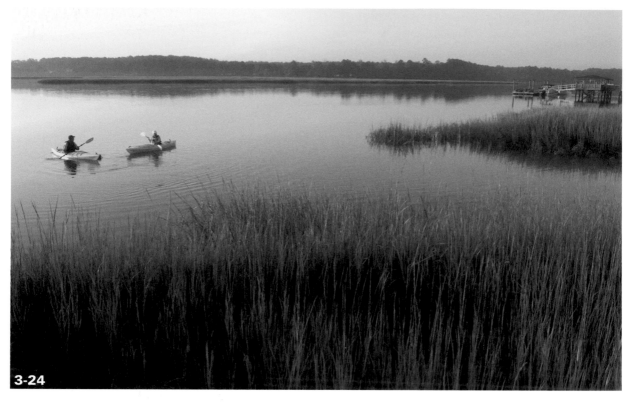

3-24

WATCHING THE LIGHT BEFORE DAWN AND AFTER SUNSET

When the sun is below the horizon and is about to make its appearance or has just disappeared, a low level of beautiful soft light is available. This low light situation means that exposures get very long, so using a tripod is a must. This twilight works for some situations because there is still light in the sky, but the entire scene is in shadow. This, in effect, lowers the contrast of the scene but is more like a giant soft box than when the light is just overcast. An example is seen in 3-25.

When shooting while the sun is below the horizon, remember that the entire scene is in shadow,

and this light is very blue. To maintain the color of the scene as your eye sees things in this low blue light, it might be necessary to set the white balance to cloudy over shady, and even then the image might seem too blue. You can take this opportunity to use either the in-camera manual white balance setting to warm the scene further, or set the image to the warmest standard setting and then make white balance changes in Photoshop Elements. Additionally, when in question about extreme situations, it is then that using the RAW file is particularly helpful because of all of the ability to change white balance at the base level of the image file.

ABOUT THIS PHOTO *Taken some time after sunset, this image retains a soft glow in the sky. 17-35mm f/2.8 lens, and the exposure was 14 seconds at f/5.6 with the ISO set at 200.*

3-25

SUNSETS AND CLOUDS

Great sunset photos come from great cloud formations. This is a double-edge sword, because the texture clouds are needed to capture and reflect the sunset's red light; without them, the sky just turns darker blue until night. Sometimes everything is perfect for a fantastic sunset, with puffy clouds interspersed with sections of blue sky, but

then something happens in the atmosphere with some low clouds and the blue sky with clouds just turns grey.

The Rayleigh effect, as discussed in Chapter 1, is when atmospheric particles scatter the sun's rays and make the light more red in color, which helps to get the vibrant color in sunsets. Using the evaluative meter might render a scene that

looks too washed out without some underexposure. In 3-26, the exposure compensation was set to −1 stop to maintain the richness of the color. The amount of shadow in this scene also makes this difficult because the evaluative meter tries to give an exposure that lightens that shadow area. This scene also uses a Neutral Density Graduated filter to bring the brightness of the sky down to better match the detail of the beach and the boat in the shadow.

○
ⓟ *x-ref* | More on filters, especially neutral density graduated filters, is located in Chapter 7.

A more subtle sunset might happen when the clouds are more dispersed and wispy. In that situation, some of the sun's rays might pass through the clouds, letting only some of the light reflect back toward the camera. This gives clouds more of a pastel color — pink and orange rather than a rich red. Over the course of the sunset, the clouds continue to change color. Varying exposures and techniques when you are in place can bring many different looks to your photographs. Using a neutral density graduated filter once again brings the sky exposure close enough to the canyon exposure so that detail could be seen as in 3-27. Without that filter making the sky three stops darker, the foreground would be almost complete shadow.

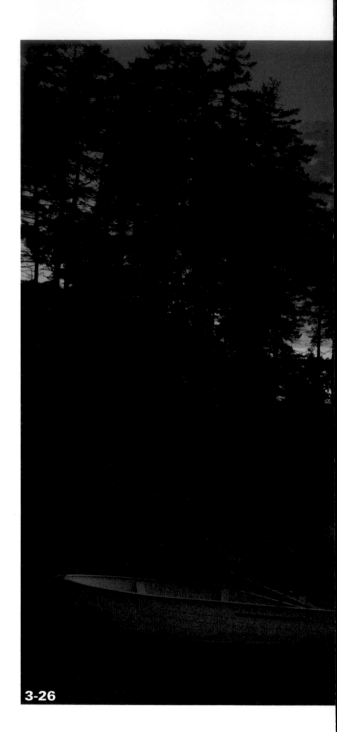

ABOUT THIS PHOTO *A Nikon 17-35mm f/2.8 zoom lens was used for this sunset. The exposure was ISO 100 at 1/25 sec. at f/9 with the exposure set at −1 in Aperture Priority automatic.*

3-26

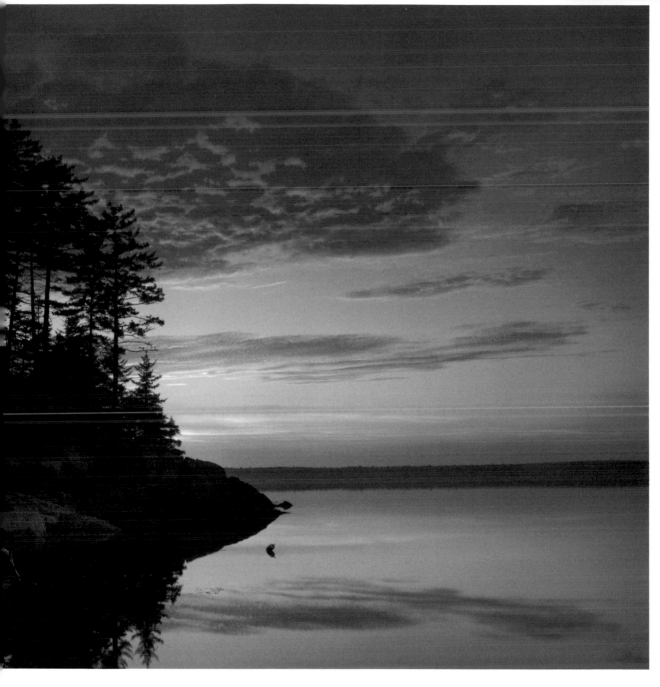

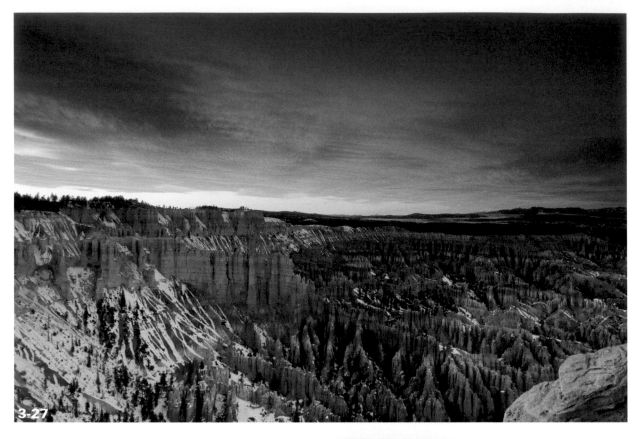

3-27

Using a strobe with a sunset is a great way to light up a subject in front of the beautiful sunset light. Sunsets have a lot of light, and items in front of them become shadows and silhouettes. Using a strobe along with the sunset is a great way to get light on a subject that is otherwise totally backlit. This type of scene could be captured with any sort of digital camera, and many digital cameras even have a special scene setting for this, which is called anything from night strobe, fill-in flash, or night snapshot. This label often is paired with an icon that displays a person with a moon. This scene mode gives the proper longer exposure to the scene in the background and then uses the automatic strobe; it only fires as much light onto the subject as it needs (3-28). In many cases, a tripod is needed as the exposures in this setting can get long.

3-28

MAKING GREAT IMAGES WITH OVERCAST LIGHTING

When the weather conditions become overcast, it should not mean that the photography is done. You have plenty of ways to work with the soft light of low clouds and still make dynamic images.

CREATING DIFFERENT MOODS WITH CLOUDS

The best part of working with overcast skies is the softness of the light. The shadows aren't as black, and the highlights have nice detail. The drawbacks to photographing when it is overcast are that the colors are less vivid, things begin to look more monochromatic, and when a scene is busy, it is hard to discern the shapes that separate the subject from the rest of the image.

Learning to see more simple objects and scenes when it is cloudy helps your photography when it is bright and sunny. Separate shapes and textures with your camera when it is cloudy by getting closer to the subjects. Finding subjects in the details where you might otherwise never look is a great thing to do when the great sunset panoramic shot gets grey and flat. The light on an overcast day allows you to see texture in the scene, when on a sunny day, it might just look like darks and lights. In 3-29, the texture of the weathered wood really pops off the fine red sand, and by using the proper white balance, cloudy, the tones remain warm and rich.

3-29

ABOUT THIS PHOTO *Using a tripod to get low on this gloomy day shows how using the correct exposure and white balance can help create warmth. 17-35mm f/2.8 lens with an exposure of 1/5 sec. at f/8 at ISO 100.*

Just as you can find texture on a cloudy day, you can also find great shape. The light on an overcast day has very little direction to it, so shape can come directly from the subject that you find. Because the light is lower on an overcast day, it often helps to slightly overexpose your images. In 3-30, the image is overexposed +1/2 stop over what the meter said, and to further make this scene simple, the color was removed to just show the shape and tones of the plant.

The soft light of an overcast day works so well with the softness of organic shapes, because the light is so even and wraps around those shapes. Once again, a monochromatic scene allows the shape and subject of the scene to become the prominent part of the image. The pale white of the bone pops out of the darkness of the rest of the scene so nicely, letting the smoothness and symmetry form the shape of the image in 3-31.

3-30

ABOUT THIS PHOTO *The soft light gives the plant even exposure so that you can focus on the texture and design of the plant. A 17-35mm f/2.8 lens was used with an exposure of ISO 200 at 1/80 sec. at f/8.*

3-31

ABOUT THIS PHOTO *In color, this image might be just a snap-shot, but by shooting in black and white, you can create an interesting image. The shape of the bone is interesting with great texture. 1/200 sec., f/5.6 at ISO 400.*

Sometimes, the cool color cast of a stormy or cloudy day can enhance the image. By leaving the white balance at sunny or even forcing the image to be even more blue by setting it to incandescent, you can use the blue monochrome look to accentuate the simplicity and strength of the image, such as in 3-32.

The mood of an image with a strong blue cast is very different from one with warm sunny skies, and those images can use graphic elements and drama just as well by being monochromatic, blue, and projecting a more ominous feeling. The stark look of the empty trees across an empty field

works better with a heavy sky and the soft dark light of 3-33. To give the image an even greater edge, a nontraditional lens was used. The LensBaby is a simple lens attached to rubber bellows. This lens does not auto focus, auto expose, or zoom. It has a fixed aperture and is focused by pushing or pulling the bellows back and forth. The LensBaby also can be tilted and bent in an interesting manner so that certain parts of the image can be thrown out of focus.

3-32

ABOUT THIS PHOTO *The matrix meter did a fantastic job of exposing this high-contrast scene. The white balance was set to daylight on a stormy day, creating a blue cast over the entire scene, exposed at 1/30 sec., f/4, ISO 100.*

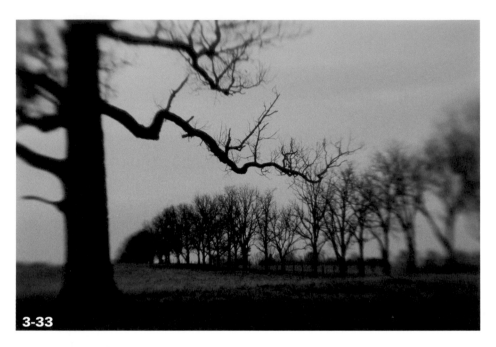

ABOUT THIS PHOTO
This image was taken with a
LensBaby attached. The effec-
tive aperture is f/4 with a shut-
ter speed of 1/350 sec. at ISO
200. The blue cast was achieved
by changing the white balance
in a software program.

3-33

THE DRAMA OF CLOUDS

Cloud cover can increase the drama of a scene, and when there is real texture in the clouds on an overcast day, the interplay of the sky and the ground often makes for exciting photographs.

Usually, a storm front going through creates clouds. Heavy clouds, as opposed to just a low flat sky, have very interesting and ever-changing texture in them. A photographer who can find that texture and use the light available can bring fantastic drama to his or her photographs on a day when most people wouldn't bother shooting.

The light on a cloudy day has some small pockets of brightness that actually give the clouds their definition. The contrast between the sky and the ground is still high, and the exposure must be accurate, or the drama of the clouds is washed out and pale or the scene is too dark. Using the

evaluative meter in this situation is the obvious choice. The chance that a spotmeter would pick just the right tone to match the sky and ground exposure is extremely small.

Because 3-34 is still nearly monochromatic, the thought of converting this to black and white might be a good one. When the image is showing on the monitor, the options are endless; trying different things to the image is one of the great parts of photography. Digital photography has brought instant gratification to a new level.

A truly exciting cloudy scene happens when heavily textured clouds, moving in against the sun, are allowing the light to hit the subject; yet the clouds are extremely prominent in the sky. Metering for this scene is relatively straightforward as the light is generally from the front,

ABOUT THIS PHOTO *The cloudy light minimizes the color in the scene, but the shadows bring out some drama. The exposure here is 1/60 sec., f/8 at ISO 200.*

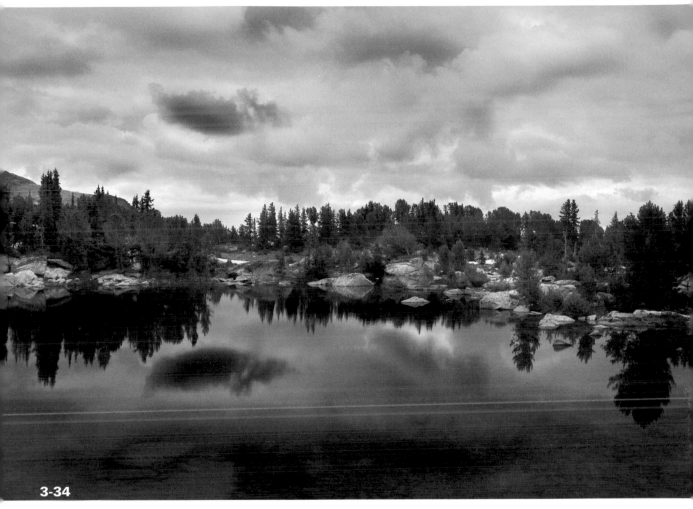

3-34

lighting both the foreground and maybe the clouds a bit. Photographing in this situation is difficult, not because the lighting is particularly hard, but because the light is fleeting and fast, probably faster than a setting sun. To make matters worse, a storm is often rolling in after this type of weather.

The light is so glorious on the fall foliage in 3-35 and the sky so ominous, it is hard not to be

excited about lighting like this. The situation in 3-35 is a rare one when the foreground is actually brighter than the sky, making the metering and exposing pretty easy. This particular instance would have been easy to underexpose for more drama in the sky and increase the richness of the color, but already plenty of drama and rich color are available, and underexposing would just make the shadows in the tree trunks too dark.

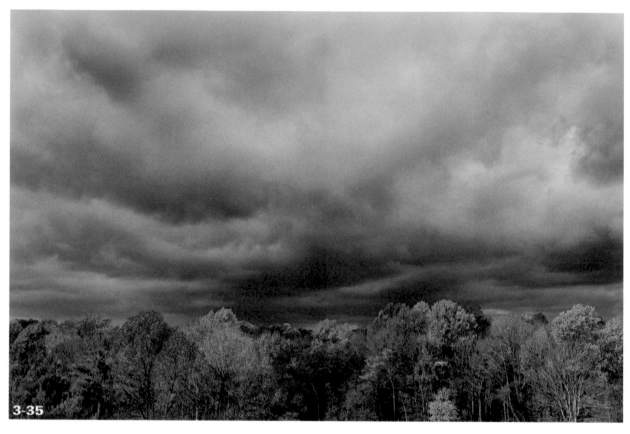

3-35

BRINGING INTEREST TO THE SKIES

Even the addition of a small amount of clouds can generally enhance a shot. In many cases, a photograph that is taken in less than perfect light, slightly overcast, or backlit, or in the case of 3-36 an image that is simply taken in the middle of the day. The hot midday light in the middle of the desert made for a very dry looking shot except for the balance of the warm and cool colors and the odd, nearly singular cloud in the sky.

Using the recommended meter setting and a polarizer to saturate the colors, the cloud does all the rest of the work to make this solitary mountain scene a dramatic photograph.

The polarizer along with a high contrast frontlit subject that is turned black and white creates a near black sky. By exposing for the brightness of the sun, the sky becomes very dark and adding clouds for relief from the stark black of the sky adds needed depth and texture to the photo of

ABOUT THIS PHOTO *Photoshop Elements used to darken the hill, saturate the colors, and give the foliage a bit of glow. This image taken with a Nikon D100 and 20-35mm f/2.8. Exposure was ISO 100, f/10 at 1/80 sec.*

3-36

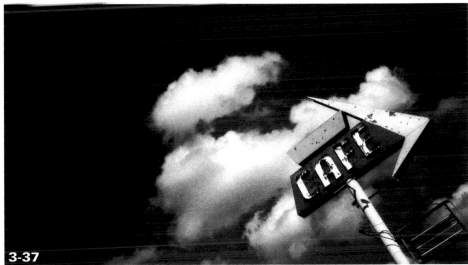

3-37

ABOUT THIS PHOTO
A polarizing filter was used to darken the sky, and this works just the same with black and white. The contrast and grain of the image was done in Photoshop Elements. 1/60 sec. at f/8 at ISO 200.

the sign in 3-37. The image was underexposed –2/3 of a stop to further darken the sky and maintain detail in the white of the clouds and sign.

Clouds rarely need much in the way of additional exposure, mostly because they are generally peripheral to the shot and the subject that is being captured is on the ground, and the light there is what is important. Many times, though, the sky is the light source so it becomes flat and white and unimportant. Look for times when the sky has drama and the light is hitting the clouds, not coming from the clouds, to find the drama in your photographs.

Using a polarizing filter is one of the easiest ways to add drama to your skies because in most cases it helps to separate the clouds from the blue of the sky, by saturating that blue light. In 3-38 the scene is mostly backlit, and the sky appeared nearly washed out and white to the naked eye. By adding the polarizing filter to the scene, the sky becomes nearly striped with the thin high cirrus

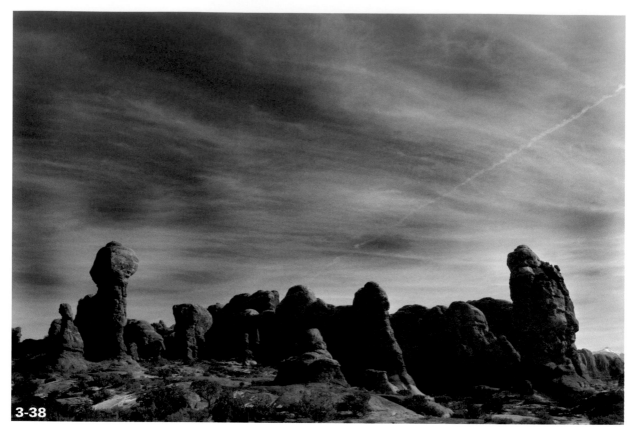

3-38

clouds above. Seeing the delicateness of those clouds across the blue sky is an interesting visual contrast with the heavy and strong red rock formations on the ground whose shapes are only intimated because of the back light giving them a sense of shape.

Occasionally, the clouds become an element below the horizon. This situation is similar to shooting a scene with substantial snow and because the white of the clouds is so dominant, overexposure of the scene is called for. Because the evaluative meter is more than adequate for this situation, and there is a substantial amount of rich red rocks in the scene, it is determined that only about +1/3 exposure is needed to get the proper exposure. Anymore overexposure than that makes any texture in the low laying clouds disappear into a washed out white mass (see 3-39).

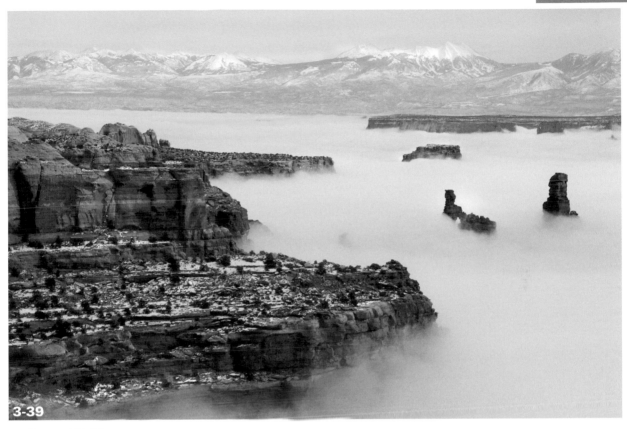

3-39

ABOUT THIS PHOTO *When shooting into the clouds, take a look at the amount of white in your scene. It might need to be overexposed to get enough brightness. The exposure setting here was ISO 200 at 1/200 sec. at f/16.*

Assignment

Using Backlight

Take a photograph of a person or object with the light coming from behind the subject. Remember that this is tricky because you can get lens flare. Use what you learned in this chapter about metering for this kind of situation and take several photographs. Upload the best one and tell everyone how you compensated for the two different light conditions.

This photo has some extreme backlighting as the sun is directly behind the girls' heads. Even though I had the camera set to shade, the warmest standard setting, when I got the image in the computer I worked at maximizing the warmth. This makes the image more like how I saw it in my mind's eye. I had my lens shade on, but I still had to have the girls' mom hold my clipboard just above the lens, to prevent lens flare. The exposure was 1/180 sec. at f/5.6 using center-weighted metering and ISO 400. Using a Nikkor 80-200 f/2.8 lens allowed me to get in tight to their faces without being too close, and this also allowed for the background to go very out of focus.

Don't forget to go to www.pwsbooks.com when you complete this assignment so you can share your best photo and see what other readers have come up with for this assignment. You can also post and read comments, encouraging suggestions, and feedback.

WORKING WITH INTERIOR LIGHT

When you go inside, your eyes don't register the light change as immense. And while the change is not recorded as a large difference by the eyes, the camera sees everything differently. The biggest things to think about when photographing inside are the lower light level and the very different white balances. This chapter should help you better understand how to deal with light when shooting inside.

SETTING YOUR EXPOSURE INSIDE

Even on a cloudy day, when you step indoors, the level of the light drops by more than 5 f-stops. So, on that same cloudy day when the exposure might be ISO 100 at 1/60 at f/8, indoors the exposure suddenly becomes ISO 400 at 1/15 at f/4. On a sunny day, the difference is even greater.

Why is there so much less light inside? Outdoors, the sun creates a huge amount of light, and even when the sun isn't directly hitting the subject, as on an overcast day, the sun lights the clouds, making the entire sky one giant, soft light. When inside, the roof and the walls block virtually all of the light. Even if you have four 3-foot by 5-foot windows, the light coming into the room is still limited. Exceptions obviously exist, such as skylights and when direct sunlight is streaming through a window.

Photographically, light bulbs only bring the light level up marginally. In the daytime, the amount of light coming through the windows is still brighter than all but floodlights, and even though it appears as though a light bulb is bright in a room, generally the bulbs only light the area in close proximity.

This lower amount of light indoors simply means that a photographer needs to think a little harder when shooting inside. Take a minute to think about how to best create an exposure inside with less light and how those changes affect photographs.

Depending on what you are shooting and the situation with which you are working, the first option when working with less light is either to set the camera on a tripod or to increase the ISO. When creating a still life or interior shot, the best way to maximize image quality and yet still work with lower light is to get out the tripod, keep the ISO as low as possible, and use a long shutter speed to get the exposure. In the case of 4-1, the exposure is almost totally created with the light from bulbs placed around the room and set in the ceiling, and the white balance, set at incandescent (or tungsten) reflects that.

In many situations, a tripod might not be a reasonable solution. People might be moving around, and working with a tripod might slow you down enough to miss the shot, or the tripod might not fit into the tight space where you are shooting, or perhaps the tripod was left at home. No problem. One of the most exciting parts of shooting with a digital camera is the ability to quickly and easily change the ISO of the camera to whatever is necessary for the shot. This ability is especially handy when shooting a wedding, whether the photographer is the official photographer of the event or is just a good friend of the bride and groom shooting images for that special day; the ability to change ISOs in each different lighting situation is fantastic.

4-1

ABOUT THIS PHOTO *Using the correct white balance and the evaluative meter set at f/8 at 2 seconds at ISO 100 yields an image that is well exposed, has enough depth of field, and has a great color. 17-35mm f/2.8 lens.*

In 4-2, the bride is taking a last look at her dress to make sure everything is set. The lighting in this image is soft and simple, and using the shadow of the body becomes more interesting than just a head or photograph of the bride. Look creatively at different angles and how the light works with the different layers within the image.

4-2

ABOUT THIS PHOTO *This atypical wedding photo makes the most of the window light. The 18-200mm f/3.5-5.6 zoom lens has Vibration Reduction, which helps to correct blur from camera shake. ISO 500, 1/25 sec. at f/5.*

HOLD STEADY Vibration Reduction, Image Stabilization, Optical Image Stabilizer, and Super Steady Shot are all various trade names for technology that uses either moving glass elements in the lens or a moving digital sensor in the camera to help eliminate camera shake. This technology often allows shutter speeds much lower than would normally be used when hand-holding a camera. When shopping for this type of technology, make certain that you get optical stabilization, where there is actually shifting of the lens or sensor. Some camera manufacturers have anti-shake technology, which is essentially just a higher ISO setting; this often lowers image quality instead of making it better.

The window light illuminates her, and yet because the window is behind her, you cannot see the light except in the mirror. The ISO in this case was set to ISO 500, which allowed for fast enough shutter speed to hand-hold the camera with minimal camera blur, but blur in her hand is evident.

Because of the lower light level, not only is it important that the camera is correctly set with a higher ISO or locked to a tripod, but also in many cases, it is important to overexpose the scene further. Once again, what the eye sees and what the camera sees are different. Even though an inside scene might appear to be bright, it is only because the eyes have gotten used to it. Corners and furniture create dark shadows in a room, and different lights inside the room do different things to those shadows. In 4-3, the window light creates the beautiful sidelight for this bride and flower girl and also presents the challenge of being the main source of light for the image. This light gives the scene its texture and throws the meter for a loop. In this case, using AEL (auto exposure lock), the exposure is captured by pointing the meter at the bride so that very little window is seen, then the image is recomposed and exposed.

4-3

ABOUT THIS PHOTO
This sidelit image was taken with an exposure of ISO 200 at 1/125 sec. at f/4.2 with a Tamron 28-105mm f/2.8 lens.

SEEING THE CONTRAST INDOORS

Not only is the amount of light limited indoors, but the contrast of that light also can pose challenges. Because light sources indoors often are smaller, the light near them is often relatively bright, but the amount of light tends to fall off relatively quickly, and it gets darker the farther you get from the window or light.

When the light is mostly just window light, it is usually nice, soft light, although window light is generally cool because it is in shadow. Window light is great for shooting people, things, and places as seen in 4-4. If light is streaming through the windows, the light is very direct and hard, and this is difficult to deal with because of the extreme in contrast between the sunlight and the darkness of indoors.

4-4

ABOUT THIS PHOTO *The light from a window at the end of this row of bottles creates backlight, which causes nice highlights and reflections on the glass and medals. 1/40 sec., f/5.6 at ISO 200.*

Indoor scenes are also affected by the lighting within the room. In many cases, tungsten or incandescent light sources tend to be very warm in color. Other times, they might be fluorescent or even a mix of different sources. Take a look around the room to determine what the main light source of the room is before you begin shooting. When you have multiple sources, determine the source that is lighting the subject and then change your white balance appropriately.

When the light is minimal or you have light sources that are small in size, more contrast can be achieved in the scenes indoors. This is because the small source can light only a small area leaving the rest of the scene dark, and an example of this can be seen in 4-5. Even though the light source is relatively soft, since very little light is elsewhere in the scene, it becomes a scene with a lot of contrast. Use small light sources like small windows and lamps to light a subject so that it can pop out of a dark scene.

Using a number of small light sources creates a much brighter scene as light is hitting all sides of the scene. In 4-6, this interior scene has many small, high-contrast light sources, but because there are so many, the scene itself does not have too much contrast. When shooting scenes that need to appear brighter, make sure that the light source is large enough or that you have a sufficient amount of lights to light the entire scene. Don't forget to check that your white balance is set correctly.

4-5

ABOUT THIS PHOTO
A spotmeter reading was taken off of the subject's blouse, for an exposure of 1/125 sec. at f/2.8 at an ISO of 400 with a Nikon 80-200mm f/2.8 lens.

ABOUT THIS PHOTO *There are many small light sources in the images that all add up to enough light to make the scene bright throughout. The exposure was 2 seconds at f/8 at ISO 100, with the white balance set to tungsten.*

4-6

WORKING WITH WINDOW LIGHT

Shooting with light from a window can be very rewarding. It can also be either extremely difficult or relatively easy. The type of light that comes through a window makes all the difference in the world to your photography. If the light is bright and sunny and comes directly through the window, the amount of contrast can be difficult but not impossible to deal with; however, if you have a window that is in the shade, the light can be great for portraits and interiors, but the amount of light is limited, causing problems as well.

THE QUALITIES OF WINDOW LIGHT

Two types of light can come through a window: direct and diffused. These are essentially synonymous with hard and soft light. Take time to look at the light coming through the windows in your home or workplace. Watch the light change as the light comes directly through east-facing windows and note how at noon the direct light is gone only to be replaced by soft light coming through shaded windows.

By observing and photographing the changing light in your home and how that light affects the walls, plants, furniture, and artwork in your home, you can make it second nature to recognize the different light qualities that window light brings to your photography.

DIRECT LIGHT

When direct light comes through a window in the form of hard sun rays, the light is very bright, coming into a very dark place, which creates bright shapes of light on the floor and furniture (the kind of light that a cat likes to sleep in). Because this light is direct sunlight, it creates too much contrast, making scenes very dark except for where the sunlight comes through. Where the sunlight touches is correctly exposed as in 4-7. If the dark part of the scene is exposed correctly, the places where sun comes through become completely white and overexposed as shown in 4-8.

4-7

ABOUT THIS PHOTO *The light here is very harsh and direct. The light was measured with the spotmeter and was still underexposed -2/3 to get the exposure of 1/250 sec. at f/5.6 at ISO 100.*

HISTOGRAMS A histogram is the graphic representation of the amount of highlights, shadows, and midtones in your image. The histogram is like the twenty-first century version of the handheld light meter, and they are located somewhere on the monitor of every digital camera. Checking the histogram is a more reliable way to see what is happening with the exposure than the LCD screen because in different situations that monitor appears different.

If your image is too underexposed, the curve on the left of the graph will be slammed all the way to the left of the histogram. If you have overexposed whites, the bars of the graph will be all the way to the right. The histogram changes along with your exposure changes. You don't change the histogram, you change the exposure, and the histogram shows you what you have done in that image.

A great tutorial on how the histogram on digital cameras works is available in the tutorial section at www.luminous-landscape.com.

In 4-7, a spotmeter was used to measure the light areas on the boy's face. The contrast level of the scene is such that measuring the highlight areas makes the rest of the scene virtually black. That amount of shadow causes an evaluative meter to make all of that black go grey, which totally washes out the sunlit part of the scene. Make certain to check your LCD and the histogram as you are shooting to ensure that the exposure, especially the highlight areas, is properly exposed. If there are parts of the scene that are too overexposed, the graph of the histogram will be all the way to the right and the bars of the graph will hit the top. In the case of shooting a portrait with such direct and hard light, exposure is particularly important because skin tones can very easily get too washed out in an image with so much contrast.

The scene in 4-8 is difficult to deal with because of the extreme contrast range. In most cases, just deciding whether you can deal with some areas of overexposed white or underexposed black in your image is all that you can do; then you expose for the area in shadow or the area in the sun.

4-8

ABOUT THIS PHOTO This photo was taken with a Nikon 12-24mm f/4 lens set at ISO 200. The exposure was 1/8 sec. at f/11. The scene was metered normally with the evaluative meter and then +1/2 f-stop of exposure compensation added.

In 4-8, the evaluative meter did a good job of exposing the large area of shadow in the scene, but the exposure compensation needed to be dialed up +1/2 stop because the bright areas on the right side and floor made the rest of the scene too dark. The overexposed pillars and sun on the floors are disregarded.

Depending on the amount of the contrasting area, the evaluative meter just averages the entire scene, leaving the sun-affected area still too bright and the shadowed areas murky and grey. When shooting into the shadowed areas and letting the bright areas overexpose, check to make certain that the sunny areas do not affect the meter, which makes the image darker. Look at your LCD screen and the camera's histogram to make sure that there is still plenty of detail and enough brightness in the main, shadowed area.

DIFFUSED LIGHT

Diffused light is created when the light comes through the windows on the shady side of the building, or when it is overcast outside. This light is indirect and is softer, much like the light on an overcast day. In many ways, diffused window light can appear like a studio strobe with a soft box attached. Diffused light is great for shooting many things, but the obvious drawback is that it is simply a low light source, which limits the ISO, depth of field, or shutter speed that you have to deal with.

When shooting a tight portrait with window light, it is important to meter off of or get close to the subject to get the correct exposure for the face. In 4-9, the light was even broader than just one window lighting a room. This window opened into a small, very white hallway, which allowed the light to wash all over the bride and her mother.

Diffused window light is also toward the blue end of the color temperature range because the light

is shadowed light, usually because the sun is on the other side of the house, and the house is creating shade. Using the shady or the cloudy white balance is important for portraits. Even if the image is going to be black and white, to get the proper skins tones, it is important that the white balance be correct. In 4-10, a tall picture window creates a giant soft box like light that not only has a nice sidelight across the girl's face and hair, but also lights up the blue wall, which is a great complement to her red hair.

4-9

ABOUT THIS PHOTO *The exposure was 1/30 sec. at f/5.6, which was slightly overexposed from the evaluative meter reading but was perfect to get the skin tone so bright and with a bit of glow. 18-200mm f/3.5-5.6 lens set at ISO 500.*

ABOUT THIS PHOTO *After making sure the correct white balance was set for this portrait, I used an 80-200mm f/2.8 lens set to ISO 400. The exposure was 1/125 sec. at f/2.8.*

4-10

Other things besides people look great with window light. Plants, pets, and collectibles can all look great with diffused window light. This light looks great because it has nice direction and contrast but is generally soft enough that it can show the texture of an item. Putting items right up to the window lets the soft light wrap almost completely around small items like the shell in 4-11.

Another advantage to using diffused window light is that because the exposure is relatively low, you can really take advantage of large apertures and shallow depth of field. By using the shallow depth of field available because of the lower light situation, you can get a subject sharp and in focus and let the background go soft, but still give sense of what that background is. This technique is a great way to take advantage of the situation with the light that you have.

4-11

ABOUT THIS PHOTO *This image was taken with an 18-200mm f/3.5-5.6 lens set to ISO 400. The exposure was 1/180 sec. at f/5.6 to allow the diffused light to envelope the shell.*

INTERIORS

Shooting the interiors of homes and businesses only with window light is difficult because the light source is usually part of the scene. Because the light source is in the scene, it is a white space in the image, and the contrast between the window and the scene is difficult to work with. Your eyes see the scene as looking great, but the meter sees the window and wants to average the exposure to include this large area of brightness, making the scene too dark. Using Manual exposure, or exposure compensation, just metering for the areas that are important in the scene can work, as in 4-12.

By eliminating the windows from the scene, it is easy to use great window light, without having to deal with the contrast of the actual window. This situation is great when shooting more of the interior details. The detail in 4-13 actually has light coming from both sides of the scene, because a small window lights the grey wall and black vase, and the nook it is set in is actually a pass-through, so light from the window behind lights the blue wall.

ABOUT THIS PHOTO *The light coming through the window is diffused which wraps around the columns and fills up the room with soft light and allows the exposure of the reflection and the ceiling to nearly match.1/125 sec., f/3.2 at ISO 400.*

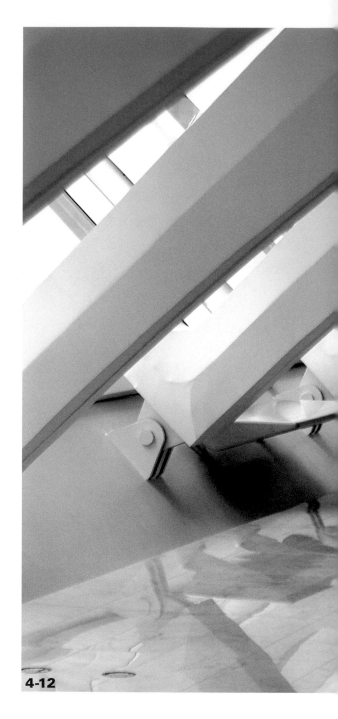

4-12

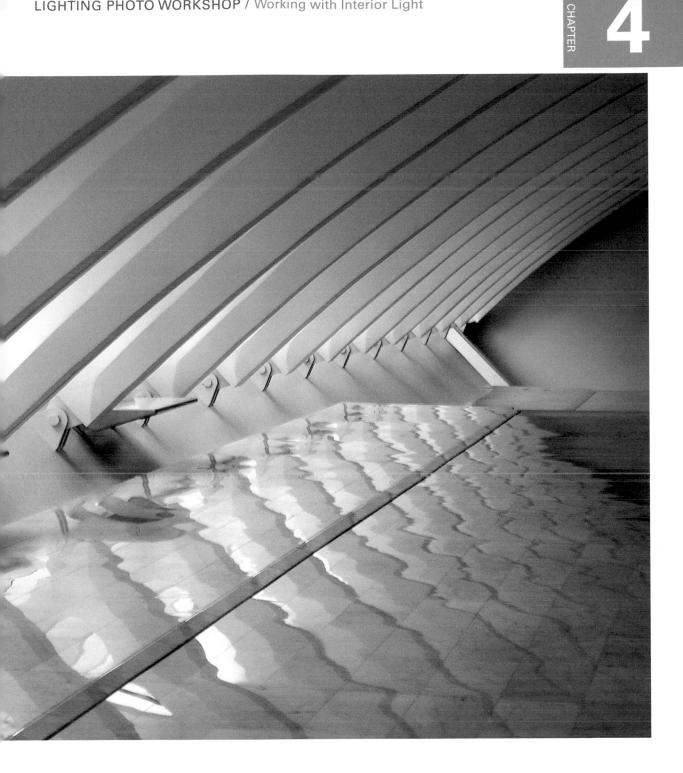

4-13

MIXING DAYLIGHT WITH STROBE

Because of the contrast window light brings into a room, you often need to augment the available light with strobe lighting. This mix can better balance the light of the window and the darkness of the room for a proper exposure. Balancing the light sources can be done with one or several strobe units of varying power.

When trying to shoot interiors and mixing window light and some strobe, be sure to carefully evaluate the light coming in and how the windows affect the scene. Try to get an angle that limits shooting directly into the window, maximizes the light of the room while minimizing your view of the light source, and eliminates distracting reflections of the strobe in the window.

If at all possible, try to bounce or diffuse the light coming from the strobe. If the strobe is on top of the camera aimed directly forward, the light is very harsh and can throw some distracting shadows. Direct on-camera strobe lights the subject in the front very well but then the light falls off and it gets too dark in the back, or the light is bright enough in the back of the room, but the front part is overexposed. By bouncing the light into the wall or ceiling, you can make the light much more broad and soft and allow the light to cover more area.

Additionally the on-camera flash is what cause the harsh shadow behind a subject. By bouncing the light into a ceiling or wall, you can soften the shadows or even eliminate them.

In 4-14 a strobe is aimed at a neutral wall near the lounger. This adequately fills in the shadows created by the light coming through the window. Getting the camera physically lower also helps because the trees are darker in the scene than the sky would be, and the green of the trees definitely complements the other colors of the scene.

In some cases the light from a single on-camera strobe is not enough to light the entire room, and you need to use additional strobes or studio strobes. You might need additional light to better balance the amount of sunlight in the scene or because the space is large enough that one strobe doesn't cover the room.

ABOUT THIS PHOTO
The light from the window creates shadows coming at the camera that are filled in by a bounced fill flash 1/20 sec. at f/6.3 at ISO 100, 12-24mm f/4 lens with a Nikon SB800 strobe attached.

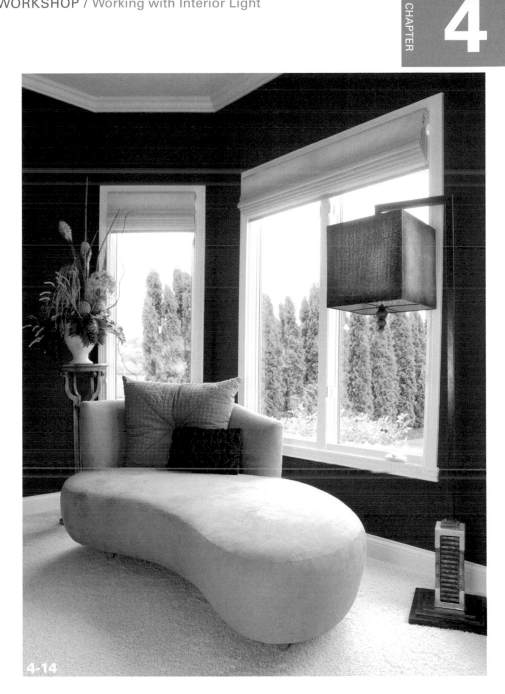

4-14

In 4-15, a substantial amount of direct light is coming through the windows, and the distance between the foreground and the background is nearly 20 feet. One strobe cannot spread enough light on the mantle and the area with the piano. One studio strobe, close to the camera, has an umbrella attached, and a second strobe unit is placed nearer the piano and bounces into the ceiling, spreading the light around the background.

MIXING DAYLIGHT WITH INTERIOR LIGHTS

Incandescent light mixed with window light can work if the amount of window light stays low enough to actually let the incandescent light register an exposure. When it is dark enough that the interior incandescent lights start being bright enough to work with window light, it can create beautiful effects. Often, the window light becomes an accent, fill, or rim light, and the incandescent becomes the main light for the exposure.

4-15

ABOUT THIS PHOTO *A 12-24mm f/4 lens set to ISO 100 and an exposure of 1/15 sec. at f/8, with a mix of window light and studio strobes doing the lighting.*

INCANDESCENT LIGHT When an electrical current runs through a thin filament, the electrons in the filament become excited and create energy in the form of light and heat. This filament is inside a glass vacuum tube, because otherwise the filament would be easily oxidized and destroyed. A halogen light works along the same process and is in the same family of lights, but it uses different inert gas and usually a tungsten filament and is a more advanced bulb type. Many different kinds of incandescent bulbs exist, from standard bulbs to mini-bulbs to flood lights and even many motion picture lights, and for the most part, these bulbs are relatively warm toned, with a cooler color temperature of about 3200 K. These kinds of lights — halogen, tungsten, incandescent, quartz, and so on — are often lumped together as the same thing because their color temperature is similar and dealt with photographically about the same. Different camera manufacturers use these terms interchangeably; even different cameras from the same manufacturers do. In this book, I have made every attempt to maintain the same terminology to minimize confusion, but having all the information can help you make better decisions behind the camera, no matter what terms are used.

tip Rim light comes from the back of the subject (backlight) and hits the subject causing a highlight around the top, sides, or both. This highlight helps to accentuate the subject or separate the subject from the background.

The exposure settings when shooting a rim-lit situation should be relatively close to what the meter recommends as the rim-light just accents the subject. When looking at a scene that has both incandescent and window light, try to visualize the amount of contrast between the subject and the scene before you shoot. Look for the interplay of the different kinds of light and the amounts of each type creating the exposure.

In 4-16, a tungsten spotlight hits the black boots just enough to give detail in that dark area, while bright sunlight comes through the window behind the boots, rim lighting them. You can see both blue and amber reflections in the boots, so that you can see there are two different colored

light sources. Because warm light is considered more pleasant light, setting the white balance according to the window light works well as it allows the window light to stay white and the incandescent to stay warm.

In a larger scene, window light creates texture and scale in an interior image. When incandescent is the main light, the light from a window is used as an accent light, and the warmly colored incandescent light fills in the shadow area all around the direct window light. In 4-17, the beams of sunlight hitting the floor are diffused enough to lighten the floor of the stone church, giving it texture and interest, when otherwise it would have just disappeared into dark grey. The main exposure is made from the incandescent, although the window light is bright enough to affect the scene, so by zooming into the center of the image to get a reading and then setting the exposure in manual, the highlights of the windows are disregarded, and the exposure is set all for a scene at the front of that church.

4-16

ABOUT THIS PHOTO *The exposure is set to 1/20 sec. at f/3.3 at ISO 200, and the white balance is set to sunny to maintain the warm tones and the hard window light helps to create the rim light on the boots.*

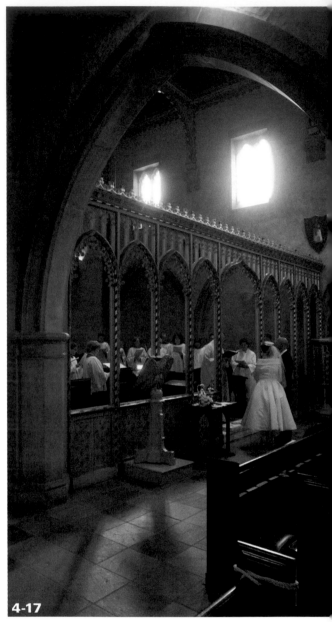

4-17

ABOUT THIS PHOTO *The exposure is 1/30 sec. at f/2.8 and the white balance was set to sunny to maintain the warm glow of the incandescent lights. 17-35mm f/2.8 zoom lens set to ISO 800.*

INCANDESCENT LIGHT

Light from tungsten light bulbs is the most common source of light in most homes. This source is very warm and can be used in a lot of photographic situations, but tungsten bulbs are limited because of their relative low light output. In some cases, you want to set your white balance to the incandescent or light bulb setting to get the color correct. Other times, setting the white balance to sunny can warm up a scene nicely.

USING THE WARM TONES OF INCANDESCENT LIGHTS

When you start to realize the affects that different light temperatures and white balance have on your photographs, you can start to visualize the image even before you bring your eye to the camera. A warm-toned scene can be accentuated by the warm light of the incandescent bulb and by using the incandescent setting; however, too much blue might be introduced into the image. On the other hand, as a warm-toned image, the scene might be too warm, making it look just flatly orange.

Try different white balances in a scene and try not to delete the different images until after you evaluate them on the computer screen. Sometimes, the LCD screen on the back of the camera is not perfectly calibrated, and sometimes a white balance change at the camera can't even be recognized as a change on the back of the camera, but in your computer software, the change might be huge.

In 4-18, a spotlight hitting orange-colored lilies in front of a richly textured adobe-like wall works great, creating a very amber look. Although the scene is very monochromatic with all of its warmth, enough contrast and texture occur in the scene for those flowers to pop off the orange background. Setting the white balance to sunny even though the scene is lit with all incandescent light gives the image that warm richness.

The warmth of that incandescent light can even help create mood in a photograph. Whether it is a studio, coffee shop, or office, the warmth of incandescent light and its contrast can create a lighting effect similar to the old master portraitists, who used to paint portraits in which the subjects were lit by lamp or candlelight with bold light and contrast between light and dark.

Using a slow shutter speed and purposefully staying out of focus in order to force some blur and softness into a scene shows shape and form with an almost impressionistic feel. Also, try using an incorrect white balance to further intensify a warm glow of an image. Try different things to create new and bold images.

INCANDESCENT LIGHT AND WHITE BALANCE

Using the incandescent setting also helps reveal the real colors in a situation that is lit by tungsten bulbs. You should have no problem looking at an incandescent light source and determining what it is. These bulbs are standard filament style bulbs, large and small, spotlights and frosted whites, but they are all in the same family. The warmth of their color has been discussed over and over in this text, mostly in the context of ignoring the incorrect white balance in order to force additional warmth into the scene. So when the correct white balance is used, what happens? The pictures look fabulous.

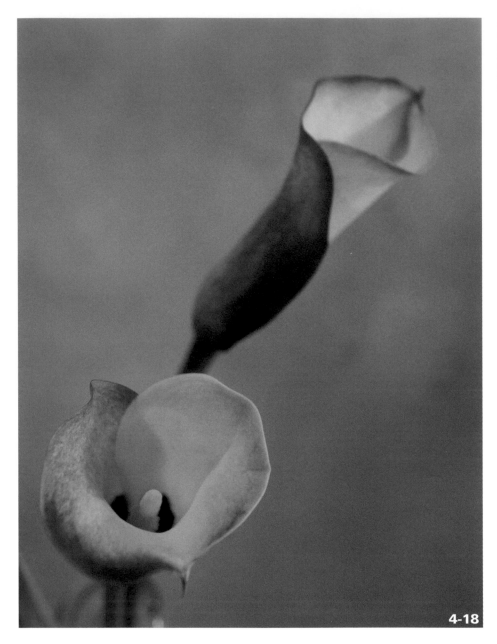

Setting the white balance to sunny even though the scene is lit with all incandescent light gives the image that warm richness. Nikon 18-200mm f/3.5-5.6 lens set to 200, 1/20 sec. at f/4.8.

4-18

Whenever you are indoors, there's a good chance that you are shooting with an incandescent light source. The lighting in this situation is what you see is what you get, unlike using any sort of strobe. A strobe introduces new contrast, shadows, and reflections and totally changes the scene that you have composed. By simply placing your subject in front of a simple background and making sure that the light is hitting the subject nicely and the shadows are not objectionable, you can easily create a great still-life image, as in 4-19.

By using the white balance setting incandescent, the camera is effectively adding a digital blue filter to the images. This blue acts to balance all the warm or amber-colored light to make the white appear actually white. Much like the warmer white balances create an image that appears more warm than it, the incandescent setting might make things look a little more blue than you originally thought. This effect is no bad thing, and in fact, in many cases yields some very cool photos!

The low light of the tungsten bulbs generally means that a tripod is necessary for fine detail or to maximize image quality. A number of incandescent lamps are set around, but mostly above and to the left of the shell in 4-20. This lighting gives the nautilus nice texture, but not too much contrast, as the iridescence of the inside of the shell is still there. A true macro lens is used very close to this subject, which is only a few inches big. The shell itself is placed on a brushed aluminum surface near a blue wall, which gives a blue cast to the aluminum and adds to the iridescent nature of the inside of the shell. The blue of the reflected light and the natural yellow color of the shell are nice complements to each other. Using the tungsten white balance allows all of these colors to be perfectly rendered.

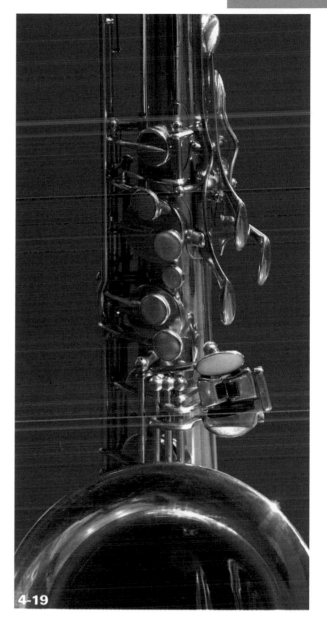

4-19

ABOUT THIS PHOTO *This image was created with Aperture Priority auto using +1 full stop of exposure compensation, for an exposure of 4 seconds at f/5.6. 28-70mm f/2.8 lens was used with the white balance set to incandescent.*

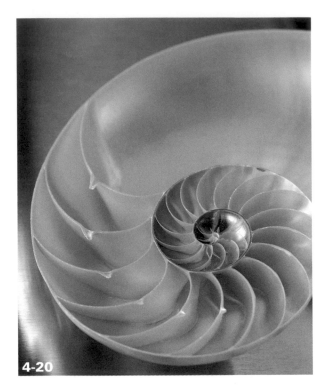

4-20

ABOUT THIS PHOTO *This photo was lit entirely with incandescent light, and the white balance was set at incandescent. The lens used was a Micro-Nikkor 105mm f/2.8 with the ISO set to 200, exposure to 1/5 sec. at f/8, and exposure compensation to +1/2.*

MIXING INCANDESCENT AND STROBE

Much like when using incandescent light and window light, a large color temperature difference exists between incandescent and strobe light sources. The only proper way to match the light between incandescent and strobe is to use filters on the strobe to give the strobe the warm tone of the incandescent. These filters are called *gels* and can be purchased at most photographic supply stores. The gels come in various levels of correction and are about $6 for a 2-foot square sheet. Gels are not optically perfect, so they cannot

cover the lens to correct the light; they go over the light source and are attached with tape. Some strobes even come with their own fitted filter cover in some popular color corrections. The gels used to correct for incandescent are called CTO (Correct To Orange), and they come in different strengths of color. Full CTO corrects daylight to 3200K, and there are steps of correction, each lower than the next, 3/4, 1/2, 1/4, and 1/8, which give lesser amount of warming to the light.

Blue gels can be put in front of incandescent light to correct that light to daylight or strobe. The blue gels are CTB (Correct To Blue) and come in multiple strengths, full, 1/2, and so on.

If you are using an on-camera strobe, you can just cut a small strip of the CTO gel that can be put over the face of the strobe. With studio strobes, you can place full sheets over the light or inside a soft box or umbrella to get those light sources matched to the incandescent light. After placing the filter in front of the strobe, you can set the white balance to incandescent, and the light from the strobe's color temperature should be very close to the same temperature as the incandescent light, and the whites should remain white. Adding a warming gel can also make the on-camera strobe simply seem a little natural because of its warmth, as in 4-21.

In certain situations, the strobe might go unfiltered, and the incandescent light just remains warm. In those situations, set the white balance to a warmer setting such as cloudy to warm up the light somewhat, even though it makes the incandescent light even more warm. This is largely a taste issue, and many photographers want the color of the strobes at least somewhat warmer.

ABOUT THIS PHOTO
Placing a warm gel over the flash balances the light of the incandescent light and makes the overall scene more warm and inviting. 1/6 sec. at f/6.7 at ISO 100.

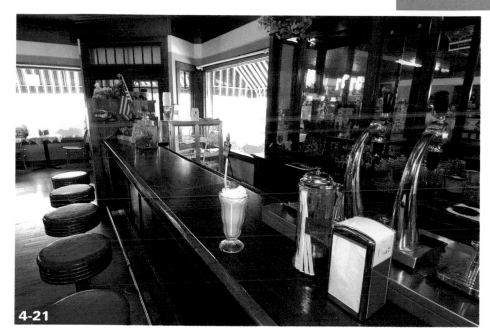

4-21

FLUORESCENT LIGHT

Fluorescent light appears very green in color to the digital sensor. The complementary color to this green is magenta. When the white balance setting is set to fluorescent, the camera essentially uses a magenta filter in the software of the camera to balance the green of the fluorescent to daylight.

In most cases the fluorescent white balance or the auto white balance allows the colors to be accurately rendered in the scene. Using the fluorescent white balance makes the overall tone of the image magenta, so if the scene is totally lit with fluorescent light, this should be perfect as in 4-22. When shooting in an industrial facility, the light is often totally fluorescent, and setting the white balance for that situation should yield good results as long as other light sources aren't mixing things up.

Additionally, fluorescent bulbs can be daylight balanced, warm or cool. Each of these has a different white balance, and in the case of daylight balanced bulbs, they have far less of a green tint to them. If in question, it is perfectly okay to shoot fluorescent with the white balance set to auto white balance. In critical situations, and the color temperature is unclear, it is highly advisable to shoot in the RAW format in order to maximize the white balance in the computer.

When the light sources mix a bit, sometimes they yield multiple color temperatures. This might happen, once again, in industrial settings with multiple types of fluorescents, mercury vapor, sodium arc, and so on. These sources all have different light temperatures, and the best thing might be to use the auto white balance when in doubt. In 4-23, the lights above were various colors, which could be seen just by looking at them. Trying to force a specific white balance onto the image didn't make sense when the auto white balance works pretty well in most cases.

Similar to mixing strobe with incandescent, a colored filter should be used over a strobe in a fluorescent lighting situation. There are a myriad of fluorescent corrective gels, but the most common one, plus green, corrects the standard large fluorescent tubes. Using a plus green gel over the strobes while having the white balance set to fluorescent balances the entire white balance of the scene, as in 4-24. The other fluorescent gels correct for the cool white, warm white, and even out the compact fluorescents.

4-22

ABOUT THIS PHOTO
Stacks of stainless steel rings are lit by standard fluorescent tubes seen in the metal reflections. 80-200mm f/2.8 lens set at ISO 400, 1/4 sec. at f/5; exposure compensation set to +2/3 to make the scene adequately bright.

4-23

ABOUT THIS PHOTO *The color of the race car is as important as making sure the color pops off that white background. Using AWB with the commercial warehouse lights of various color temperatures rendered this perfectly. 2 seconds, f/13 at ISO 200.*

4-24

ABOUT THIS PHOTO *A strip of plus green gel was placed over the flash unit, and the exposure was 1 second at f/5.6 at ISO 200. Nikon 12-24mm f/4 lens along with a Nikon SB800 strobe unit.*

Assignment

Creating a Mood with Window Light

Take a picture of someone or something near a window in diffused light without your flash. Remember the information you learned in this chapter about the difficulties of metering for window light. You want your subject to be well-exposed, although that might mean having dark areas in the room. Diffused light gives a soft light to the subject. You might also need to adjust your white balance as diffused light can give off a blue or greenish hue to your images.

I really enjoy using window light for portraits when I can. In this case, the studio shoot was over, and this subject ended up just walking over by a window, and the light on her was perfect. I was glad that I still had the camera in hand. There was enough wrap of the light around her face for the shadows to give definition, but they are not black or harsh. The light coming through a window creates direction, even with very diffused light, because the ceiling and walls are blocking all the other light. I shot this image at 1/90 second, f/2.8 at ISO 400.

Don't forget to go to www.pwsbooks.com when you complete this assignment so you can share your best photo and see what other readers have come up with for this assignment. You can also post and read comments, encouraging suggestions, and feedback.

Working with light when taking pictures of people requires some additional time and effort to get great results. When shooting people photographs, you may encounter many pitfalls that are easily avoided — don't avoid situations that can yield great images just because the lighting isn't perfect. Try to keep an open mind about the lighting in the scene you are working with, because when shooting people, the best light might come from places that you would never expect.

SHOOTING GREAT OUTDOOR PORTRAITS

Many photographers prefer to shoot landscapes, flowers, and the like, because they prefer shooting subjects that stay still. People's expressions can be fleeting, and when you are shooting portraits of people, the intent is to show a part of them — the essence of the subject.

Photographing people is more than lighting, and learning to show emotion from the subjects that you are photographing is every bit as important, if not more important, than the light. Learning to work with a portrait subject takes time and practice. A photographer and subject must have a respect between them, but even more important is to make sure that the subject is comfortable in front of the camera.

Take time to talk, even for just a few minutes, with the subject, explaining what you are looking for in the photographs. What sort of emotions do you want the viewer of the photographs to have? What is the feel of the photo? Just talking about those types of things can help to create a better connection between you and the subject, enabling you to work better together, like in 5-1. The feel for 5-1 is supposed to be warm and pleasant. The light is very soft, and although she is smiling, she does not have the big cheesy grin.

ABOUT THIS PHOTO *Using a Nikon 80-200mm f/2.8 lens gets the photographer close to the subject without being right in her face. The exposure in the shade here was ISO 250 at 1/60 sec. at f/4.*

5-1

When shooting portraits and people, the first thing to think about is setting a larger aperture. With a larger aperture (smaller f-stop number) you get less depth of field, which makes the subject sharper and the background more out of focus. By doing this, the subject appears to separate from the background more, putting more emphasis on the person, as in 5-2. Using a telephoto lens, or zooming closer with a compact camera, helps blur the background of the image. Another advantage of the larger aperture is that it also means using a faster shutter speed, to better stop the subject from moving. This is especially important in working with kids.

ABOUT THIS PHOTO
The ISO for this shot was set to 200 with an exposure of 1/80 sec. at f/4. Because of the large aperture and the telephoto zoom lens set to 175mm, the background of fall foliage becomes a sheer blanket of out-of-focus yellow.

5-2

Using Aperture Priority automatic is very advantageous in portraiture. Being able to control the depth of field and letting the camera's meter control the shutter lets you work quickly, hopefully never missing a moment. When the light does get low, make sure to monitor just what the shutter speed is so that it remains fast enough to stop any blur.

FINDING THE BEST LIGHT

Lighting for portraits outdoors is as easy as going outside, right? Well, maybe not. Generally, lighting for portraits is softer than bright sunlight. This softer light lets you see more of the eyes and

more facial expression, as opposed to deep shadows across the face. The biggest problem with taking photographs of people in the middle of the day is the extreme contrast and shadows on the face caused by the direct overhead sunlight. This direct lighting creates shadows in the eye sockets, making people look like raccoons. Contrast often occurs even in late daylight, and because half of the image is in direct sun and the other in shadow, half of the face is either washed out or plunged into murky shadows.

In most cases, softer light is not too far away; it just takes a moment to look around and find it. The situation that you are looking for is called *open shade*. Open shade can come in the form of

light haze, big trees, or even the other side of a building. When shooting in open shade, people are less likely to squint than they would in direct sunlight. When under the canopy of large trees, the softness of the light wraps around the subject's face, making it appear as if the light is coming from all sides, such as in 5-3.

Metering in open shade is a mixed bag. In most cases, the evaluative meter does great, but overexposing by +1/3 to +2/3 of an f-stop increases the brightness of the scene nicely. Make sure to set your white balance correctly as well, to the shade setting. Without setting the correct white balance, you run the risk of having your images appear too blue. Using the correct white balance maintains rich skin tones, and keeping the subjects near the edge of the shade helps to capture more of the direction of the light and texture to the faces, like in 5-4.

ABOUT THIS PHOTO *This photo was taken with dappled sunlight all over. The light tree cover made for great texture in this image, with the camera set to ISO 200 at 1/30 sec. at f/5.6 and a center-weighted meter.*

Shooting inside deeper shade, like that of a building or large overhang, can limit the exposure, but the lighting situation stays the same. Using the evaluative meter up close limits the amount of extraneous background light and is a great way to get the correct exposure as, in 5-5.

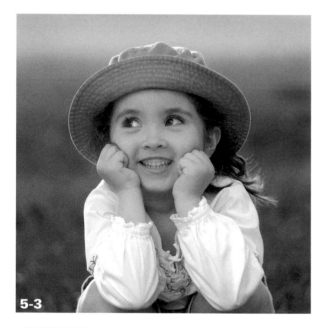

ABOUT THIS PHOTO *A spotmeter was used to get an exposure off the face of this girl, and then the exposure was set manually to 1/160 sec. at f/2.8 at ISO 200.*

ABOUT THIS PHOTO *The exposure in this situation was 1/40 sec. at f/2.8 at ISO 200. The exposure compensation was set to +1/3 to brighten the skin tone, and the white balance was set to shady.*

5-5

5-6

Mottled sunlight, as from thin tree cover, can be especially tricky. The contrast of the bright spots needs to fall where it does not distract too much from the subject. The most important considera- tion in a situation such as in 5-6 is that any pock- ets of light on the subjects don't overexpose too much, especially on the face. Use exposure com- pensation if you need to, but mostly just watch where the light is. In this situation, the models can move, a slight breeze can move the trees, and, of course, the sunlight moves across the sky. So be sure that you are constantly monitoring just where the light is.

ABOUT THIS PHOTO *Exposure compensation was set to +1/3, to make sure the shade was bright enough with the dark background. This photograph also was sepia toned in Photoshop Elements, adding a warm tone to the black and white image.*

Shooting people while the sky is lightly overcast can also be great. This type of lighting creates a large soft overhead light, potentially with some nice highlights. Make sure that the light is soft enough or directed in such a way that the eyes of your subjects are not filled with shadows. The light in 5-7 still has quite a bit of contrast, as you can see from the nearly white sky and highlights on the hair of the couple. Because seeing the background is important, a smaller aperture and a wider lens were used for better depth of field.

ABOUT THIS PHOTO *Using a center-weighted meter was impor-tant so that the bright sky was not considered in the exposure. The expo-sure was 1/100 sec. at f/7.1 at ISO 200 using a 28-70mm f/2.8 lens.*

5-7

5-8

ABOUT THIS PHOTO *By turning the subject against the sun, his face is in shadow, allowing you to see his eyes and his expression. ISO 200 at 1/640 sec. at f/5, with +2/3 exposure compensation and white balance set to shade.*

Sometimes, no open shade is readily available. Inevitably, this happens when you need to shoot in the middle of the day. One place to find some shade is to have the subjects make their own shade. By turning your subjects so that the sun-light hits the back of their heads, their faces nat-urally are in the shade of their own shadows, as in 5-8. Turning the subject is not without pitfalls. Using this technique also can cause bright areas on the shoulders and heads of your subjects. To avoid these shadows, make sure to expose for the subjects' faces; use center-weighted or spotmeter or exposure compensation by about +2/3 f-stop, or both. With high, direct sun behind a subject, you also might get flare. Make certain that your lens is adequately shaded to prevent lens flare.

When the light has more direction to it than just overhead, you can use the directional light more to accent the people in your photograph. When

the light is lower in the sky, that accent can be created by backlight. The light hits the back of your subject, causing a rim of highlight around the perimeter of your subject, which is shown in 5-9. This rim light makes the hair look like it is glowing, and yet the face of the subject remains in the soft light of the shade.

5-9

ABOUT THIS PHOTO *The rim light accentuates the hair in this image with the white balance set to shade and the ISO at 100. The exposure was 1/320 sec. at f/2.8 and with an exposure compensation of +1/3.*

This situation is ripe for lens flare, and remember that the exposure must be set for the face, so having the highlights of the hair might skew the exposure a little dark. Setting the camera to overexpose 1/3–1/2 of an f-stop helps. By using a spotmeter on the face in a subject like 5-10, not the jacket, dress, or the highlighted hair, you can also get the right exposure. (Some light lens flare on the right of this image makes the groom's jacket a little too light.)

5-10

CREATING BETTER LIGHT

In learning how to better see the light that creates compelling photographs, the next step is learning to create your own light. By using a few small tools and tricks, you can create better light and further add to the dimension of the light in your photography. As much as shadows help to create shape and drama in some types of outdoor photography, in portraiture, shadows must often be overcome.

REFLECTING FILL LIGHT

Fill light is short for fill-in light, which means that you are trying to fill in the shadows with light. Since too much contrast on a face can often detract from a portrait, using a simple reflector can bring light back into the shadows — brightening the scene and allowing detail to be seen in the shadows.

A reflector can truly be anything that reflects the sunlight back into the scene — that is, a piece of white cardboard or white foam core, cloth stretched over some sort of a frame, someone else wearing a light colored shirt, or one of the vast amount of commercial reflectors available for purchase. The most popular of these are flexible discs with white, silver, or gold fabric stretched over a plastic frame that can be folded down and placed into a small pouch.

Learning to use a reflector takes a bit of time, and having someone to help hold it or some sort of a clamp and stand is recommended. The easiest way to use a reflector is to have a subject backlit and then hold the reflector toward the subject's face. Keep the reflector in the light and move it around. In bright sunlight, it is obvious when the light is hitting the subject. In lower light levels, it might not be as simple. Notice the angle of the reflector and how the angle correlates to the position of the sun and the person. In some cases, the reflector is virtually flat; sometimes, it is almost pointing away from the person, and other times the reflector is angled directly toward the subject. If you are having trouble seeing the light hit the subject, point the reflector directly at the sun and then slowly turn the reflector toward the subject, because roughly in the middle of those two points you can find the point where the optimal amount of reflection is evident.

Moving the reflector in and out of the scene also helps you determine the amount of light that gets filled into the shadow. In many cases, if you don't find enough effect, you need to bring the reflector closer to the subject. The reflected light also

changes when the reflector has different material. A silver reflector has a much harder light than a white one, and a gold reflector reflects a much warmer light. In 5-11, you can see the use of a white reflector in a very backlit scene. You don't need to go out and buy fancy gold and silver reflectors, but if you want to experiment with the effect, wrap a piece of heavy cardboard with tin foil and spray paint the other side white, or gold. Or go to the hobby store and get a piece of gold or silver matt board. Any of these solutions costs less than $10 and can at least get you comfortable with using an additional piece of equipment.

In some cases, a reflector just brings the light level up a small amount so that the light isn't so flat. This also helps so that the exposure level stays up, and the background doesn't get too overexposed. Even when the reflector is in a more shady area, bringing a white reflector close to the subject brightens up the scene a small amount. In 5-12, the reflector is just barely out of the scene to the left of the image, about 15 inches from the woman.

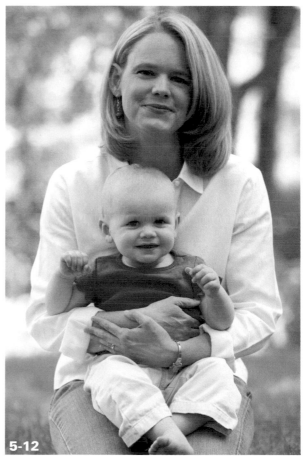

5-12

ABOUT THIS PHOTO *A collapsible reflector was used in this image to bring a small amount of brightness to one side of the scene. The exposure was 1/320 sec. at f/3.5 using ISO 200.*

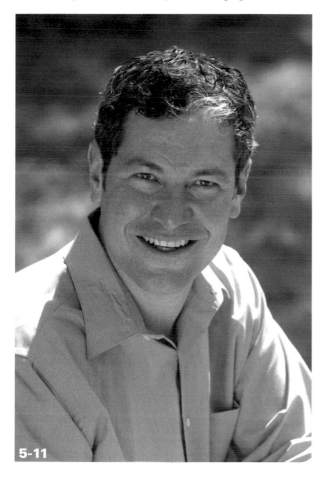

5-11

ABOUT THIS PHOTO *Using a simple white cardboard panel, the light was bounced back into the shadow of this backlit portrait scene. The exposure was ISO 200 at 1/250 sec. at f/5.6.*

BALANCING SUNLIGHT WITH FILL FLASH

Turning on a strobe in the middle of a bright sunny day might seem to be unnecessary and unwanted, but turning the flash on full time might be the best way for beginners to get the best photos. A lot of shadows surround people, especially in bright sunlight, and using a strobe fills those shadowed areas with light with minimal effect on the bright areas. The flash simply brings the exposure level of the shadow area closer to the exposure of the sunlit areas, making for a more balanced exposure, as in 5-13.

In today's digital camera, the software is so advanced that balancing the strobe and sunlight to get a great exposure is totally automatic. Only a few years ago photographers would have to do complex calculations regarding distance from the strobe to the subject and the ambient exposure and the flash output level using charts or graphs; now, it is virtually a "set it; forget it" proposition.

ABOUT THIS PHOTO *With sun hitting the couple from the left, their eyes and half of their faces are plunged into shadows. By hitting them with a bit of strobe, the shadows are opened up. ISO 200 at 1/640 sec. at f/4.*

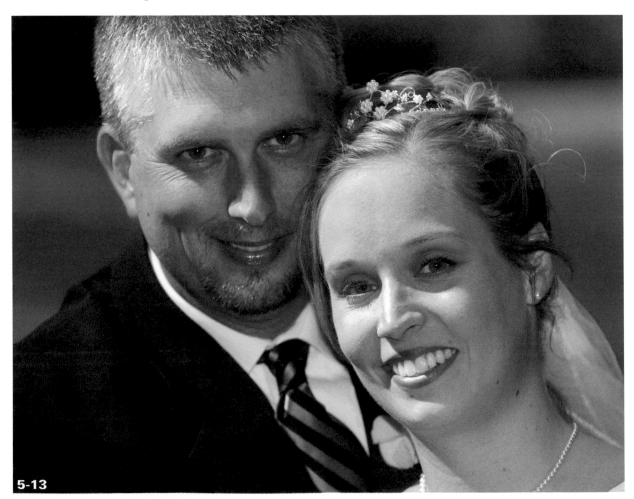

5-13

FLASH SYNC SPEED The flash sync speed is the shutter speed at which the flash fires. In most cases, the fastest shutter speed that can be used with a strobe is around 1/125 or 1/250, but consult your owner's manual to make certain. Digital cameras with built-in flashes and dedicated accessory flash generally do not fire if the exposure is incorrect for their operation. When a shutter fires, the first blade (or curtain) opens the shutter; the second blade closes the shutter. At shutter speeds up to the maximum sync, the shutter is fully open for that fraction of a second, and that is when the flash fires. Faster than that, the closing shutter blade actually begins closing before the opening blade is fully open, blocking the light from a flash that fires at a faster shutter speed than the maximum sync. This causes a dark band across the image.

Sometimes, though, slower shutters are more desirable, especially when the light level is lower. In most cases, the camera's default sync as it gets darker is 1/60. This sync can cause the background to get very dark prematurely. By using manual exposure, but still having the strobe set to an automatic mode, a photographer can set the shutter as slow as is necessary to get the background as bright as is wanted. Remember, though, that you get more camera shake and blur as the shutter speed goes down. Some cameras allow you to set the default to any shutter from the maximum sync to as slow as 1 second.

The flash fires, and during the millisecond that the shutter is open, the sensor and the computer determine exactly how much light is needed for the correct exposure and fire the flash exactly that much.

Using fill flash for portraits is also important to simply give them a little life. Even when good light quality is on a subject, using fill flash outdoors can add to the image. By turning the flash on, you can brighten up a face, add a sparkle to eyes, give some sheen to the hair, and soften the shadows, as in 5-14.

ABOUT THIS PHOTO *Exposure was manually set to 1/250 sec. at f/5, using ISO 100. The evaluative meter gave the reading, and the accessory flash was set to TTL with flash exposure compensation set to –1/3 to lessen the flash a bit.*

5-14

As the light gets lower in the day, fill flash is used to put light on a subject so that it does not appear as a silhouette. This is great for shooting against a sunset. The light is very bright behind the subjects in 5-15, and the exposure should be set for the background so that it maintains its color and richness. Using the strobe in its TTL mode automatically balances the amount of strobe light with the background exposure. If the subject is too dark or too light against the background, use flash exposure compensation to raise and lower the amount of flash power.

Much like a sunset, by placing the subject in front of a bright background a silhouette is almost ensured. Sometimes using only a little bit of fill flash is what is called for, such as in 5-16. Setting the exposure to get the proper exposure on the background is important, and using manual keeps the exposure consistent frame to frame. The exposure for the background sky is too dark to maintain any detail on the subject. The power of the dark subject is important, though, so just blasting this subject with light is not good. Using the flash exposure compensation, the power of the flash is set to –2/3, and the actual exposure stays the same. To further make sure that only a bit of light hits this subject, the strobe was zoomed to telephoto manually, and the lens stays wide. Further, the flash head is tilted upward so that the light hits only the subject's head.

5-15

ABOUT THIS PHOTO
The exposure in this image was 1/125 sec. at f/5.6 at ISO 200 and was set in manual with a 28-70mm f/2.8 lens. The exposure was set for the background sunset; the accessory flash was set to TTL automatic.

5-16

CREATING A NICE DAY

Whether it's Murphy's Law or just unfortunate scheduling, oftentimes the weather you have when shooting people is more gloomy and overcast than what you were hoping for. Pictures without sunshine, however, can still look good if you know a few quick techniques.

The first thing to look for is some sort of contrasting background, such as the light sweater and dark green foliage of 5-17. This contrast helps separate the subject from the background. The next thing is to set the white balance to cloudy, which gives the image a neutral or warm tone in an overcast situation. It might be necessary to cither use a manual white balance setting to further warm the scene or to use some of the color enhancements in Photoshop Elements. Additionally, by overexposing 1/3 to 2/3 of a stop, you can brighten an overcast scene enough that it does not look gloomy.

5-17

Using black and white is also a great way to deal with overcast situations. In 5-18, the kids have very light skin tone and hair, so putting them against the sky complements them. Adding a very small amount of fill flash can also just add a little life to an overcast portrait.

5-18

CANDIDS, KIDS, AND ENVIRONMENTAL PHOTOGRAPHY

This might appear to be a wide-ranging section, but these topics are more related than you might think. A large part of shooting people when you are out and about — either for candid shots or environmental shots — has to do with being ready for anything. Making certain that the camera is set to do what you want it to do before you even sling the camera strap over your shoulder

saves a lot of time and allows you to get the shot instead of missing it because you were fiddling with your camera. Working with kids is much the same, but having patience as well as forethought is immensely helpful.

In 5-19, an overcast day makes the light rather flat, but with a camera already with a telephoto lens, the white balance set to cloudy, and the exposure set correctly in Aperture Priority mode, when the little cowboy takes a stroll over the small bridge, everything is ready without having to give him any direction.

ABOUT THIS PHOTO
Exposure was set to f/3.5 in Aperture Priority automatic, which allowed for the background to be slightly out of focus, letting the subject pop out of the background. The shutter speed is 1/250 sec., which stopped his movement.

5-19

Having the camera already set makes it easy to capture far more beautiful light when the sun pops out unexpectedly, like it did a few minutes later. Notice in 5-20 that the foreground is dark, meaning that he is in the sun, but just outside of the shade in front of him. The only difference in the settings between the two images was that the aperture was set to f/4 in 5-20 as opposed to f/3.5 in 5-19 in order to get slightly more depth of field with the lens zoomed to a longer telephoto.

When shooting candid photographs it also is very important to recognize the importance of the moment that you are photographing and be ready to capture it. Legendary Photographer Henri Cartier-Bresson called this "the decisive moment."

ABOUT THIS PHOTO
The exposure in this image was f/4 at 1/750 sec. Using Aperture Priority allows you to control the depth of field, quickly maintaining the correct exposure by letting the camera determine the shutter speed.

5-20

Now that you have looked at so many lighting situations, you should be able to read what the light is doing and already have in mind what you and the camera should be doing to capture the light as needed to create your image.

In creating more of an environmental portrait, waiting for the moment, and waiting for the lighting at that moment is just as important. When the subject just sits comfortably in a favorite chair and the light from a large picture window lights up the subject's face, don't hesitate for one moment. In trying to capture people's nature and their essences, it is important that they are comfortable. This is far more important than making sure that the subjects have big smiles.

Being comfortable with the camera allows you to work quickly so that the subjects don't lose interest or the look that first captivated you. In 5-21, using a thumb switch to quickly access the spotmeter in order to capture the delightful window light on this subject's face happens in a snap. The result tells a far bigger story of who this man is than if he were posed and directed.

Using the different exposure modes, Aperture Priority, Shutter Priority, Program, or Manual all has a lot to do with personal preference and how things work best for you in each situation. Each exposure mode has its own advantages and disadvantages. No matter which one you select, make sure that you monitor what choices the camera is making as it corresponds with the decisions that you make. If you use Aperture Priority, make certain that you still have a fast enough shutter speed to stop your action, and if you use Shutter Priority, make certain that you have the depth of field that you need.

When shooting people, the situation is often dynamic. A very posed portrait quickly becomes a great candid look at a couple as they react to their kids hamming it up in 5-22. Being able to keep your eye in the viewfinder to capture priceless moments that can never be reposed is a great skill to develop.

When the focus of the image is a person, capturing even just part of the face can be an effective way to get a sense of the essence of the subject. Using a telephoto lens helps to limit the depth of field. In 5-23, the background becomes totally obscured. The telephoto lens in this case was a 200mm, and the lens along with the aperture of f/2.8 keeps the depth of field very shallow. This is useful when the subject is against a distracting background and keeps the distractions to just background shapes. This shallow depth of field situation is particularly demanding on the focus, so make sure that your focus is locked on and that you refocus the camera often when shooting that tightly as any camera or subject movement could result in out-of-focus images.

5-21

ABOUT THIS PHOTO *A spotmeter determined that an exposure of 1/40 sec. at f/4 was correct to capture the light on this subject's face. The texture of the face, hands, and shirt is a result of light from a big window.*

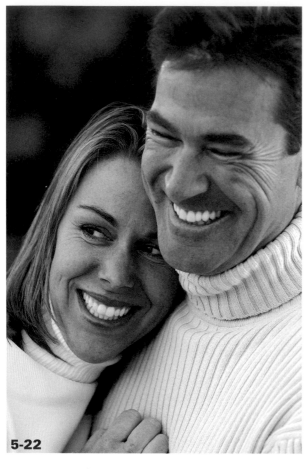

5-22

The same situation crops up with kids even more frequently. Shooting children is challenge enough, but they also work against photographers by being happiest where there is the most clutter. By getting a child close to a window to create nice soft light and then using a shallow depth of field and a telephoto lens to eliminate any clutter, you can create great images of kids, as in 5-24.

WORKING WITH GROUPS

When lighting groups, you face a number of challenges. Photos of one person can use very shallow depth of field, but even one other person can change the amount of depth of field necessary for an image. Further, getting good light on everyone in the group is always a challenge. People can cast shadows on one another if the scene is sidelit, or if in the shade, almost invariably one tiny ray of light is hitting one person, causing him to be washed out while everyone else is properly exposed.

So working with groups can be just as much about location as it is about lighting. Finding the location with *even* or *flat* light can be a challenge, but when the groups are large, you need light that covers all the people in the group so that you can see everyone's face. The obvious problem is that when the light is shady or overcast, you have less light and, thus, less depth of field. Using a wide-angle lens can help with depth of field because there is more inherent depth of field as the lens gets wider.

5-23

Increasing the ISO is another way to increase the depth of field. In order to get the most people in focus, increasing the ISO from 100 to 200 allows for an aperture of f/8 as opposed to f/5.6 to be used in 5-25. This small increase in ISO really does not change the image quality substantially but increases the depth of field a fair amount. Even increasing the ISO to 400 is okay in most cases, unless you know the image will be printed extremely large. Large groups like this often cause a photographer to split some differences in order to get the best possible shot. Trade-offs between image quality and depth of field and between depth of field and the risk of blur are all things to weigh into your photography.

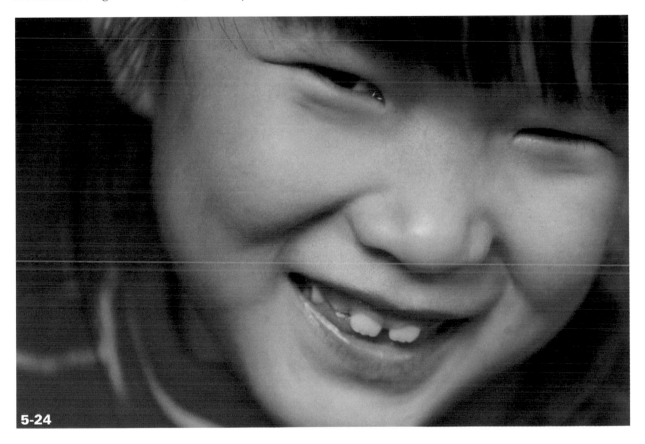

5-24

ABOUT THIS PHOTO *A large window on the shady side of the house makes for great soft light, and getting tight with a telephoto lens eliminates distractions. 105mm Nikon Macro with an exposure ISO 200 at 1/250 sec., f/3.2.*

Remember to shoot a lot when it comes to large groups. Blinks often ruin great group photos. According to the Commonwealth Scientific and Industrial Research Organization, for groups of fewer than 20 people, if you divide the amount of people by three, and take that many shots, you have a 95-percent chance of getting at least one shot without blinks.

When shooting smaller groups, lighting can be more creative and dramatic, but remember it is still important to make sure that light is on everyone in the scene. Using a large white reflector next to the camera brightens up everyone's face quite a bit, even though everyone is in shadow in 5-26. Having the subjects in shadow and the background lit up so brightly can cause the meter to underexpose the subject too much. Make sure that you get your meter reading from the light hitting the subject, by either zooming in close on one of their faces or using the spotmeter.

If you have something to bounce the light off of, using a strobe unit for a group shot is helpful in making sure that any deep shadows are filled in. The light in 5-27 is a dappled sunlight, making the light slightly different on each girl. Using the ceiling of the gazebo, the light from an on-camera strobe is bounced up softening the strobe and evening out the light. When you don't have anywhere to bounce the light, but you still want to soften it, you can buy a *light modifier* for your on-camera strobe.

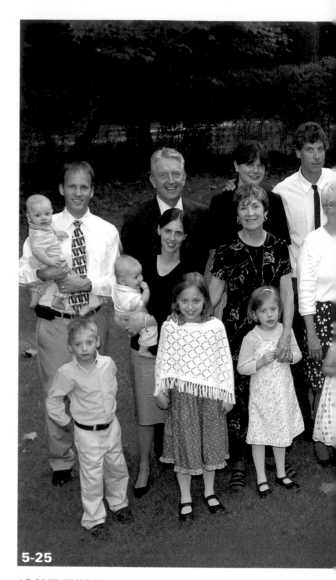

5-25

ABOUT THIS PHOTO *Getting everyone in the shade and setting the white balance for shade was the best way to have the whole group evenly lit. f/8 at 1/45 sec. at ISO 200 with the fill flash set to normal.*

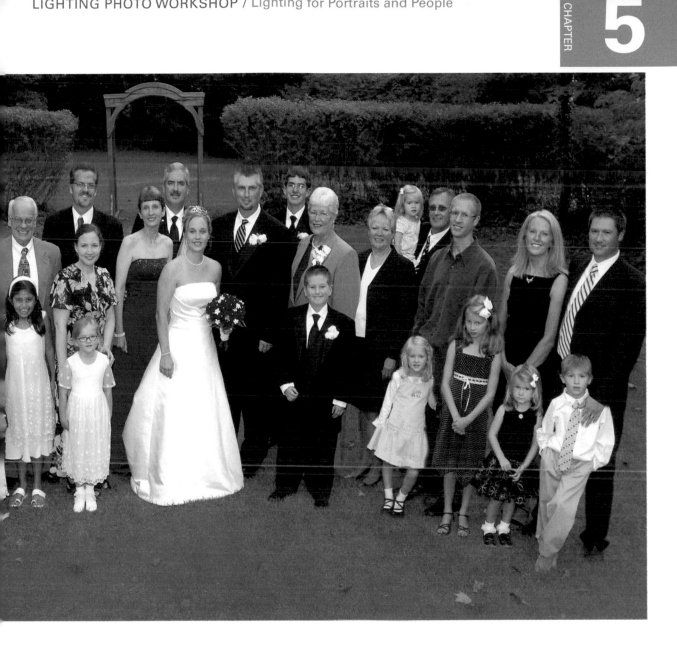

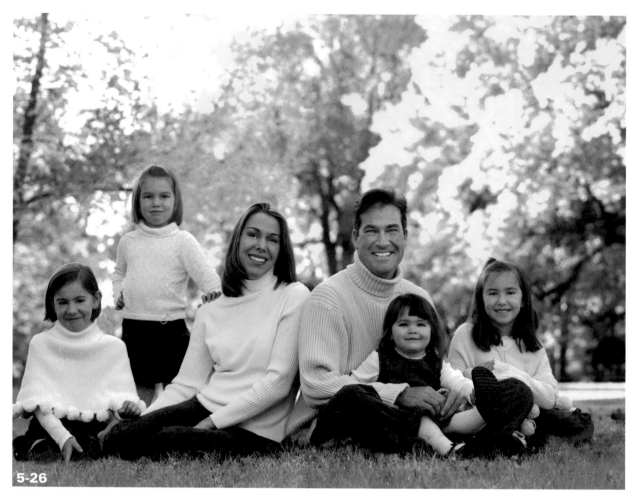

5-26

A light modifier can be anything from a 3 × 5 index card to a very expensive piece of plastic that is designed and shaped to fit directly onto your strobe. These modifiers all do essentially the same thing, redirect and diffuse the light, so that it doesn't appear like such a harsh blast of light. There are a number of companies that make light modifiers, including Lumiquest, Sto-Fen, Chimera, and Gary Fong.

Most of these still work with the TTL sensor in the camera so that your exposure is accurate, and most camera shops have these accessories. If none of those things is available, and you are trying to avoid the harshness of direct strobe, you can use tissue paper or even copy paper loosely taped over the flash head in a pinch to help diffuse the strobe light.

CHAPTER 5

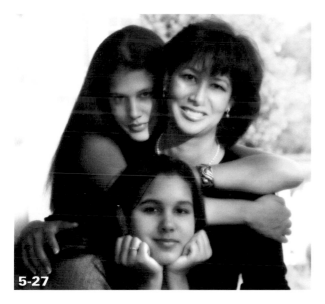
5-27

ABOUT THIS PHOTO *The strobe was bounced up into the ceiling, which evened the light from the faces that were in shadow and the faces that were in sunlight. Exposure of 1/60 sec. at f/5.6 at ISO 100.*

When composing groups, one thing to keep in mind is to try to keep the faces in triangles. This is easy when you are shooting a group of three or six, but when you have four faces, it becomes harder. By composing the faces in triangles, the image becomes more dynamic and balanced in the image. In 5-27, the triangle created by the faces is obvious; in 5-28, the diamond shape created by the faces is made up of a number of triangles: mother, father, and baby; mother, father, son; and so on.

It is also important to get the faces close to the same plane for two reasons; the first is to keep everyone in focus, especially when dealing with shallow depth of field or telephoto lenses. The second reason is to keep everyone in the same light, and shadows often happen with sidelight. Make sure to get as much of everyone's face out of the shadow and into the light as possible.

Shooting groups indoors often creates a need for additional light. Rarely is there enough light, even at ISO 400, to get enough depth of field indoors with available light. The easiest way to get more light is with your on-camera flash, but trying to get natural-looking light with a strobe on top of the camera is difficult. Try swiveling the strobe head to point the flash into a wall or reflector in an attempt to create nice sidelight.

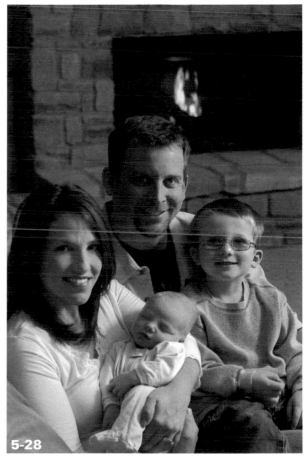
5-28

ABOUT THIS PHOTO *The flash came through an umbrella, creating nice sidelight. The exposure was set to 1/40 sec. at f/5; the slow shutter captures the firelight; and a gel placed on the strobe balances the ambient color temperature.*

Some digital cameras now have the ability to fire their strobes without being attached to the camera. This usually entails a camera with an attached strobe to be the *master* or commander unit, and a second strobe to be the *remote* unit. The light from the master strobe can be turned up, down, or off, as can the remote unit. These strobes are all connected through an infrared sensor system that is wireless, so the Through The Lens metering system still works, making this system seamless and easy to use (see 5-28).

GETTING YOUR FLASH OFF OF THE CAMERA If your digital camera does not have the capability to be fired via a wireless remote system, you have other ways to get your flash off of the camera. The first thing that is needed is some way to sync the camera and the flash together. The cheapest thing to get is a sync cord. A sync cord is connected to the PC socket. PC does not mean personal computer in this instance, but stands for Prontor Compur, which is an industry standard compact electrical socket that connects the camera to the flash.

Not all cameras have PC sockets, but if your digital camera has a hot shoe to place a strobe, you can get an accessory PC socket adapter to put on the hot shoe for $10–$20. Most large on-camera strobes have a PC socket. Take your camera and flash to the camera store to make sure you get the cord with the correct connections needed.

If you don't want to use a cord, you can use a number of wireless sync solutions that use either radio signals or infrared signals, such as Quantum's Radio Slave, and the Pocket Wizard family of products. These units have a transmitter that attaches to the hot shoe of your camera and a receiver that attaches to your flash via a very short PC/sync cord.

Assignment

Taking a Candid Shot

Candid photos can be challenging because you might have to take a few to get just the right shot. You can't really tell your subject to move into the right light, because the image would no longer be candid. Take your camera to a family gathering or a party and capture candid shots. Choose your best photo and describe the lighting challenge you faced and why the chosen image turned out so well.

I took this picture under a shady tree at a park at noon. Almost any time of day you can shoot photos of people in the shade. Some dappled light is on his hair, and the background is bright. Make sure to get your exposure off of the subject, not off of the background. The exposure here was ISO 200 at 1/80 second at f/6.3. I used the evaluative meter and the shade white balance. Another tip is to get lower when taking photos of kids; get on their level. They behave better, and your photos turn out better.

Don't forget to go to www.pwsbooks.com when you complete this assignment so you can share your best photo and see what other readers have come up with for this assignment. You can also post and read comments, encouraging suggestions, and feedback.

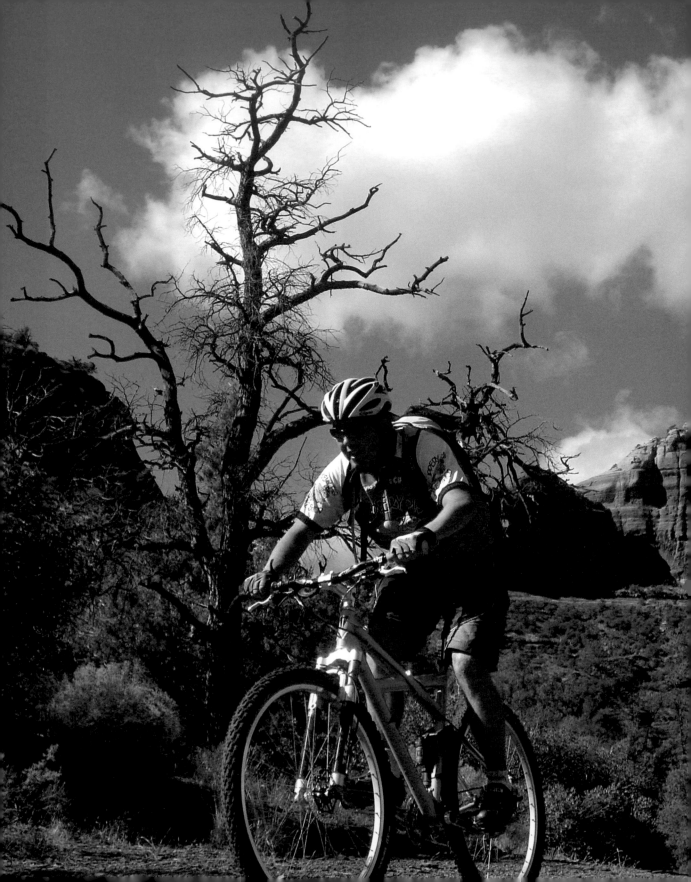

ACTION, SPORTS, MOTION, BLUR

Showing movement and motion in digital photography can be as much about stopping the action in an instant as using blur to convey that action more literally. In many cases, using blur implies more motion in a photograph than stopping it cold. Your digital camera has the ability to create images that best show that motion in your photography. This chapter teaches you to understand how to control the shutter speed to control the motion.

IT IS ALL ABOUT THE SHUTTER

Digital cameras can have shutters speeds that range from as slow as 30 seconds to as fast as 1/8000 second. These speeds allow photographers to stop the action as they see fit, as long as a good exposure can be reached. Most of the photographs are taken with shutter speeds from 1/30 to 1/1000 second. Slower than 1/30 often needs a tripod, or the shake from the photographer's hands will blur the image; faster than 1/1000 usually means using a greater amount of light, higher ISO, or much more shallow depth of field.

As the shutter opens and closes, it captures the light for that small amount of time. Things that are moving faster need faster shutter speeds to freeze that motion. As the shutter speed goes up, the amount of light needed for the proper exposure goes up. Either the aperture needs to open up, in which case you would use an f-stop with a smaller number, or a higher ISO needs to be selected. In extreme cases, both are affected.

No matter how fast a shutter speed you want to use, it is possible to use any of the exposure modes to get the exposure. It is simply easier in some cases to use Shutter Priority (Time Value on some cameras) or manual to direct the camera to the desired shutter. Using Aperture Priority to affect your shutter speed is easy but can take a moment to figure out. If you want a faster shutter speed, you must increase the light, so use a smaller numbered f-stop, and if you want to get a slower shutter, use less light and a larger numbered f-stop.

It takes some time working with your camera to learn the control of the f-stop, aperture, and shutter speed, but you need to practice changing the controls to get used to the effects that each change brings. Use family members and friends as subjects and go to local sporting events to practice, as shown in 6-1. Just make sure to evaluate exactly what you did and what the effect was.

USING BRIDGE AS A LEARNING TOOL Digital is a great medium to learn photography on because it allows a photographer to shoot a ton of images without the cost and time of taking film to be processed. Further, it allows the photographer to evaluate all the settings of the camera as you are looking at the photo, right there on the screen. When using Photoshop Elements, go to File/Browse, and an additional application opens. This is called Bridge, which is a Photo Browser. By clicking once on one of the thumbnail photos in the folder you are browsing, you can display the camera data on the lower left of the Bridge viewer under the Metadata tab.

From here, it is possible to determine your shutter, aperture, ISO, lens focal length, white balance, metering mode, exposure mode, camera and lens, and more. This is an invaluable tool to learn how the different shutter speeds stop or blur the motion.

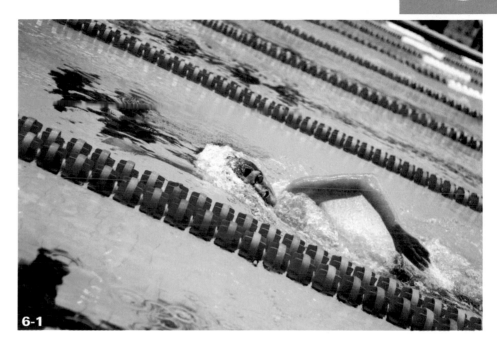

6-1

STOPPING MOTION

Although most human movement can be stopped at around 1/500 of a second, stopping the motion of smaller things, hands and feet during sports, water spray, and a hummingbird's wings often needs shutter speeds well above 1/1000 second.

With an extremely fast shutter speed of 1/2500 second, the spray of water during a water sports event totally freezes the water. The appearance is almost one of ice or some other glass. At such fast shutter speeds, each droplet of water is animated in time, as in 6-2.

The difficulty in shooting at such high shutter speeds comes in making sure that there is enough light in the first place. Make certain that there is enough light on the subject. The light quality is not very important in such situations, mostly because the scene is all about the action and the

frozen time, far more than soft shadows and skin tones. Another thing is that the contrast of hard light is often better at showing off such high speed action and making certain that colors are bright and rich with light.

Shooting indoor sports is a situation that is difficult at best because although school and neighborhood gymnasiums appear very bright to the eyes, in reality, they are very dark. In such a dark place the light and dark seats, a school logo on the wall, padded mats, and similar distractions all affect the exposure greatly when using automatic modes. It is important to get an exposure reading off an athlete and then set the exposure in Manual. In most cases, the light remains static throughout the event and over the course of the playing surface. Shoot some sample images before the game or at timeouts and check the back of your camera to make certain that

you have the correct exposure. Using ISOs of 800 or greater is common when shooting sports indoors, as in 6-3.

Using Shutter Priority with a spotmeter might initially make sense, but with the movement and action of a sporting event, keeping the spotmeter exactly where it needs to be is virtually impossible. So unless your favorite player has a medium grey jersey and you can keep the spot sensor directly on her face and jersey throughout the event, the spotmeter would inevitably get the wrong exposure more often than you want.

There is generally a big trade-off of depth of field and shutter speed, but in this case, if you are trying to stop the action, there isn't enough light for a trade-off. Just use the fastest shutter speed and the fastest aperture you can to get the exposure.

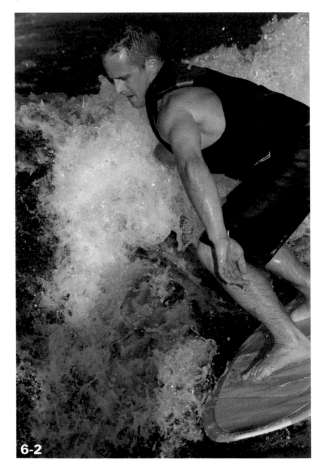

6-2

ABOUT THIS PHOTO *Using an exposure of 1/2500 sec. at f/4.5 at ISO 200 freezes every water droplet in the scene. Exposure compensation of –2/3 was used to ensure that the foam was white and that the black suit stays black.*

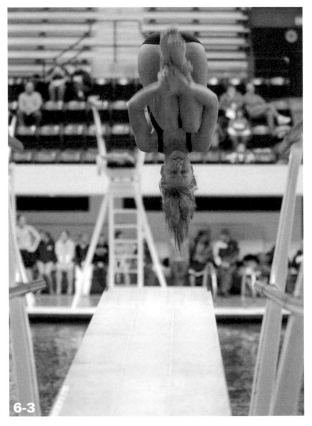

6-3

ABOUT THIS PHOTO *The exposure was set at ISO 1600 and 1/160 sec. at f/2.8. The trade-off of getting even a little bit of light on her shadowed face meant there was some blur on her feet and hair.*

RUNNING AND BIKING

Even the fastest humans have a limit to how fast they can go, and in most cases, your shutter speed settings are more than able to capture that movement. Even at speeds exceeding 25 miles per hour, a cyclist's movement is stopped at 1/1000 second, as in 6-4. Low light becomes an issue in this situation as inclement weather necessitates shooting at maximum aperture. An even bigger issue than stopping motion comes as the subject gets closer to the photographer. Auto-focus cameras are nothing short of amazing, but as subjects get closer, it becomes increasingly harder for the auto focus to remain locked onto the subject.

Auto focus is virtually perfect with most subjects, even when the subjects are crossing the scene perpendicular to or at an angle to the camera. When the subjects are coming straight toward the camera, it is often more difficult to remain in focus. To increase the odds of getting a sharp image, use the continuous focus setting on your camera or lens. This allows the camera to track the subject as it gets ever closer, and today's auto-focus systems are so advanced as to actually pre-dict the movement of the subject. This allows the focus system to keep focus even as the subject moves between the time the shutter button is pressed and the shutter opens, as in 6-5. Some cameras even let you select whether the shutter fires even if the subject is not yet in focus or limits it to only firing if in focus. This is called *Focus Priority*.

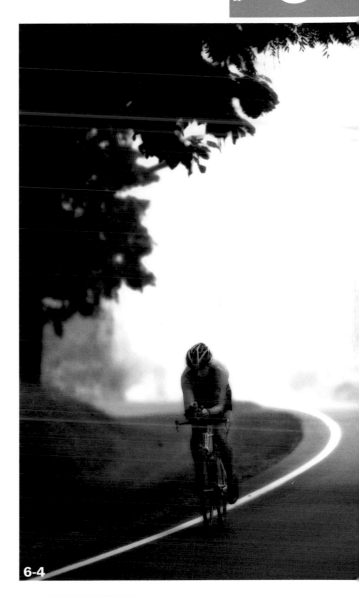

6-4

ABOUT THIS PHOTO *A shutter speed of 1/1000 sec. even stops the spinning shoes of this cyclist. An aperture of f/2.8 with an ISO of 200 keeps some light on the subject even in a backlit situation.*

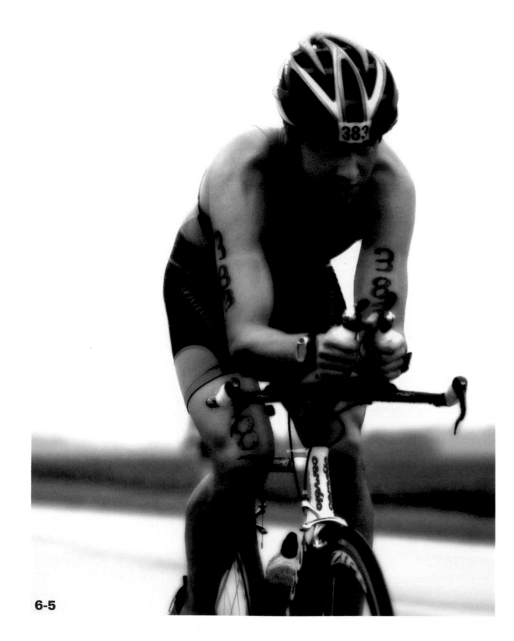

6-5

When shooting people running, maintaining good focus remains important, but unless you are shooting world-class sprinters, exposures should simply stay above 1/250 second to stop most blur. When subjects are farther away, the auto focus systems, even in a compact digital camera, can keep up with people running. Continuous auto focus should be used because that keeps the subjects in focus as they move. Focus is also less demanding than when shooting with a wide-angle lens, as in 6-6.

Athletic events are regularly where the shooting conditions are not optimal, and running in front of a body of water is a backlit situation, even when it's overcast. Be sure to look for high contrast situations and be prepared for using the center-weighted or spotmeter to get the correct exposure, as in 6-7. If you are planning to shoot a particular participant in a mass participation event such as a triathlon, marathon, or fundraising walk, it makes a lot of sense to shoot some of the front runners and walkers early to get a sense of the exposure, lighting, and shooting angle before the person you are waiting for gets there. Of course, if your better half is leading the race, you better be even more ready!

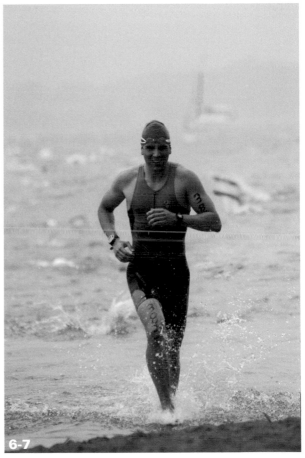

ABOUT THIS PHOTO *With dark-clad swimmers running out of light grey water, getting an exposure with the center-weighted meter helps to maintain detail in the darkness with an exposure of 1/400 sec. at f/4 at ISO 100.*

ABOUT THIS PHOTO *Using a shutter speed of 1/400 sec. and f/7.1 at ISO 100 stops the motion and gives great depth of field. The early start on this spring day yielded fantastic sidelight for shooting these runners.*

KIDS SPORTS

Even less intense athletes can take advantage of fast shutter speeds. The same principles go in most situations. To best see the athlete's face, keep the softer light on his face with backlight but be sure to meter for his shady side, as in 6-8.

6-8

ABOUT THIS PHOTO *Because the subject is backlit, the exposure is 1/1000 sec. at f/5.6 at ISO 400. Trying to get expressions and emotion on faces is a great reason to shoot when the subject is backlit, but watch for flare.*

Many kids are playing soccer today. One of the big problems with shooting soccer is that the field is very large, and trying to get close photographs of children on the other side is a challenge. Using a zoom lens that has a long focal length of 200mm or 300mm is probably necessary. A lot of options are out there from both the camera manufacturers and from some of the secondary lens producers. As with most things, you get what you pay for. If you are shooting everyday photos, the images are going into publications, or you want to blow up the images to poster size regularly, a bargain basement zoom lens probably will not hold up, optically or physically over the long term.

Look for the best lens that you can afford, but realize that unless you are shooting professionally, camera equipment is not an investment. As expensive as some things are and technology advancing the way that it does, camera equipment depreciates as quickly as a car.

A number of great Web sites rate the lenses for sharpness and distortion as well as durability. Do your research before you spend your hard earned dollars on something and check the return policy of your local camera store before you buy. Research may save you untold trouble in case a piece of equipment does not perform as promised.

Using good lenses helps the quality in the photograph when you need to crop, such as when the game-winning shot is on the other side of the field. Using a fast shutter speed and shallow depth of field helped to isolate this soccer player in 6-9, even though the lens is not particularly long.

ABOUT THIS PHOTO *Using a fast shutter speed of 1/1000 sec. at f/4 freezes this player just as he winds up. Using a spotmeter gets exposure right even in a scene with a lot contrast. Photo by Lynne Stacey.*

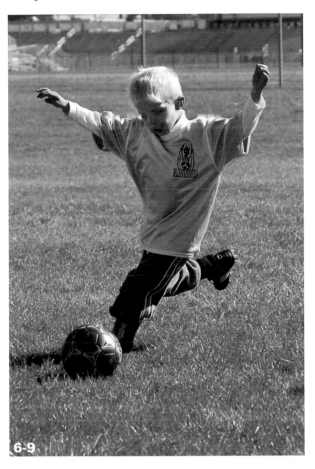

6-9

their dSLR counterparts, but their convenience helps to make up the performance gap. For example, reaching above a child at the apex of her swing would be ungainly and maybe a little risky with an expensive digital SLR (see 6-11). The fact that the swing creates some blur shows how sometimes blur can help a photograph show motion.

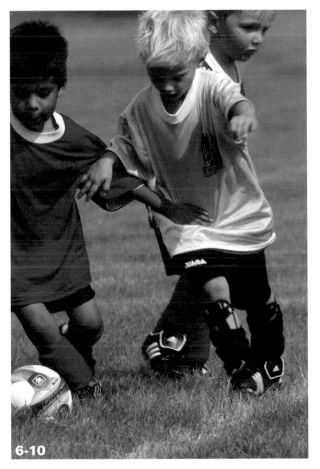

6-10

ABOUT THIS PHOTO *A slight blur can be seen at 1/400 sec. around the boys' feet and hands. Exposure was metered with a spotmeter using Aperture Priority set to f/11 and +1/3 exposure compensation at ISO 200. Photo by Lynne Stacey.*

By using a longer lens, the action is separated from the field with the shallow depth of field of the telephoto set to 270mm. Long lens have less depth of field than wide lenses, and so even using f/11 as in 6-10, the background gets very soft very quickly. The effect of the long lens in this image is that it flattens the background into a blanket of green; this effect is called *compression*.

Kids and compact digital cameras are a great match. Compact digital cameras offer ease of use and the ability to have them close at hand nearly always. They don't operate quite as quickly as

6-11

SLOW DOWN TO SHOW MOTION

As much as fast shutter speeds stop motion, slow shutter speeds create blur, which can imply more motion. The exposure is long enough to capture light moving within the scene. Blurred images can become more impressionistic and abstract and will have more a moving feel to them. The scene can become less literal on the whole, but still have the essence of the subject and scene, as in 6-12.

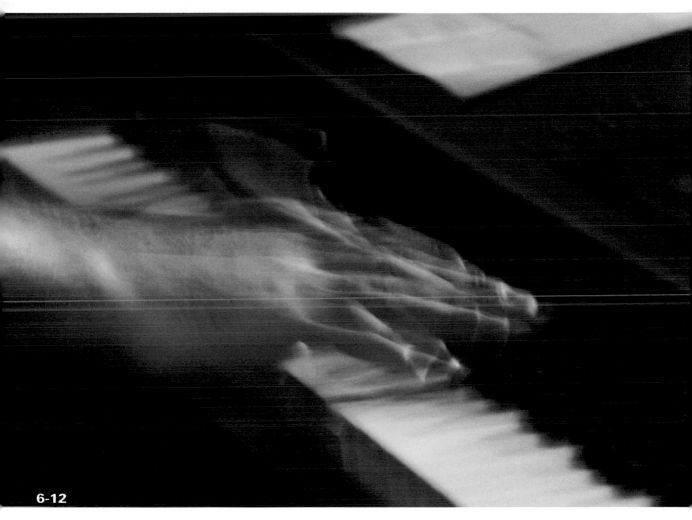

6-12

ABOUT THIS PHOTO *With the spotlights on the hands, the blur almost becomes like multiple exposures, creating the appearance of many fingers on the keyboard. The exposure was 1/8 sec. at f/5.6 at ISO 400.*

Even motion of the camera often works great for blurred images, especially if the hand movement is in the same direction of the movement of the subject. This is important in making the entire scene blur, as this helps further to create tension within the image, as in 6-13. If the background is static and sharp while the subject is blurred, it can make the background appear to be the focus of the image.

Smaller things gather just as much dynamic excitement from blur in an otherwise static subject. Just a hint of blur, especially with a sharp focus on part of an image, puts special importance onto the sharp area. In 6-14, the texture of one of the in-focus sections of flags creates tension with the blur on the left side of the image, and the shallow depth of the field of the flags on the right makes the focus of the flags even more important.

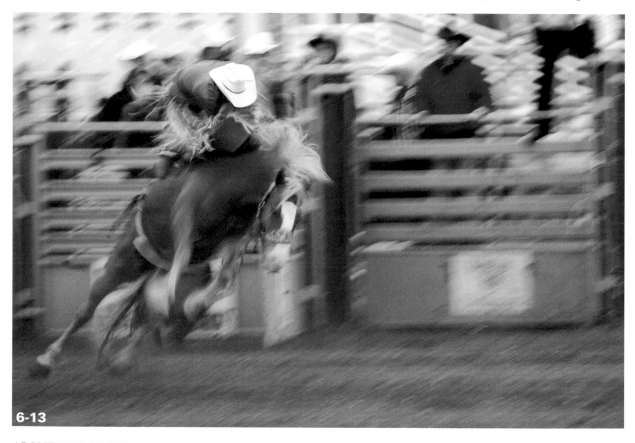

6-13

ABOUT THIS PHOTO *1/25 sec. at f/2.8 at ISO 200 is obviously too slow to stop a bucking bronco, but it is enough to show just how fast and electric such an event is. Nikkor 80-200 f/2.8 zoom lens.*

ABOUT THIS PHOTO *1/90 sec. at f/4.8 at ISO 100 was just slow enough to induce some blur. The light comes through the flags, making them almost glow with color. Exposure compensation set at +1 full stop.*

6-14

Even the blur of a child's hand, as in 6-15, gives the impression of them reaching out and creates that feel of motion. Shooting kids without additional lights or flash can be a low-light challenge, but strobes, even bounced strobes, create a different dynamic in the image that sometimes looks unreal. Manually setting the exposure to 1/60 second is enough for most static images, but as soon as a child moves, blur is quickly induced. Mixing in the razor sharpness of the eyes and the blur of the hand gives the eye a place to focus without the image being static.

ABOUT THIS IMAGE *With an exposure of 1/60 sec. at f/2.8, the shutter speed is fast enough to freeze the boy's face, but not nearly so with a fast-moving hand. A 28-70 f/2.8 AF Zoom Nikkor at a focal length of 50mm.*

6-15

LONG EXPOSURES TO SHOW MOTION

Using a long exposure to show movement generally entails one part of the image remaining static in order to create a focus point of the image, something around which the motion revolves. The longer the exposure, the more difficult the challenge as any camera movement may make the entire image too blurry. By locking the camera on a set subject for a long period of time and then moving the subject, you can create the dynamic blur, as in 6-16.

In 6-17, using a car as the creator of the blur, along with a very red sunset through the trees, makes for a fine line. As the car moves, creating the blur, it also creates the motion that increases shake on the camera. Using a shutter speed longer than 1/30 to create that trailing blur begins to create blur on the subject, but with the new VR and IS lenses. The moving glass elements inside these lenses help to limit shake in such situations, creating relatively sharp slow speed subjects and yet still let the streak of the blurring background be even more pronounced.

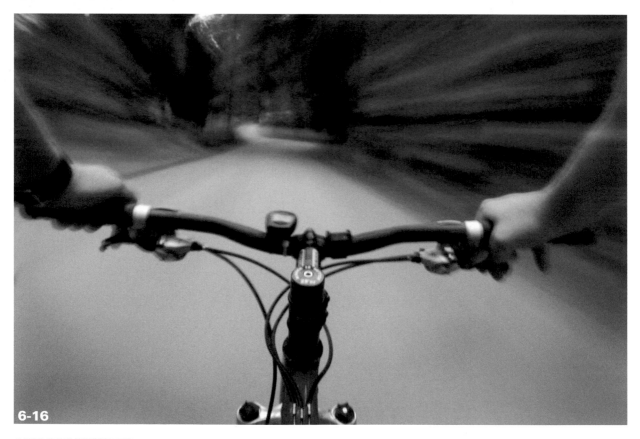

6-16

ABOUT THIS PHOTO *A system of clamps places the camera between the rider's knees, creating an interesting point of view with a Nikkor 14mm 2.8 lens. Exposure was set with the evaluative meter to 1.5 sec. with an aperture of f/22.*

VR AND IS All sorts of letter designations are on the lenses for your digital camera, but some new and very important acronyms are VR and IS. VR stands for Vibration Reduction, and IS stands for Image Stabilization. These are similar ways of solving the problem of blur caused by camera shake. This technology actually employs a series of small motors that move one or more lens elements within the lens, compensating for the small movements of the camera. It is truly amazing technology and definitely helps to keep your images sharper and at slower shutter speeds. With telephoto lenses, the IS or VR helps keep the images sharp at speeds slower than 1/250 second all the way to 1/15 second or even slower.

Each camera manufacturer has its own proprietary system. Nikon uses VR; Canon uses IS; Panasonic uses Mega O.I.S., which stands for Optical Image Stabilization; and Sony uses their own Super Steady Shot. These are all optical type image stabilizers, which means that some part of the lens or camera actually moves to compensate for camera movement.

Beware of digital stabilizers in some compact digital cameras. All that the digital image stabilizers do is increase the ISO so that a faster shutter speed is available, and then in-camera software may attempt to clean up some of the blur, attempting to sharpen the image as it is written to the memory card. This takes longer, increases noise, and still doesn't work that great.

ABOUT THIS PHOTO
Nikkor AF-S VR 18-200mm lens set to 1/4 sec. at f/8 shows background blur, and the hair and exposure length create slight blur. Exposure was set to underexpose the scene, creating deep blacks and rich color.

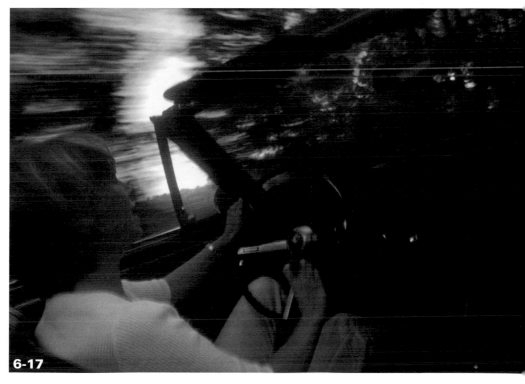

6-17

Locking the tripod down and letting the blur happen helps to create the controlled chaos of using a car's headlights as the blurring subject. Many street scenes can be truly dynamic if they are able to incorporate the motion of the city.

A busy intersection generates enough traffic that, with a long exposure, it truly meshes the lights of the buildings with the excitement of the city, as in 6-18.

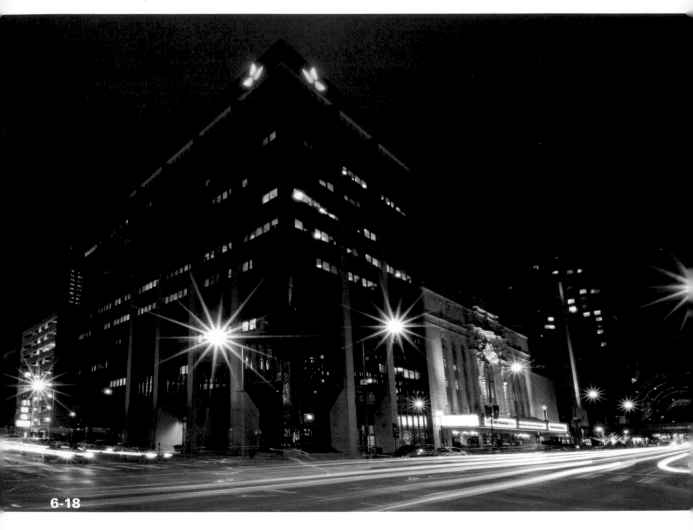

6-18

ABOUT THIS PHOTO *A long exposure of 30 seconds along with an aperture of f/22 was used to capture both the lights on the streets and the buildings. The blur of headlights makes a great image that would otherwise be ordinary.*

WATER AND NATURE

A great deal of thought goes into capturing motion when people are doing things; when shooting nature, the same considerations must be made. Landscape and macro photographers are constantly battling the elements, especially wind. Even shooting long exposures at night can be a challenge when dealing with things moving in the wind or someone bumping the tripod.

Light and water react together in many cases to create dynamic photographs. A large part of this interaction is because of water's constant state of flux; it seems to be always moving. Dynamic images can be found both when trying to stop the movement of water, as much as when working with a slower shutter speed to accentuate the water's movement.

REFLECTIONS

A pond, pool, or even puddle can create reflections of the things around it, which can be very interesting. A ripple going through that reflected scene can create a surrealistic image. Use a faster shutter speed to capture the ripple as it works through the image distorting the reflection, as in 6-19.

WATER IN MOTION

As water comes up to the land, using a very fast shutter speed freezes the spray and the droplets, creating more jagged and almost violent shapes. The shapes are defined, and the spray becomes hard, almost more like coral than how we think of water. The tension of the waves and the spray coming down around this boy, while the background appears so placid, is fascinating in 6-20.

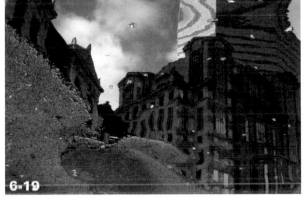

6-19

ABOUT THIS PHOTO *This image taken with Manual exposure using the evaluative meter and exposure of 1/100 sec. at f/7.1 at ISO 400.*

Using a faster shutter speed to stop water in bright light works particularly well in creating balance. Balance exists both in putting that image of great movement against the serenity of the sea behind the crashing wave, or in balancing that action with the land that the water crashes into. Shooting in bright daylight often necessitates faster shutter speeds, and in 6-21, the fast shutter speed stops the wave mid-crash, but that motion balances very well with the sharp-edged and angular dark rocks jutting into the water.

6-20

6-21

The hard light helps further define the hard rocks; by stopping the water, it further defines the line of the water.

Slowing down the shutter speed captures the water in an ethereal and soft manner. Shutter speeds that get slower than 1/4 second begin to create a serene sense of the water. Exposures longer than 1 second are even more preferable as this allows the water to continue to flow, and each bit of water and foam that move in front of the lens creates more and more of a streak, as in 6-22.

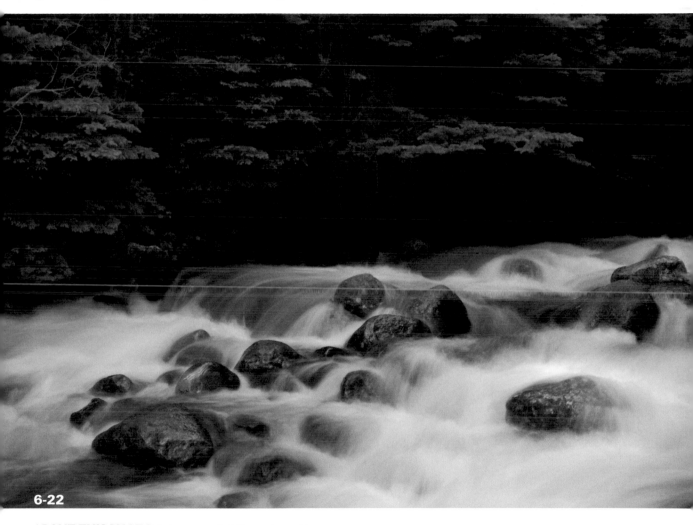

6-22

ABOUT THIS PHOTO *A shutter speed of 1/4 sec. along with an aperture of f/22 are used to create the effect of the streaking of water.*

Using such slow shutter speeds to blur movement is often difficult to do during the daytime, even in the shade because there is simply too much light. No matter how small of an aperture is set, the shutter speed is too fast to adequately create the blur. Using a neutral density filter helps to slow that shutter speed. The neutral density filters come in any number of different levels of effect, from 1 f-stop to 5 f-stops. Neutral density filters are essentially sunglasses for your camera, stopping a certain amount of light coming into the lens. The effect of a 3 f-stop neutral density filter would take an exposure of a scene that is 1/2 second at f/22 and, by blocking 3 stops of light, make the exposure 4 seconds at f/22.

In cases where longer exposures are needed, a polarizing filter can be used in place of a neutral density filter. Depending on how much light comes through the polarizer, this can be anywhere from 1-1/2 stops to 2-1/2 stops of neutral density. If you are using a polarizer as a neutral density, make sure that the effect of the polarizing filter is helping the scene as well.

In 6-23 the polarizer was used to block light and get a slower shutter speed, and it also was used to get rid of reflections and make the rocks appear rich with color.

PANNING

In some cases, shooting fast-moving subjects with a fast shutter speed is less than optimal. This could be because the background is less than great, or just to get a better sense of motion.

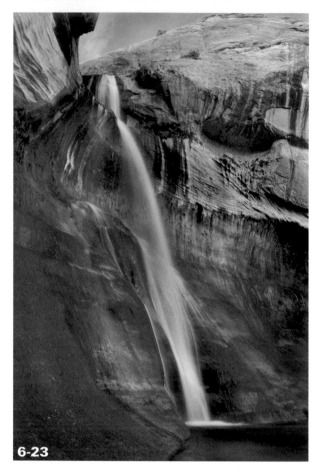

6-23

Panning is a technique where the photographer slows the shutter speed of the camera to between 1/30 to 1/4 second; the camera is then moved along with the subject. The effect is that there is a blurred background, while the subject remains relatively sharp. This can be done with any moving subject from a runner to a race car, as in 6-24.

Photographing subjects while they are moving and still getting adequate blur in the image takes a fair amount of practice and plenty of shots. Be certain to set the camera to continuous focus and the fastest drive that your camera has. Shoot all the way through the subject's movements within the scene. This increases your odds of getting a great shot, as in 6-25.

Panning often works great when using the camera on a monopod. This helps the image stay steady and smooth while turning or rotating the camera. The new vibration reduction and image stabilization lenses help create smoother panning photos as well by reducing the camera shake problem in shooting with a slower shutter speed. Many of these lenses have multiple modes for different types of shake reduction. Be sure to read your manual to determine what is best for each situation.

6-24

ABOUT THIS PHOTO *Keeping up with cars approaching 200 mph is a challenge. Using different shutter speeds yields different effects. A shutter speed slow enough to see some blur on the wheels and background helps to show a sense of motion. Taken at 1/1250 sec., f/7.1 at ISO 400.*

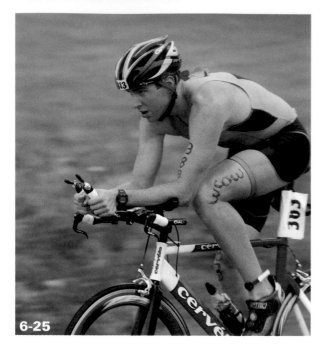

6-25

and what got hit with the strobe effectively is frozen. This excitement of the situation is maintained, with all of the blurred motion, but the subject also is strong because it is lit with and stopped by the strobe, as in 6-27.

This is also called slow sync and happens when the shutter speed is slow. This can be done by using Manual and setting the shutter speed to a slow shutter speed or can be done using Shutter

USING FLASH TO CAPTURE THE MOVEMENT

When the light is waning and darkness is moving in, using flash to balance the blur gives the scene a focus point. In an urban scene, the lights from streetlight, neon, and shop signs all give a night scene some colored texture and the possibility for blurry streaks of light. In 6-26 a strobe placed on a camera mounted on a bicycle lights up the subject, the rider's yellow jacket. The strobe freezes the movement of the jacket, while the long exposure extends the small points of light into long trails of brightness.

Because the flash happens so fast, it can stop the action as well. When the exposure is longer, other action happens in the exposure that blurs,

6-26

Priority. In both cases, the accessory flash should still be set to TTL so that the flash puts out the correct amount of light for the exposure of the subject.

Some cameras also have a slow sync setting on the camera. This setting is used with one of the auto exposure modes and allows the camera to fire the flash at any slower shutter speed. If this is not selected, the shutter speed is set to an automatic default speed, usually 1/60 second, which generally is fast enough to counteract any camera shake, but 1/60 second is also fast enough to make the background very dark in most situations. Using a slow sync will let more of the background light of the scene into the image, increasing the balance of background light and strobe, which in turn helps make ordinary snapshots far more interesting.

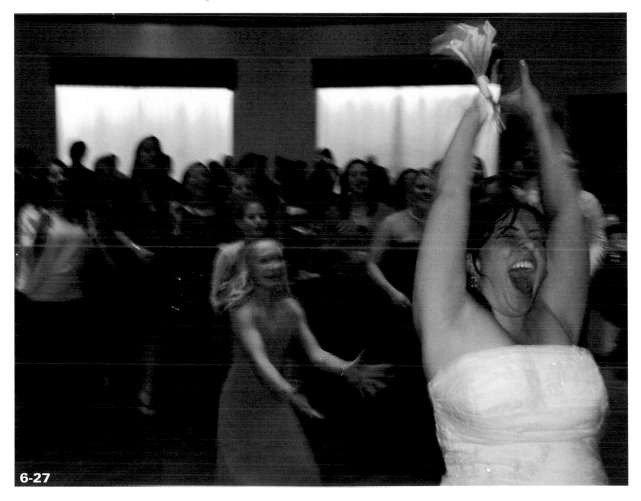

6-27

ABOUT THIS PHOTO *A manual exposure of 1/15 sec. at f/4 at ISO 640 was used to get the action of this bouquet toss. The default shutter speed would result in a much darker background, reducing the excitement of the shot.*

Assignment

Things in Motion

Action shots can be tricky if you want to show a subject in motion as opposed to freezing a subject in action. Freezing an image is easier because you can set a quick shutter speed and snap away — catching people and things in mid-air. Showing somebody or something in motion is more complicated because you have to adjust your shutter speed to show motion without the entire picture looking blurry or too soft. Take a photo of someone or something in action and show movement. Your image can be an animal, an athlete, a car, or anything that moves. Post your best to the Web site and describe the lighting challenges you faced while taking the photo.

I took this photo on a lightly overcast day. Using a shutter speed of 1/3 second to get the blur for the background, the aperture on the 20-35mm f/2.8 lens was stopped all the way down to f/22. For this particular shot, it was more important that the blur and motion were inherent than seeing the detail of the driver. It took several hundred images, using different shutter speeds and angles and different backgrounds to get the shot I wanted. The exposure was set using the spotmeter, but after an initial reading, substantial trial and error was needed to get the motion feel just right. Different exposures were used to make the scene brighter and darker.

Don't forget to go to www.pwsbooks.com when you complete this assignment so you can share your best photo and see what other readers have come up with for this assignment. You can also post and read comments, encouraging suggestions, and feedback.

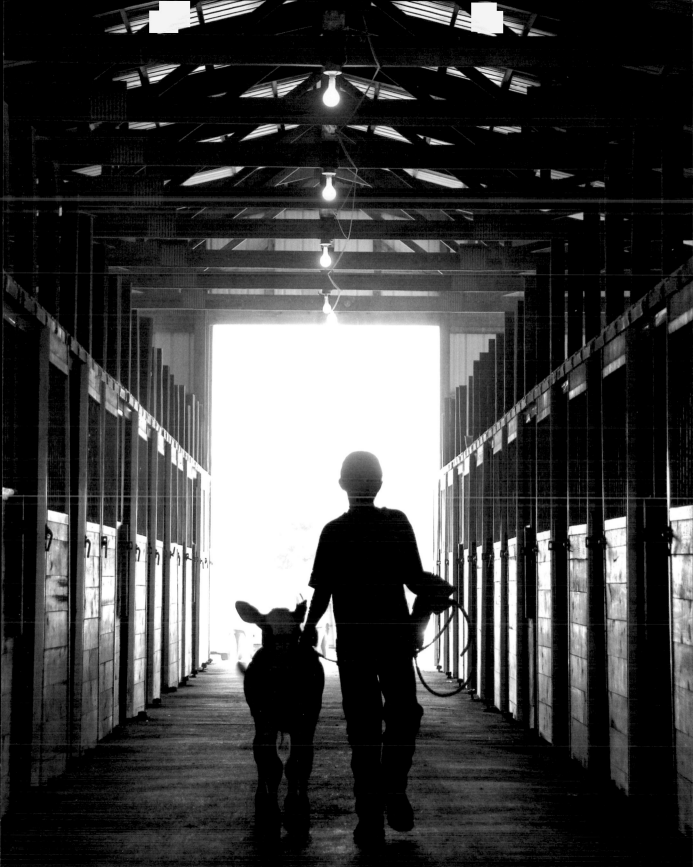

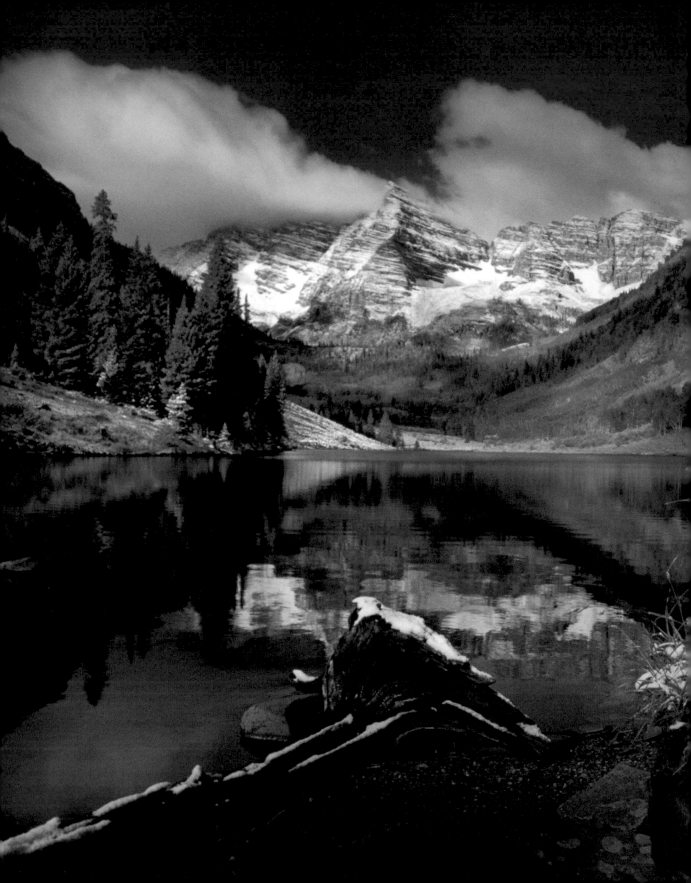

LIGHTING SCENARIOS IN LANDSCAPE PHOTOGRAPHY

You've no doubt seen an Ansel Adams or a David Muench western landscape photograph. These photographers spent years mastering light, composition, exposure, and timing to create unbelievable photographic art of the American West.

One of the most vital elements that goes into any landscape photograph is the light. And those photographers spent countless hours finding their locations and waiting for the light to be *just right*. Throughout the day and throughout the year the light is rarely the same twice in any location. Sunlight is always changing, so when shooting landscapes you must learn to work with the weather to create the best light and shadow opportunities for your photographs.

However, landscapes are much more than just the great canyons, mountains, and oceans of the world (see 7-1). Because you can look at the world in many different ways, I want to look at landscapes as a style rather than focusing on the specific photography subject. Landscapes can be in a city, on the plains of the central United States, in the suburbs, or even in your home or workplace, such as in 7-2. Each of these locations has its own distinct lighting characteristics and challenges, which are discussed in this chapter.

7-1

ABOUT THIS PHOTO
Late afternoon sun lights up the Rocks of Park Avenue at Arches National Park. That light was captured with a 28–105mm zoom lens with a polarizer using Aperture Priority automatic.

ABOUT THIS PHOTO *This tiny interior landscape was taken with a 105mm f/2.8 Micro Niklor. The ISO was 100, and the exposure was f/7.1 at 1/3 second.*

7-2

LIGHTING TERMINOLOGY

Before you delve completely into lighting for your landscapes, take a moment to review some of these lighting terms and how they relate to landscapes. In earlier chapters, light direction (front, back, side, top), light quality (soft and hard), and contrast and brightness range were discussed.

■ **Directional lighting.** If the lighting is from the top or flat, it has a tendency to look flat and uninteresting. Light coming from the side of the scene, called *sidelight* or *crosslight*, emphasizes shape and texture in your images. Backlight in a landscape is just as tricky as it is beautiful. Well done backlight can cause parts of your image to glow rich with color, although if you are not careful, backlight can fill your image with black shadows and your lens with flare.

- **Light quality.** Unlike a portrait, it is easier to use harder light in a landscape because you don't need to see anyone's eyes. Generally, though, the most pleasing light quality for landscapes comes during the twilight of dawn and dusk. With the sun lower in the horizon, the light is filtered through many layers of atmosphere, softening and changing the light. Early morning sun seems to have more tones of pink and yellow, while in the evening, the light will look more orange or red.

> **x-ref** For more information about directional lighting, see Chapter 5. For more about the quality of light, and more about contrast and brightness, see Chapter 1.

TIMING YOUR LANDSCAPE EXPOSURES

Face it, when you go out to photograph a landscape, you hope to get an ultra-dramatic, panoramic landscape; however, what you often get is more snapshot than art. Even if you live close to a natural wonder, getting to the most scenic parts of, for example, the Grand Canyon or Zion National Park, is difficult. And you have to consider whether you are going at the right time of the year. Is your spring break at the optimal time to see and shoot sunset at Delicate Arch? Is a storm going to roll in just as you pull into Yellowstone? Are the wildflowers going to be at their peak?

The sun is the predominant light source for landscape photography. The sun is constantly moving across the sky, taking the light hitting the landscape with it. Finding the right time of day for the landscape you have in mind is immensely helpful. For example, in the mornings light hits the eastern faces of landscapes, which is optimal.

In the afternoon and evening, scenes that face the west have the best light hitting them.

BEFORE DAWN

In the morning, beautiful light exists even before the sun rises. In that pre-dawn time, the light level is still very low. You need to use a tripod and a cable release to keep the camera still and eliminate blur as your exposures could reach many seconds or even minutes. As discussed in Chapter 1, to maximize the image quality, keep the ISO as low as possible. Long exposures also have a tendency to generate *noise* or graininess in photographs.

If you use the Aperture Priority mode of your camera, you can select an aperture that gives you enough depth of field to get your entire scene in focus, and then the camera selects an appropriate shutter speed. Before the sun rises, while just a slight glow is in the sky, you could set an exposure around f/8 at 30 to 60 seconds or even more. Even if it seems to be very dark out, just that little bit of glow, with the long exposure, can still make for a very bright scene, as shown in 7-3.

MORNING TWILIGHT

The light quality at twilight is soft and tends to wrap your landscapes with a blue glow. This is a great opportunity to work with the different white balances in your camera. At the daylight or sunny white balance, landscapes have a cool or blue cast. Changing the white balance to cloudy or shady incrementally makes for warmer looking photographs. The shade white balance should cause a relatively neutral scene because that is exactly what the situation is — in twilight you are at the edge of the shadow of the globe.

7-3

ABOUT THIS PHOTO *Taken with a 18-200 Nikkor Lens. The exposure was f/5.0 for 30 seconds, giving the water its soft glow and leaving streaks from the headlights. Shot 15 minutes before sunrise.*

It may be necessary to keep the sky out of twilight photographs as the sky gets brighter before the landscape in longer exposures. This could cause too much contrast in a landscape photograph because the sky either exposes as a beautiful blue and the rest of the landscape is very dark or the landscape is exposed correctly, and the sky is far too bright.

When the sun finally starts to spread the light across the landscape, the light generally hits the tops of mountains, hills, and trees first, which can make for a very dramatic scene with rays of light

hitting a small portion of your photograph. This tricky light situation is a great time to use the spotmeter of the camera, as shown in 7-4.

Your digital camera probably has a spotmeter. Unlike the averaging or multi-segmented meter, which averages the scene to get the right exposure, the spotmeter allows you to select a very small part of the scene and find the exposure for just that area. This is particularly useful when you need to find the exposure of your subject because it is surrounded by large amounts of light or dark.

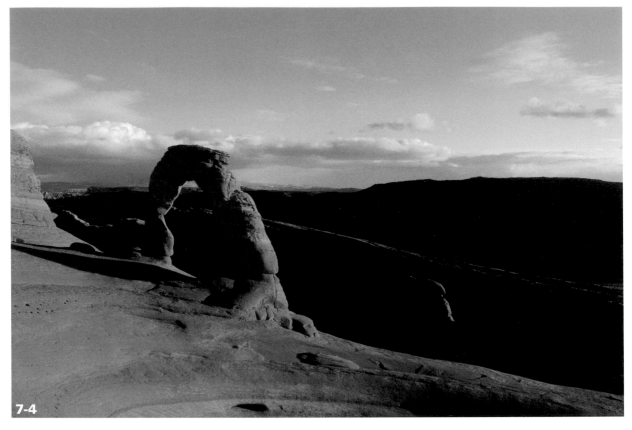

7-4

Placing the spotmeter's spot circle or spot frame where the sun is hitting the landscape should get your camera's meter to the correct exposure. Remember, the meter is going to tell the camera the correct exposure for a middle grey. As the sun comes up, it does not take long for the sun to be far brighter than middle grey, so you have to over-expose the spotmeter setting by a stop.

A camera without a spotmeter is still able to capture this difficult scene. Using the average or multi-segmented metering mode creates an exposure that is too bright because the meter is measuring the overall dark scene with just a small amount of brightness. By underexposing the scene by one to two stops, you get an exposure that captures the drama of this light.

EARLY MORNING LIGHT

As the sunrise turns to full sun, you have the sun at your back when looking west. Positioning the camera and the landscape to get sidelight or crosslight can accentuate the natural shape and texture of the landscape. However, because light does not fall into canyons or tree-lined meadows until later in the morning, this is still a difficult time to shoot. Much contrast can exist between large areas of shadow in valleys and the large amount of sun on the mountains. Using some of the shadows falling across a field helps to add texture and scale to a wide scene.

 tip A quick way to check on the contrast of your scene is simply to squint. If an area is much brighter than everything else, squinting eyes read the shadowed areas as almost black, while brighter areas are still bright. This allows you to see what the contrast of your final image is going to look like.

When the sun has risen, and the brightness of the sky more closely matches the brightness of the landscape, using Aperture Priority and your average or multi-segmented meter allows you to control the depth of field and proper exposure. In 7-5, the sun is up, lighting the entire scene and backlighting the leaves, making them glow. Using f/13 was a compromise in this situation; more depth of field would have made the image too busy when the important part of the image is the leaves, and less depth of field would have made the mountains and trees in the background less defined.

MID-MORNING LIGHT

With the sun still at your back, the mid-morning is another good time to create great landscapes. The light has already been up on the high points of your landscape for a while and, the light is now spreading all over the landscape. Although the light in 7-6 is coming from the side, because of the angle of the valley, the rock faces of the scene are very front lit.

Shooting the light at this time of the day is a trade-off because the light has strong direction and great warm color in the morning, but it also is creating some strong shadows in the valley. In this case the shadows are used to separate the mesa from the plains outside of the valley.

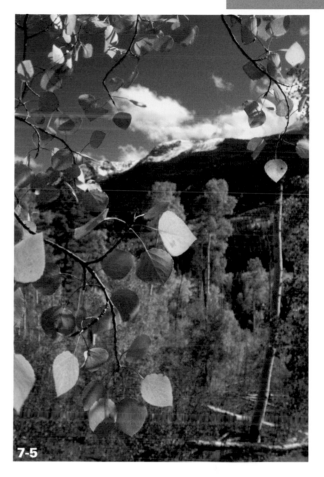

7-5

ABOUT THIS PHOTO *A Nikkor 20-35mm f/2.8 lens was used here at ISO 200, 1/160 sec. at f/13. Even though a wide-angle lens and small aperture were used, the leaves are close to the lens, leaving the background slightly soft.*

In many cases, a photographer can use the strong shadows from directional light for framing or as another graphic element in the photo. If it is important to see into the valley in a scene like this, the light will be far less dramatic as the sun gets higher in the sky.

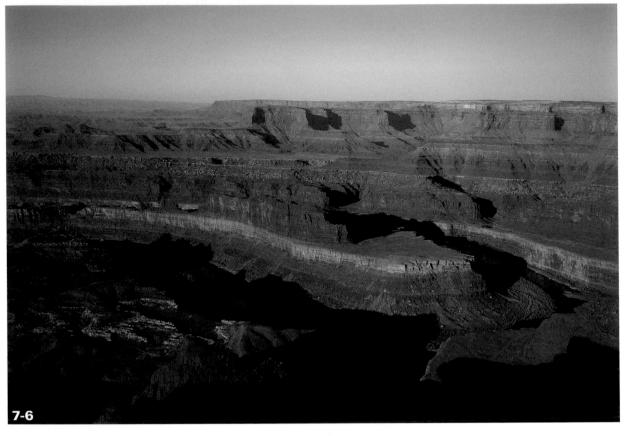

7-6

MIDDAY LIGHT

Photographs taken in midday can have a hard and flat appearance. Sometimes, though, the midday light is the best light you are going to get. In 7-7 of Antelope Canyon, in Northern Arizona, the sun slips through a crack in the ground about three feet across. A shaft of bright midday sun hits the red walls and that light bounces off the walls creating both a warming and softening effect.

Because the light is reflected, it also then becomes much softer, making the light redder and creating a warm glow inside the canyon. The midday sun enters the canyon unimpeded, and the light has enough contrast for the color and

the shadows to be full and rich, so this is an ideal scenario for using midday light.

Not all of your midday landscapes are going to work in your favor. But, good composition and balance can make up for less than ideal light. The image in 7-8 was taken in the middle of the day — almost exactly at noon in the middle of the summer. The scene and the final image were very compelling to me nonetheless, and coming back later was not an option. The positioning of the cloud, the foreground, and the horizon was a once-in-a-lifetime shot; certainly getting into an overloaded motorboat off the coast of Maine on a blustery day with very choppy seas wasn't going to happen again anytime soon.

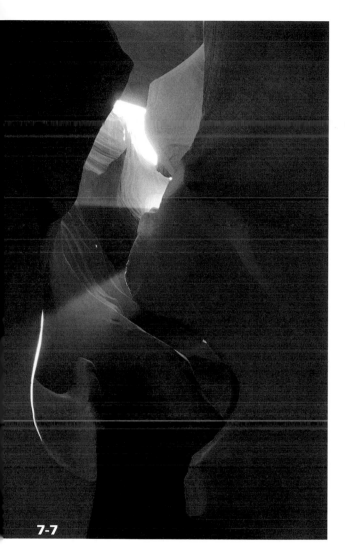

7-7

ABOUT THIS PHOTO *A Nikkor 20-35mm f/2.8 zoom lens was used for this photo with an exposure of 1/30 sec. at f/8 at ISO 200. The interplay of the light and the dark shadows in this red rock canyon makes it a photographer's favorite subject.*

As the sun climbs high into the day, the light quality of the light can be hard, even harsh. Often, however, that is when you can capture a landscape photograph. Take this time to focus on composition elements like shape, balance, and repetition in your landscapes if you can't get the light just perfect.

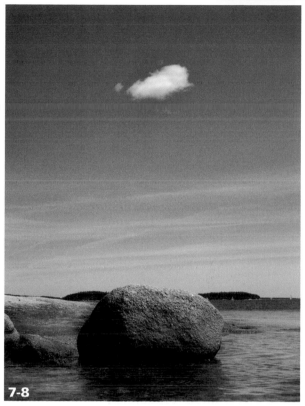

7-8

ABOUT THIS PHOTO *Good composition and balance can make up for less than ideal light when shooting in the middle of the day. Program mode at ISO 100 at 1/800 sec. at f/6.3 using −1/3 exposure compensation.*

Composing for black and white in middle-of-the-day sunlight is also a good option. Because of the contrast, black and white can simplify what you see in your images. Realize that the hard, bright light of that bright sun washes out a lot of color in your photographs.

Most digital cameras now have a black and white option, which gives pretty good results simply by changing a setting in your camera's menu. However, to get more control of the tone and contrast of your digital photographs, you should use a color image and convert it into black and white on the computer.

Using the black and white setting on your camera is far more forgiving when it comes to light with more contrast; however, it won't mask other problems in your photographs. Overexposure is one of the most common mistakes in black and white photographs. Seeing shadows that are too black is better than seeing highlights that are overexposed and blown out. When parts of an image have lost all detail in the highlight or white areas, those areas are considered *blown out*. It is virtually impossible to retrieve that detail from the image after you are in the computer.

Most digital SLRs have functions in the playback that will show where those overexposed highlights are. This setting is usually called highlight and in this setting the image on the LCD screen on the back of the camera, if there are overexposed highlight areas, are shown by flashing black into the area or overexposed highlight. In 7-9, the scene is full of bright snow along with dark trees. To make sure all that white snow still has detail and tone in it, you can go to the highlights screen and see what is too washed out. In 7-10, you can see the snow area is blacked out meaning that the white area is totally overexposed. To get the correct exposure the scene needed to be underexposed so that the blacked-out highlight area is minimal.

tip As many of the best known landscapes have been captured in black and white, consider some things to help better visualize the black and white image. Although both high and low contrast scenes work great with black and white, scenes that have strong graphics, such as line, shape, and repetition work best. Scenes that are busier are harder to read without a high contrast or high impact subject.

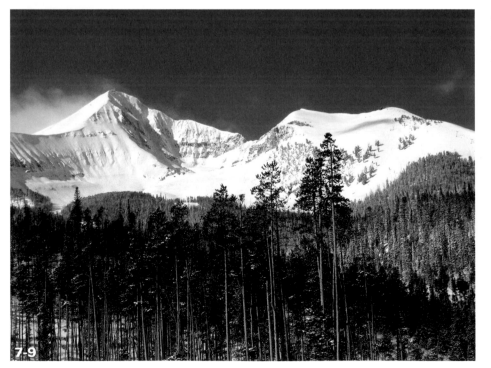

7-9

ABOUT THIS PHOTO
For bright scenes or those with extreme contrast, the camera has tools such as the highlight setting, which shows where the overexposed areas are. The correct exposure was 1/500 sec., f/8 at ISO 100.

ABOUT THIS PHOTO
The highlights setting, selected so that blown-out highlights are shown in black. This is particularly useful in bright situations, when the screen is difficult to see. This is just another tool that helps you maintain the correct exposure.

7-10

AFTERNOON LIGHT

As the day goes on, shadows start to re-emerge and lengthen, and the scene that was so compelling and beautifully lit in the morning starts looking hazy and flat. That happens because the sun is behind the scene, making it backlit.

Much as the morning light, afternoon light is bright and makes most scenes look nice. The exposure, on a clear day, remains static until the last hour or two of the day, but the shadows lengthen,

making many scenes darker. Paying attention to where the shadows of valleys, trees, and mountains fall helps. By shooting all through light that is changing, you can see how the moving light affects your scene when you get back to your computer.

You often are surprised at how nice something looks at one time over another because of the light, as in 7-11, and in other cases, you are pleased because the light is only doing something for one particular moment, and then it is gone.

ESTIMATING SUNSET The afternoon is also a good time to determine just where the sun is going to fall for the golden light of sunset. If you don't know exactly where and when the sunset is going to happen, try this: Fully extend your arm and then stretch your forefinger and pinky as wide as they can go and bend your middle two fingers with your thumb over them. (I think this is the hang loose surfer symbol but may be something else, so be careful.) Turn your hand sideways, with your forefinger pointing at the sun and your pinky below, your pinky will show roughly where the sun is going to be in an hour. Each time you drop your arm, placing your forefinger where your pinky was is another hour. Remember, though, that the sun doesn't always fall straight down, it arcs to the south. In the middle of summer, it may come almost straight down, but near the winter equinox, it comes down at almost a 45-degree angle.

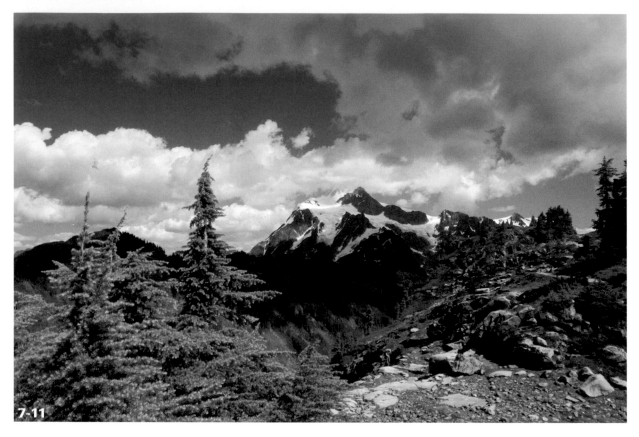

7-11

DUSK

The light at dusk is very similar to the light at daybreak, but because of the particulate matter generated by the activities of the Earth over the course of the day, the sunset light is visually more intense. As discussed in Chapter 1, the molecules of the atmosphere as well as the additional air-borne particles create light that appears more red-dish in color.

During the sunset, often four types of light are happening, although rarely can a photographer optimize them all in one landscape location. With the sun dropping low in the sky, the light will get more and more directional. This can create very strong sidelight across your landscape. In this scenario, the camera's light meter usually does a fine job in the evaluative or matrix meter mode, but watch out for large areas of shadow or large areas of brightness. The second type of light during your sunset is the front light, and as front light comes over your shoulder, watch out for your shadow in the scene and watch out for how bright the scene is. If the light is hitting a big

wall of red rock or white capped mountain, you may have to overexpose by a half or a whole stop to capture the brightness of the scene, as in 7-12. If you have bright front light, you probably have lots of back light in the opposite direction. This is great for generating silhouettes in your landscape as in 7-13 and actually capturing the sunset.

Backlight can be confusing, so don't over-think your situation, especially if you are trying to maximize the saturation and richness in the sunset. If you are actually photographing the sunset, with the meter trying to get that bright scene into grey, it is actually doing the underexposing for you.

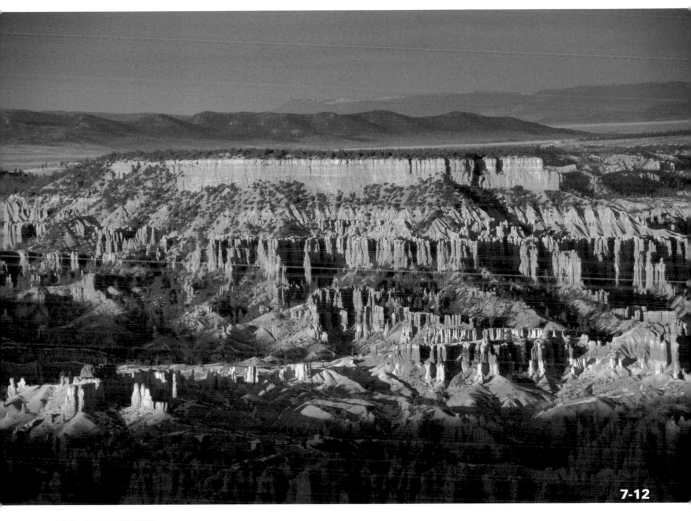

7-12

ABOUT THIS PHOTO *As the sun goes down in a scene like this, the shadows quickly fill up the valley, making the entire scene dark. An exposure of 1/250 sec. at f/5.6 at ISO 100 is determined by the evaluative meter.*

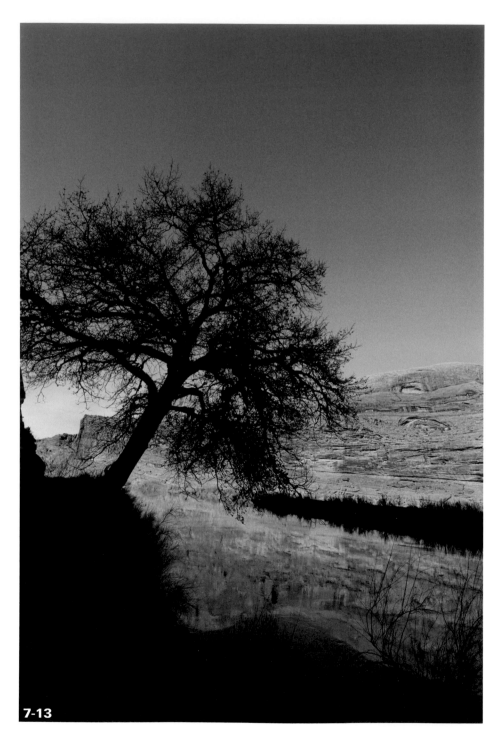

7-13

AFTER DUSK

The fourth type of sunset light really doesn't happen until the sun has set. Although the light is below the horizon, the sun's rays are now going upward, and when clouds are available for the light to reflect off of, beautiful soft light is the result. This reflected light is much more subtle and pastel in tone, as in 7-14. In fact, if no clouds are in the sky and the skyline is open, often you can see how the color of the sky along the horizon changes from very red around the point of sunset to orange, yellow, pink, and purple on the opposite horizon.

This light is often called the afterglow, and in this situation very little light is on the ground, but a lot of light is still in the sky. Placing the subject of your landscape as a silhouette against a colorful sky is one way to be able to capture the afterglow. Another option would be to use the color of that soft, low light for tighter landscapes, such as rocks in a stream or gently swaying wildflowers.

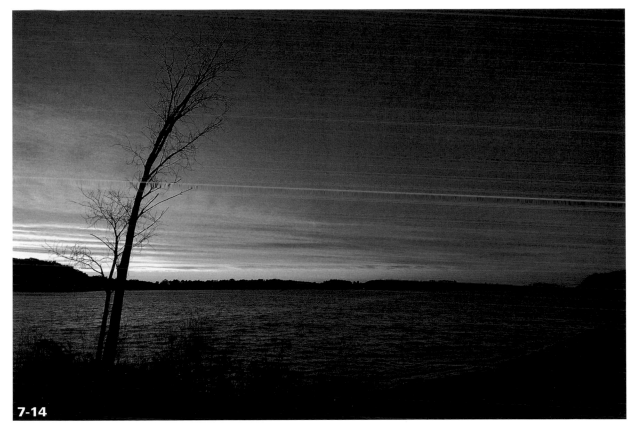

7-14

ABOUT THIS PHOTO With a 12-24mm f/4 lens, the skyline and sunset color are captured. The exposure here is 1/60 sec. at f/5.6 at ISO 100, with the white balance set to shade to increase the warm glow of the sunset.

WORKING WITH OVERCAST LIGHT

Weather is one variable in photographic lighting that you can't control, but you can use it if you understand how the weather is affecting your light. Weather brings drama, texture, and excitement to photographs, especially in the case of landscapes.

Most of us consider sunny blue skies as an optimal time to take a photograph; however, sometimes that solid blue sky can be just as boring as a dull, overcast day. You want your landscape's sky to be exciting and full of life, so don't pack it in quite so fast when the weather begins to turn a little stormy, as in 7-15.

Gloomy days might tempt you to just keep the camera in your packs, but this is a great time to look a little deeper into a scene and capture the details in a landscape.

It was indeed fortuitous to come upon this rock with flowers on a pretty dreary day with a little speck of sunlight on it. On a sunnier day, you might be temped to overlook such a beautiful scene as many grand vistas come from every direction. An overcast, even stormy, sky really brings up the drama because of the great contrast of these rocks with flowers with the dark silhouettes in the backgrounds in 7-16.

Landscapes look different on cloudy and overcast days, because the quality of the light is much different; it is softer, flatter, and has a moody, dramatic look. Much like midday shots, overcast days can be perfect for black and white photographs (see 7-17). If your digital camera has a black and white option, you can use it to create drama in your overcast landscapes. Converting color pictures into black and white in the computer allows you far more additional options with filtration and tone.

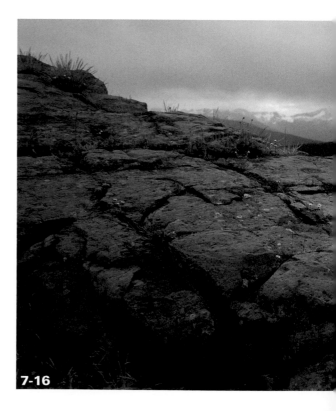

ABOUT THIS PHOTO *The exposure for this photo was 1/30 sec. at f/8 at ISO 100 using an evaluative meter and Aperture Priority. This image also shows nice color balance with the warmth of the rocks and the blue of the sky.*

7-16

ABOUT THIS PHOTO
Exposure for this photo was at 1/640 sec. at f/11 at ISO 200 using an evaluative meter and Aperture Priority. The meter balanced the sun with the dark mountains in the foreground, making the clouds dark and ominous.

7-15

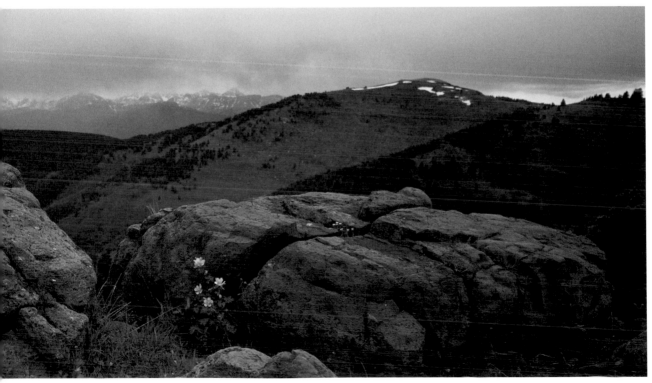

PROTECTING YOUR CAMERA AND YOURSELF Countless weather covers are available for your gear. Rain shields likely come both customized for your particular camera as well as generic. I generally recommend using a waterproof backpack and keeping cameras and lenses wrapped in extra towels. This keeps your gear dry when out in the backcountry. I haven't found many times when the shots were so good that I wanted to actually shoot in driving rain, but I have seen photographers, with heavy-duty rain gear for both themselves and their photo equipment. Generally, these are sports photographers who also have an assistant keeping things dry, toweling off equipment after every play. Those are hard-core shooters! And, some specialists even do lightning photography. This is for the experienced only.

Don't get caught in any real serious weather. As exciting as it is to see a big thunderhead moving into or through your landscape with the light moving through and around the clouds creating visual drama, don't get yourself stuck. Plan ahead. Talk to the locals. Think about your safety before your shot.

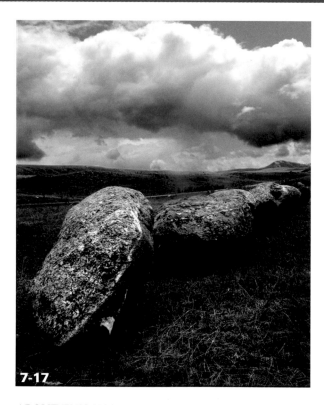

7-17

ABOUT THIS PHOTO *Creating black and white images allows a photographer to really concentrate on the contrast and tone of photographs, especially with dramatic clouds. The exposure of this image was 1/250 sec. at f/8 at ISO 200, with –2/3 exposure compensation.*

USING FILTERS TO ENHANCE YOUR SHOT

Sunsets and sunrises make for great photographs, and in many cases your photographs can be enhanced with the use of photographic *filters*. Filters are pieces of glass or optical resin that are placed in front of the lens to affect the image in the camera (see 7-18). During a landscape shot, I usually have the camera on a tripod; often the fastest moving thing in the image is the light, and this makes for perfect situations for working with filters.

Filters come in three basic types:

- **Screw-in.** Circular with metal threads that screw into the front of the lenses. Generally these filters are glass and can be used for UV elimination, black and white effects, light polarization, and some color correction.

- **Slide on.** Usually square in shape. Slides into a holder that screws into the lens threads. Slide-in filters are usually for image effects, such as changing the overall color of the image, to softening, to adding the look of

ABOUT THIS PHOTO
An assortment of filters and holders. Clockwise from left, a gel holder, 81EF gel, yellow gel, 30 cc magenta, P size filter holder, polarizer, ND grad, 81B warming, and blue graduated.

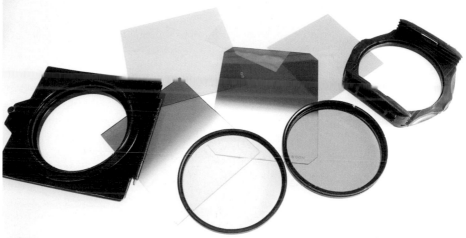

7-18

fog or motion to the image. The most commonly used slide-on filter is the neutral density graduated.

■ **Gels.** Very thin pieces of resin that are placed in a holder in front of the lens. Generally used for color correction. Gels can come in small increments of effect to precisely change or correct your image.

Because such a wide variety of filters and associated effects are available, the following sections take a look at a few of the filters that are most used for landscape photography.

POLARIZING FILTER

A polarizer as shown in 7-19 is used for taming reflections and glare on glass, water, and foliage. It can also darken the sky and increase color saturation. No other filter can do these things. The polarizer does all this by aligning light waves as they come into the lens so that they only come in from one direction. The major pitfall of this filter

is that it also blocks 1-1/2 to 2 stop of light. In-camera meters can compensate for this, at the cost of slower shutter speeds, less depth of field, or higher ISO.

7-19

ABOUT THIS PHOTO *Although this just looks like a grey filter in this photo, a polarizing filter can add a tremendous amount to a photograph by polarizing the light in the scene.*

GRADUATED NEUTRAL DENSITY FILTER

This filter is immensely helpful in landscape photography, particularly during sunrise and sunset. The bottom of this filter is clear; the top is a neutral grey; and the middle is a smooth gradation between the two (see 7-20). The grey part, the neutral density, simply lets less light in. This is used to darken a bright sky, bringing the exposure closer to that of a shaded foreground. Often called an ND grad, this filter comes in various levels of density and lengths of gradation. The most commonly used ND grads are the 3 stop with a short or hard gradation and the 2 stop with a long or soft gradation.

7-20

ABOUT THIS PHOTO *A Neutral Density Graduated Filter blocks light from half of the scene and lets all the light through, making the upper half darker to better match the light on the lower half of the scene.*

Many colors and special effects filters have now been replaced by software. The effects of the polarizing filter and graduated neutral density are filters that affect the photograph in ways that the computer simply cannot easily duplicate. Because neither a film nor a digital photograph can capture the entire brightness range when bright sky and shadowed foreground are included in one image, using the ND grad is recommended.

SHOOTING LANDSCAPES IN FOG

Light from foggy mornings often produces some of the most beautiful and ethereal images. Fog creates a light quality unlike anything else and that is really unrepeatable with filters or other post photography devices. You can use the effect of the background disappearing into nowhere as a tool in itself, as in 7-21; it really allows you to make landscapes of the things in the foreground, as the background just becomes this ghostly visage lending some scale.

Foggy days, however, present challenges. In fog, your light meters attempt to expose for middle grey, which creates images that tend to look murky and dark without some adjustments. Try to overexpose a little, maybe 1/3 or 1/2 of a stop. You can then see the soft texture of the light without blowing out any of the whites.

If you are looking for a moodier or spookier look, you can underexpose by 1/2 of a stop or more. When the fog starts lifting and you can see the sun, stop down more to create silhouettes of the subjects against the fog. Direct sunlight coming through fog can create beautiful direct rays of sun. Take care not to overexpose if you are starting to see the rays of light through trees or buildings. To actually see the rays of sun, you need to place them against a darker background for your camera to see them. Also, there must be something in the air such as dust or moisture for the light to reflect off of to create the effect shown in 7-22.

Like many of the overcast situations that I have talked about, the color balance or light temperature of a foggy day is very cool and blue in color,

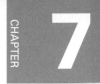
so if you want your pictures to look neutral, you either need to dial in a shade or cloud white balance, filter the lens, or both. A very cool effect might be to dial in an incandescent white balance. Since in a foggy scene you see very de-saturated colors, the blue cast of the incandescent white

balance might make for a very interesting photograph. Shooting in fog already gives a very monochrome look, and using that almost black and white look helps to create layers within the image. As the subjects disappear deeper into the fog they become more diffused and soft, as in 7-23.

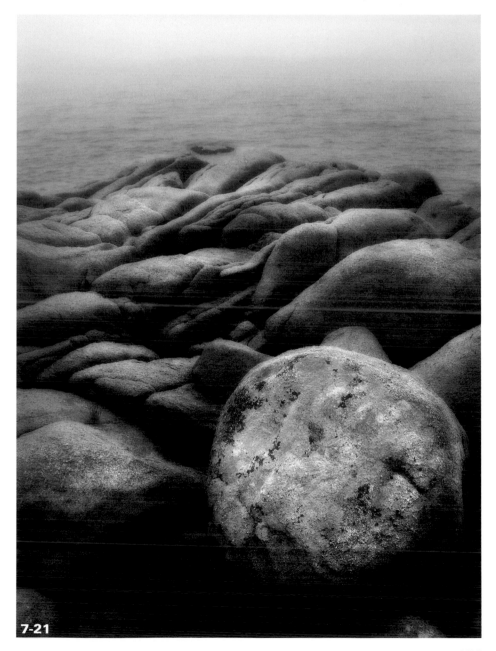

ABOUT THIS PHOTO
Using a compact digital camera on a foggy day, this image was captured at 1/200 sec. at f/5.6 at ISO 100. The soft glowing light of the scene was enhanced somewhat in Photoshop Elements.

7-21

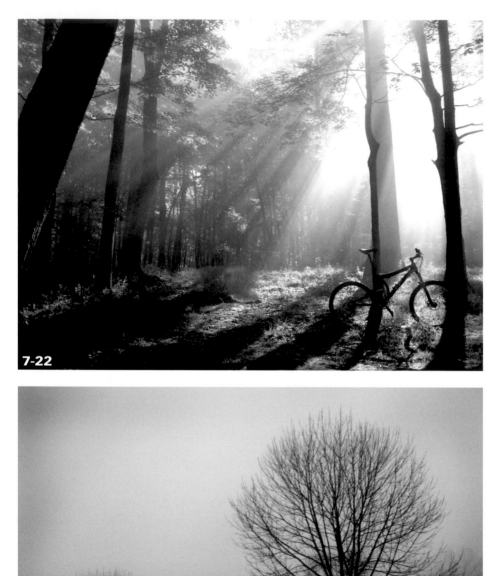

7-22

ABOUT THIS PHOTO

ABOUT THIS PHOTO
*Exposure of 1/250 sec. at f/2.8
at ISO 100 was used to capture
the beautiful rays of light filter-
ing through the trees. Photo by
Jonathan Juillerat.*

7-23

ABOUT THIS PHOTO
*An exposure of 1/1000 sec. at
f/4 at ISO 200 is used in this
foggy image. The contrast of
the dark trees and foggy sky
gives the scene a nearly black
and white feel.*

Assignment

Getting the Best Light from Your Landscape

This assignment is to show you how to better see the ever-changing light over the course of time, especially through the twilight time and to teach you to see how your camera handles those changes. Shoot a sunset at a chosen location. Shoot a number of images of that landscape from 20–30 minutes before the sunset through 20–30 minutes after. See how drastically the light changes throughout that relatively short period of time.

Shooting all the way through the sunset, you can capture so many different colors and various light qualities. I can rarely stay still during a sunset, but it is hard to move too far because the next vantage point may or may not be better. For this particular sunset, the shot needed something. As I looked around to see what else was going on with the colors and shapes, I saw the small boat. By the time I positioned myself, the colors in the sky had changed. I used a graduated ND filter to make the sky darker, which closed the gap in contrast between the sunset sky and the shadows of the beach. Taken with an AF Nikkor 17-35 f/2.8 lens set to 1/2 second at f/9 at ISO 100. Evaluative metering and the camera set to manual.

Don't forget to go to www.pwsbooks.com when you complete this assignment so you can share your best photo and see what other readers have come up with for this assignment. You can also post and read comments, encouraging suggestions, and feedback.

193

DEALING WITH CHANGE: TRAVEL AND ADVENTURE PHOTOGRAPHY

Many people take photographs so that they can travel, and others travel so they can take photographs. Either way, shooting away from home is fun and exciting and full of great possibilities. This chapter discusses topics to help make travel photography easier and more fun. Some of these topics relate directly to lighting, and other things are just good ideas and tips for better photographs.

TRAVELING LIGHT: WHAT TO TAKE

Many photographers begin with a digital camera and one or maybe two lenses. This is great, and in some cases, this is all the photographic equipment that you need. For others, the camera bug can cause you to quickly fill a number of camera bags with lenses, flashes, filters, backup cameras, chargers, cords, and compact digital cameras.

With ever-changing air travel restrictions, it is a good idea to carefully consider your photographic equipment. Even when traveling by car, keeping on top of your camera, lens, and accessories is important. Keep your cameras in a well-protected bag or case, because cameras and lenses are expensive.

Pack your camera ahead of time, not as an afterthought as you are walking out the door. Are you taking a separate camera bag, or putting the camera in your carry-on luggage? Will there be enough room for your camera in your carry-on gear? The last thing you want to happen is for your cameras to ride along with the checked bags in the cargo hold.

Think about the type of photographs that you might want to take and the amount of time that

you will have to shoot. Is your trip specifically for photography, or is it vacation where you may happen to shoot some things, or somewhere in between? Some trips mean once-in-a-lifetime photographic opportunities, and packing for every possible contingency is a great idea. On the other hand, if you are going on a romantic weekend away with your better half, taking a nice compact digital to capture fleeting moments like the one in 8-1 might be sufficient.

8-1

ABOUT THIS PHOTO *This photo was taken with a compact digital using an exposure of 1/125 sec. at f7.1 at ISO 100 nearly at sunset.*

 tip Camera bags look like camera bags. To help prevent theft when traveling, consider alternative transportation for your cameras. Backpacks often allow plenty of space for camera equipment if packed in some pouches or with dividers, and there are even some photo backpacks that don't scream "There are expensive cameras in here!" So, check those other options out.

Gone are the days of having many rolls of film in each ISO and wondering whether it is okay to run film through the x-ray machine at the airport. With digital photography, you can now take a handful of memory cards, which can be x-rayed with no problem, and have every ISO you need. There are also plenty of all-in-one zoom lenses that cover every focal length from wide-angle to telephoto. In many cases, the quality of these zooms is so good that one lens may be all that you need.

STROBES AND SMALL REFLECTORS

Whether you have a large accessory flash or use the flash built into your camera, it is important to bring and use your flash when traveling. Having a flash on hand is nice because you can use it to fill in shadows or balance light when the subject is in shadow, as in 8-2.

Keeping a flash on the camera when hiking, especially near sunset, can be a great tool for brightening a foreground during and after sunset. In many cases, shooting near dusk simply makes the foreground totally shadowed. Adding a little bit of strobe to that foreground can liven up the shot and not only make the foreground interesting, but also the contrast of the brightened subjects and the dark sky generates a very striking image, as in 8-3.

ABOUT THIS PHOTO
The exposure for this image was 1/60 sec. at f/9 at ISO 200 with the compensation set to 2/3. The flash was used to brighten the subject and darken the background when using a compact digital camera. Photo by Jennifer Bucher.

8-2

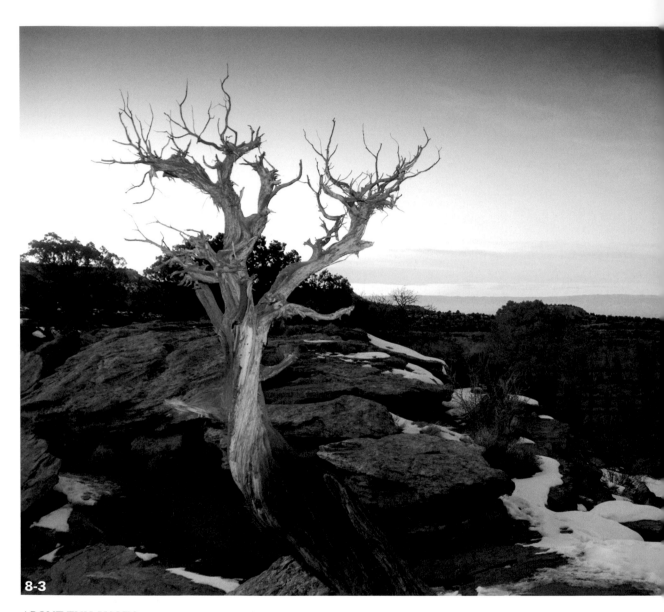

8-3

ABOUT THIS PHOTO *Taken with an 18-200mm f/3.5-5.6 lens, set to its widest. The exposure was 8 seconds at f/4 with −1/3 exposure compensation at ISO 200. f/4 was used to make certain the flash exposure was adequate.*

Flashes are always great to simply capture a price-less family moment. Whether in the daytime or night, sometimes just having a strobe on the camera lets you shoot a great snapshot, but hopefully by working the strobe in with the light that is already there, it is possible for you to create photographs that are much more than just snapshots, as in 8-4.

Small reflectors can either be simple pieces of cardboard or other reflective material, or they can be the small collapsible type. Either can be slipped into a camera bag or backpack for nice fill light when shooting quick portraits. By keeping the reflector in the sun and the face in the shade, the reflector becomes like a second small light source and fills some light into the shadows.

8-4

ABOUT THIS PHOTO *The exposure of 1/250 sec. at f/6.3 at ISO 100 with exposure compensation set to −1/3. The flash does most of the exposure in TTL mode and keeping the shutter at 1/250 sec. makes certain the background doesn't get too bright.*

Small reflectors can also be used to fill in when the subject is in brighter sunlight. Not only can a small reflector take the edge off of hard shadows on subjects such as the flower in 8-5, but also it can used as a small windbreak. Any sort of breeze makes a flower on a stem swing back and forth. Having the reflector to block the wind allows you to keep the flowers sharp.

8-5

ABOUT THIS PHOTO *With the hard sun hitting the flower, a tiny bit of fill light from the reflector brightens up the shadow side. The exposure is set to 1/640 sec. at f/5.6 at ISO 200.*

MEMORY CARDS AND ON-THE-ROAD BACKUP

Depending on your camera, you could have any one of four or five memory cards, but in most cases, if you have a digital SLR, you use CompactFlash cards. If you have a digital point and shoot, the camera uses secure digital cards. CompactFlash cards come in sizes from 16 megabytes, which is really not even enough for one RAW image, to 8 gigabytes, which, depending on the resolution, can hold several hundred images. A 1-gigabyte memory card holds about 50 RAW files from a 10-megapixel camera.

The storage sizes for Secure Digital (SD) cards are similar, but the sizes of SD cards are markedly smaller than CompactFlash cards. SD cards are about half the size and half the thickness of CompactFlash. Similar in size to the SD cards are the Sony Memory Sticks. Olympus cameras use XD (Extreme Digital) memory.

It is important not only to have the proper card for your camera, but also to make sure its capacity is adequate to your needs. Make sure that you have enough cards or cards with enough capacity to capture all the photos you want to take before backing up the images. Certainly, it would be pretty terrible to get to the end of the day and not have enough room for sunset images like the one shown in 8-6.

Losing travel and vacation photos is extremely disappointing and disheartening whether they are accidentally deleted or you miss a shot because the cards are full. Trying to find new memory cards at vacation spots can be expensive or impossible. Try to think through the different options for image backup before you leave. Additionally, it is a good idea to try new equipment out before you leave.

ABOUT THIS PHOTO
*This photo was taken with a
20-35mm f/2.8 lens with an
exposure of 1/45 sec. at f/9.5 at
ISO 200 and the white balance
set to shade.*

8-6

Try to anticipate just how much you may
shoot and how long you will be gone. If you are
considering taking a laptop, make sure you have
enough space on the drive for the photos. For
those who are extremely paranoid about losing
their digital images, there aren't enough backups.
Saving the images to the laptop and then an
external hard drive, burning them to a backup
recordable media, such as a CD or DVD, and
then uploading the favorites to a remote server is
not too far fetched for a professional. Even send-
ing backup discs home is not a terrible idea if get-
ting through security in a foreign country seems
sketchy.

Saving so many copies while traveling may be
overkill, but making sure that you have at least
some way to save your digital images is very
important. The laptop is a great option but can
be burdensome. A number of stand-alone hard
drives let you download the photos directly to the

drive from the memory card without a computer.
These run from $100 to several hundred depend-
ing on the memory, screen (or not), and the bells
and whistles. There is even an adapter available
that allows you to download your memory cards
to your iPod.

BATTERIES AND POWER SUPPLIES

By the time you get the charger for your digital
camera, charger for the rechargeable batteries
for your flash unit, cable for a card reader or a
cable to upload images to the laptop, and the
power cord/charger for the laptop, you have quite
a mess of chargers, cables, and cords. Not to men-
tion the chargers for things like cellular phones
and mp3 players.

Here are some tips and useful information to
make your travels with camera equipment
smoother.

- **Make sure that you have all the cables and chargers that you need.** Make a checklist of the devices to take and then place the appropriate charger or cord in a plastic bag or pouch. Keep the list with the chargers and cables so you can make certain that nothing gets left in a hotel room. Labeling the cords with some tape or labels, or even just numbering them can also help you keep on top of your cord situation.

- **Pack a small extension cord with a multi-outlet end or even just a 3-way adapter.** This allows room for additional plugs and can be very helpful. A day of shooting in a small hotel room with minimal outlets, or outlets behind the bed or in the bathroom can mean not enough outlets for the things that need to be charged. It is important to keep everything charged up because in some places, it is simply impossible to get things recharged, as in 8-7.

- **Use rechargeable batteries, particularly AAs.** This can be a great cost savings as opposed to regular alkaline AAs. Although the initial investment may seem big, if you go through a lot of batteries, the return on investment can be realized in just a few months. Both for compact digital cameras and flashes, the NiMH (nickel metal hydride) rechargeable AAs last far longer

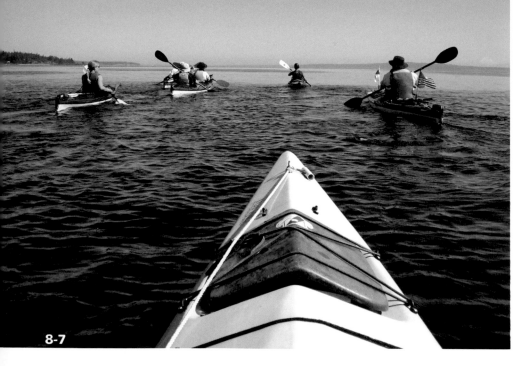

8-7

ABOUT THIS PHOTO
Keeping a full charge on your compact digital camera usually allows for shooting through the bulk of the day especially in situations where you can only take the bare minimum. 1/500 sec. at f/5.6 at ISO 100. Photo by Jarod Trow.

tip

Some information on the different power outlets can be found at www.kropla.com/electric2.htm or www.walkabouttravelgear.com/wwelect.htm.

than their alkaline counterparts, can be charged anytime and have the longest life (you can charge them hundreds, if not thousands of times).

Rechargeable batteries are also better for the environment than trying to dispose of all those alkaline AAs. There are plenty of rechargeable options both online and at the local electronics stores. The AAs with a capacity of more than 2,000 mAh (milliamps) are better, but more expensive. As with so many things, spending a little bit more up front may be more economical in the long run as the higher capacity mAh lasts longer between charges. This means that they have to be charged less, meaning they have a longer useful life; the additional capacity might mean the difference between getting a shot or having the batteries give up on you.

■ **Consider the power requirements when traveling abroad.** If you are traveling internationally, don't forget to look into what sort of power the countries that you are traveling in will have. Each part of the world seems to have its own style of plug, and many even have a different voltage. Plenty of adapters and converters are available for international travel power needs.

■ **If it is cold, remember to keep your batteries warm.** Extreme cold weather can wreak havoc on batteries. Keep this in mind and keep

batteries as warm as possible as long as possible by keeping them close to your body, and if possible, inside your coat. Make sure that you have enough extra batteries with you, or at the very least make sure that you have a fully charged battery before heading out into extremely cold situations, such as in 8-8.

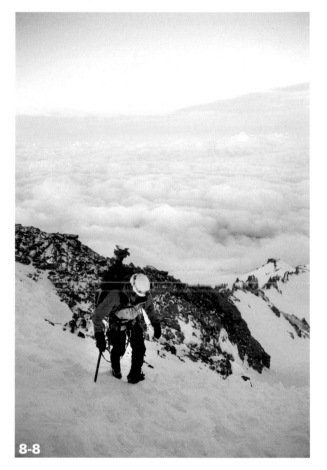

8-8

ABOUT THIS PHOTO *Extreme cold is a challenge for even the best batteries. Take plenty of batteries and keep them close to your body to maintain their charge. This photo was taken at 1/250 sec. at f/3.5 at ISO 200. Photo by Jarod Trow.*

SHOOTING STREET PHOTOGRAPHY

Each city has its own sense of life and dynamic, even when many of the buildings, parks, and landmarks are in reality very similar to other urban and suburban areas. Nowhere is this more apparent than in street photography. The uniqueness of each different locale also helps photographers to see everyday things fresh when traveling.

CANDID SITUATIONS

Taking photos on the street is similar to shooting candid photos of friends and family; keep your camera always ready to shoot, so that when a great shot happens you are prepared to capture the image. Using black and white for street photography often makes a photograph look timeless, as if it could have happened yesterday or 50 years ago, as in 8-9. Using black and

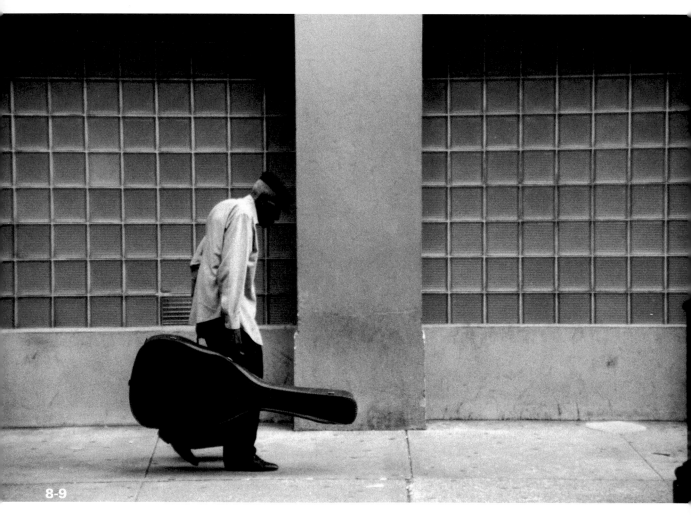

8-9

ABOUT THIS PHOTO *Black and white images can be created in the computer, but many cameras have a black and white option. This image was taken with the latter with an exposure of 1/125 sec. at f/5.6 at ISO 400.*

white can also help mask distractions in a scene like colorful trashcans or the like. Black and white can enhance the mood of a dreary day, or it can accentuate contrast and excitement on a sunny day.

Using a telephoto lens allows a photographer to capture moments unnoticed that otherwise might cause people to look too posed or staged if they know you are there. Although after a photographer is there for a while and becomes part of the scenery, people tend to forget and go back to their business. When watching things happening on the street, take a look at what others are watching; interesting photos might be all around as in 8-10. Using a fast aperture with your telephoto lens, such as f/2.8-f/5.6, might isolate a subject against a background, putting further focus on that subject.

SETTING UP A SHOT

In many cases, taking a few minutes to set up for an image or waiting for a while for the shot to develop can help create more dynamic shots. Mostly this means waiting for people to enter the scene or to begin moving into the scene. The color in 8-11 is vivid but without the wave of the conductor, the image feels flat. Using a cloudy white balance when shooting on an overcast day lets the colors of the scene be true to life.

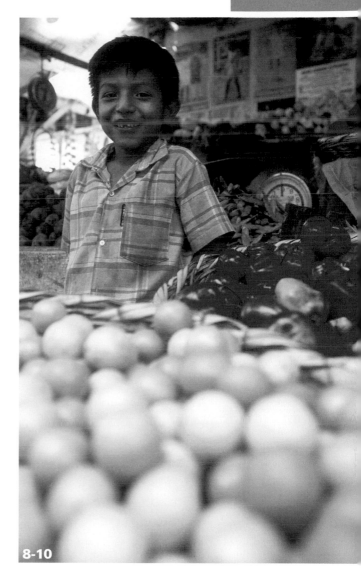

8-10

ABOUT THIS PHOTO *A zoom lens can help you to get many different views inside of a scene. An exposure of f/2.8 at 1/500 sec. at ISO 100 captures this wistful smile inside of this marketplace.*

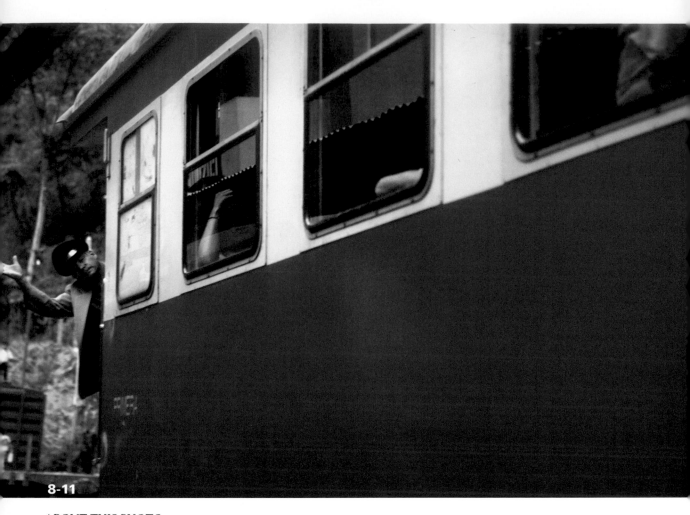

8-11

ABOUT THIS PHOTO *An exposure of 1/125 sec. at f/5.6 at ISO 200 was used for this image. Because of the flat light and overcast sky, using the evaluative meter and Aperture Priority allowed the action to unfold without having to worry about exposure.*

Taking some time to wait on a shot also gives a photographer a few moments to try different exposures and white balances to determine what might be right before any action happens. In 8-12, using +2/3 exposure compensation makes the white marble of the U.S. Capitol appear totally white, giving the scene a very high contrast look. Waiting and trying different exposures gets you ready for when action does happen. By waiting for the action, the urgency of the man in the suit creates tension with the massive and solid feel of the building.

ABOUT THIS PHOTO
*Using an exposure of 1/125 sec.
at f/9 at ISO 100, along with
exposure compensation of
+2/3, creates a brighter scene
with more contrast than if
shot right at the recommended
reading.*

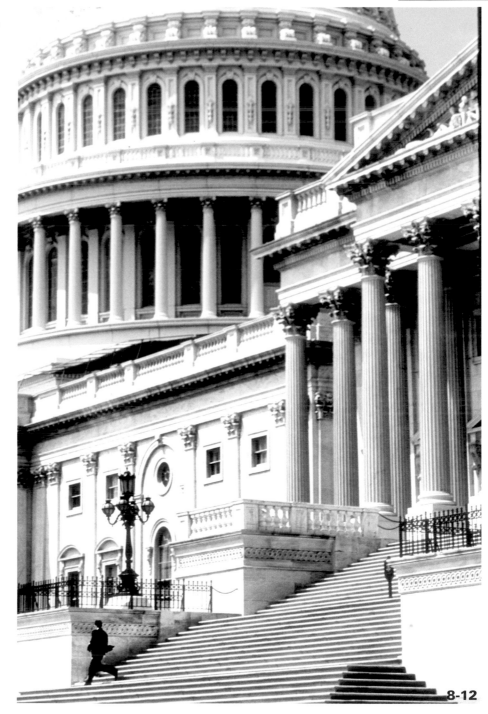

8-12

PAYING FOR PHOTOGRAPHS

When shooting indigenous people in their native garb, sometimes they ask to be paid for having their photographs taken. In many places, the locals even dress up and go to places of interest in order to have their photos taken and be paid. At festivals and the like, great photo opportunities usually present themselves as in 8-13.

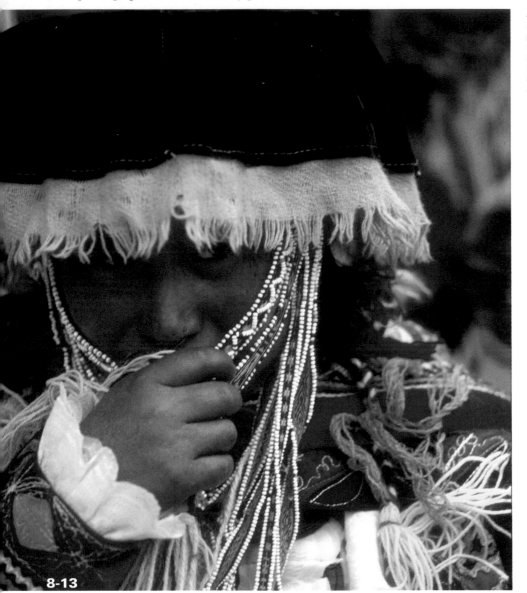

ABOUT THIS PHOTO
Using an 80-200mm f/2.8 lens gets in close to the subject while overcast skies allow the light to be soft enough to see underneath the hat. The exposure here was 1/250 sec. at f/4 at ISO 200.

8-13

When many people are about, you might be able to take photos unobtrusively, but there are those whom are still looking to be paid. Obviously, this can be a tricky situation. In most cases, the amount of money that they demand is usually minimal and is probably worth far more to them in terms of quality of life than to you.

One problem with paying for photos, though, is that it often causes the subjects to look stiff as they usually smile at the camera. Taking more time and generating some sort of a relationship goes a long way. Candy may be a better bribe for some children, but even letting them look through your camera (you hold onto the camera, just let them look through the viewfinder) will engender trust enough to yield more exciting and natural photographs, as in 8-14. Smiling helps, too!

CAPTURING THE ESSENCE OF PLACE

As much as travel photography is about far-off cities, landscapes, and peoples, it is also important to capture some of the intricate details of your travel. These details become part of the story of your travels just as much as a grand sunset, because they establish some of the texture of the trip.

The lighting is also important, because it helps tell the story of what the conditions were like at that location at that time. The blowing flags in 8-15 show just how windy it is, and even with fleeting sunlight, it still has a cold feeling because of the wind. Using the lines and color help make this a successful and exciting photograph, and it could have a place on the wall or in a digital slide show to help establish the location in the story of this trip.

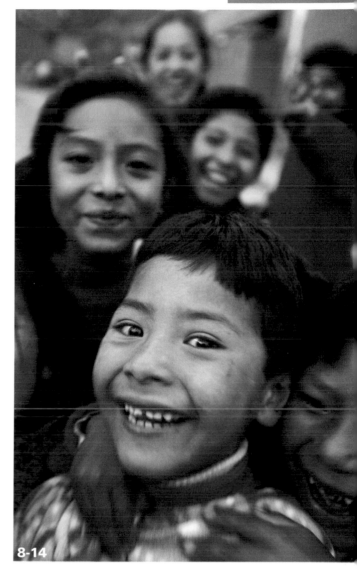

8-14

ABOUT THIS PHOTO *This exposure was 1/45 sec. at f/4 at ISO 100 using a Nikkor 12-24mm f/4 lens late on an overcast afternoon. Getting up close to the kids after trying to talk in their native language made the photographer into a clown.*

Capturing color also helps to show the essence of place. The soft light that wraps around the blue column in 8-16 shows the many different shades and tones of blue. At another time of day, this column could have been lit so that it would be just too dark and too light. Looking for softer light lets the viewer see the richness and texture of the blue.

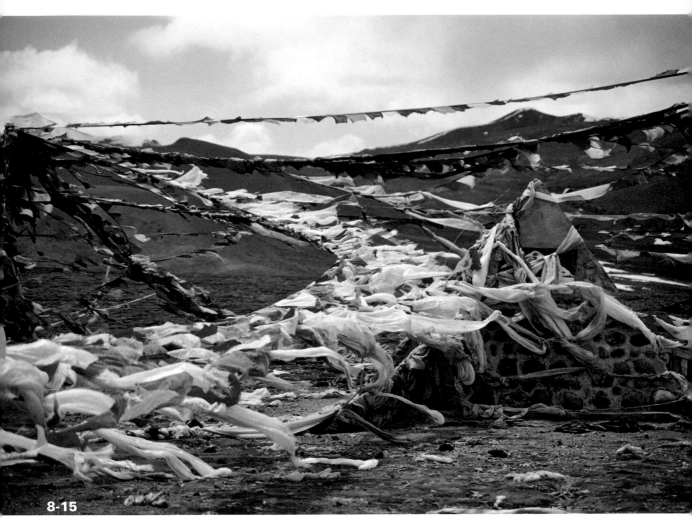

8-15

ABOUT THIS PHOTO *A wide-angle lens gets the line of prayer flags to come right to the camera. The exposure was 1/125 sec. at f/8 at ISO 100 using the sunny white balance. Photo by Jarod Trow.*

8-16

ABOUT THIS PHOTO *Using the standard daylight, white balance in the shade, increases the richness of the blue. The exposure for this image was 1/125 sec. at f/4.5 at ISO 100.*

MUSEUMS, CHURCHES, AND OTHER INDOOR DESTINATIONS

Shooting inside many locations creates additional difficulties besides just the basic limitations of the light. The management of most churches and museums do not want visitors and tourists to be using flash inside or to be setting up tripods. Tripods are cumbersome and a general hazard when set up in the middle of a tour group, and the chance of a stray tripod leg knocking over a priceless piece of art is just a far too realistic situation.

Flash photography is not permitted in many locations because even those short bursts of very bright light, although seemingly inconsequential, when repeated hundreds or thousands of time every day can start to wash out the color and detail in art. This is a very real problem for archivists. The U.S. Declaration of Independence began to have serious fading after just 40 years due to improper storage, and today, it is virtually unreadable.

Most digital cameras have extended ISO settings — meaning above 800 ISO. If you truly need to take photographs inside such places, set your ISO high enough that the shutter speed is fast enough to prevent the affect of camera shake; the aperture needs to be set to its most open available setting. In most cases, enough light is hitting these subjects that reasonable exposures can be made, as in 8-17. Get physically close to your subject because with many zoom lenses, as you zoom in (closing the aperture), more light is required.

When shooting inside churches, especially the very old European ones, the light level is very low. Any light inside them is generally from small windows or spotlights. Use higher ISOs to be able to keep the shutter speed high enough; try to find someplace to brace your body, like a door frame or wall, not a sculpture. By bracing your body against something solid, you can make the wall

part of your own personal tripod to steady you. If pools of light are available, such as near an altar, look to use a spot or center-weighted meter so the dark areas of the scene won't affect the meter reading as much. Feel free to use the exposure compensation to make the scene darker, more like what you are actually seeing; otherwise, a meter might just wash out a scene too much in its attempt to tell you what the average is.

Other indoor places, such as market places, are often helped greatly with the inclusion of the people and things that make the location unique. Lighting in 8-18 largely comes from sunlight diffused through a red tarp. Leaving the white balance at daylight lets you see better what the light temperature is doing without any additional warming. In this case, a cool daylight rim appears on the woman's cheek.

8-17

ABOUT THIS PHOTO *The exposure was set at 1/30 sec. at f/2.8 at ISO 400, and the white balance was set to automatic to balance out multiple light sources for the lobby of this building.*

8-18

ABOUT THIS PHOTO *An exposure of 1/60 sec. at f/2.8 at ISO 100 was just enough light to capture this rich red filtered light. Metered with the evaluative meter and set manually.*

CONSIDERING THE WEATHER CONDITIONS

Just like you would check the weather of the day before you sent your kids to school so should you check the general weather and climate of the places to where you are traveling. It was only a few years ago that finding that climate information meant a trip to the library or bookstore, but with the wealth of information available over the Internet or the Weather Channel on most people's cable networks, you can now get a 10-day forecast for virtually anyplace on the planet.

You can even find out the sunset and sunrise times, high and low tides, and whether you should pack a parka or a bikini. Knowing those things might get you out of bed a little earlier than you had planned for during your vacation, but getting up early and grabbing even just a compact digital, you can find exciting scenes that others will never even see, as in 8-19.

ABOUT THIS PHOTO
Montana in February at 7 a.m. makes for a very chilly morning, but taking the time to find out when sunrise is yields great results. Exposure was 1/80 sec. at f/5.6 at ISO 100. Exposure compensation set to –1.

8-19

Take advantage of the ability to quickly find out the sunrise or sunset and the weather for your photography, and even more so for your comfort while traveling. Knowing that you may be at the edge of rainy season might get you to pack your rain gear, just as it also keeps you looking for scenes such as 8-20.

Being near a beach does not guarantee days of hot sunshine. Keep on top of the drama of the weather patterns that happen where you are traveling. Knowing that large thunderstorms roll in sometimes in the afternoon can create very exiting backgrounds, as in 8-21.

Even after a storm rolls through, the light can create amazing colors and textures as in 8-22. Be ready for much softer and more pastel light as the light gets low in the horizon or has already set. It may even mean using much higher ISO speeds if a tripod isn't handy.

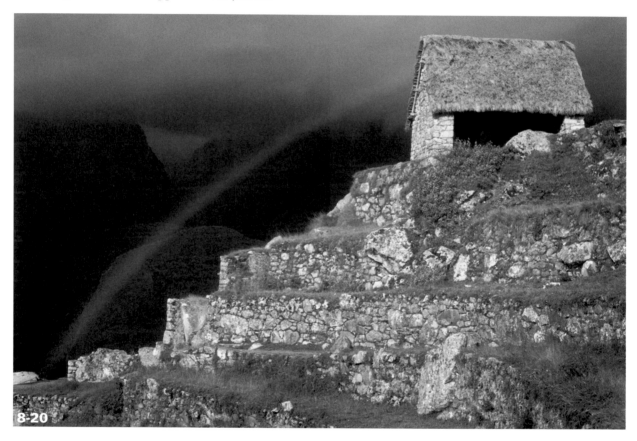

8-20

ABOUT THIS PHOTO *Where the rain and sun meet, there is almost always a rainbow. Exposure was 1/125 sec. at f/8 at ISO 100 with the white balance set to daylight.*

ABOUT THIS PHOTO
The exposure of this image is 1/640 sec. at f/8 at ISO 100. The massive thunderhead coming toward the sundeck creates very interesting tension in this photo with beautiful light. Photo by Jarod Trow.

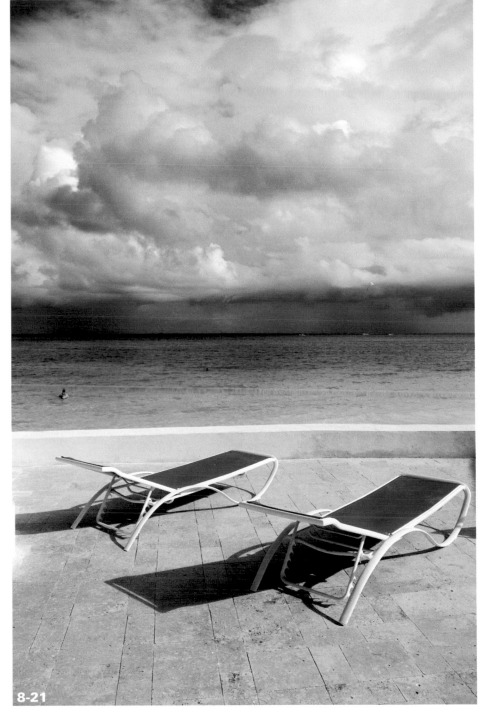

8-21

8-22

PREPARING FOR EXTREMES

Earlier in this chapter, battery life during extreme cold was mentioned. Cold weather does a lot more things than just sap the power out of the batteries. Extreme heat is no better for cameras. Humidity is terrible. And, moving equipment quickly from cold to hot is the worst as condensation can develop on the camera and on the glass surfaces, mirror, and sensor. Most digital cameras are relatively rugged, but rarely are they designed for more than occasional bumps.

The following list offers some useful information that should help you treat your camera better in weather extremes.

■ **Extreme heat can affect the moving parts of the camera, mostly the shutter.** It can cause moving parts to expand. Most digital cameras have specified operating temperatures of 32°F to 104°F or 0°C to 40°C. In many places, people spend plenty of time beyond those parameters. Obviously, if the camera is subjected to temperatures beyond the recommended parameters, it won't immediately shut down, but knowing what the limits are can help you keep your camera inside of the limits as much as possible.

■ **Keep your camera with you when the temperature outside starts inching toward triple digits.** Leaving your camera in a car, where temperatures can reach as high as 140 degrees very quickly can damage the sensor, increasing the noise that the sensor captures even at very low ISO speeds.

■ **Keep your camera clean and dry.** Shooting in the desert can make for amazing photographs as in 8-23, but the heat makes a photographer sweat. The salt and other minerals in sweat can be corrosive, so try to keep your camera in some sort of pouch or case as opposed to just holding it or hanging it from your shoulder.

■ **Water getting into the camera can cause havoc to the electrical system and can promote the beginning of corrosion.** So, keeping your camera away from humidity is important.

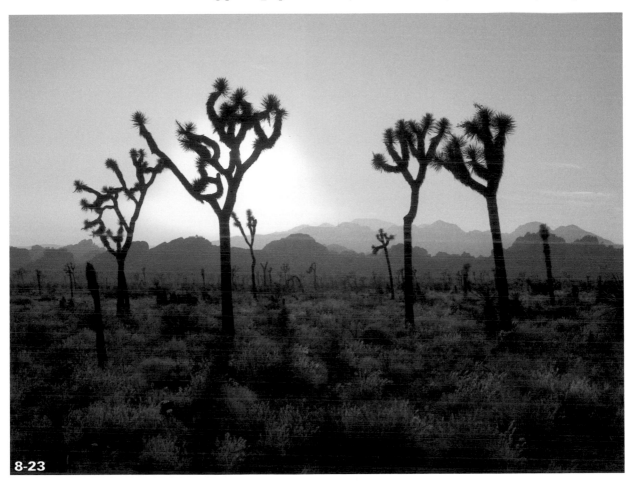

8-23

ABOUT THIS PHOTO *Using the visual heat of the sun as a backlight for the Joshua Trees and increasing the white balance warmth makes the scene appear very hot. Exposure was 1/320 sec. at f/11 at ISO 100 with exposure compensation set to −1/2.*

By no means does that mean you should stay away totally from water, as you might miss out on images like the one in 8-24. But you should make certain that if some water spray does get on the camera, you wipe it down as soon as possible. If you are traveling in wet weather, keep a towel in your bag to wipe the camera down. If you must shoot in wet weather, use an extra large plastic bag to put your camera in and cut a hole in the bottom to make a quick rain shield for your camera. Also, don't immediately discard the desiccant packets that come with the camera bag; instead, leave them in the bag to help keep the insides of the bag from getting moist in extreme humidity.

8-24

ABOUT THIS PHOTO *Using an exposure of 1/10 sec. at f/22 at ISO 200 and exposure compensation of −1/2 creates a nice blurred water effect with the reflection of sunlit mountains causing colorful highlights.*

■ **Protect your camera and gear from the cold.** Blowing snow is really just blowing, frozen rain. Use a case like the one around the neck of the hiker in 8-25 to allow easy access to the camera and adequate protection between shots. Keep additional batteries inside a jacket to keep them warm and with a full charge.

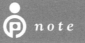 *note*

Blowing snow brings lighting problems because of the massive areas of white around the subject. Most light meters want to render the white of the snow too dark and grey. Additionally, the flat light from the storm diminishes the contrast so much that even the auto focus may have trouble finding focus. This may happen even more in lower light and during sports like skiing.

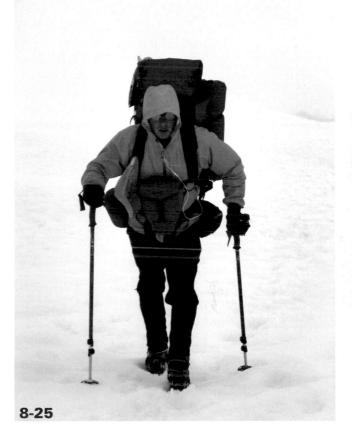

8-25

ABOUT THIS PHOTO *Keeping a form fit camera case strapped to your chest during extremely cold situations keeps the camera relatively safe and easily accessible. The exposure was set to 1/1000 sec. at f/5.5 at ISO 200. Photo by Jarod Trow.*

■ **Knocks and bumps can cause even more havoc than weather extremes.** In most cases, all that is needed in extreme weather is to get the camera to cool down or warm up and it resumes normal function. However, a camera that meets concrete or rock might not fare as well. Keeping your camera strapped on and close to your body can help it from swinging out and meeting a hard place. Using one of the auto modes also can help when dealing with difficult situations; only one hand is needed to operate the shutter release and the auto-focus button. Even working the exposure compensation one-handed operation is possible with many digital cameras, as shown in 8-26.

Being comfortable with the operation of your digital camera and keeping it safe and protected can allow you to easily operate your camera in situations where many people could not. Any time you add a camera to a climb, a hike, or so on, you are adding difficulty to your task. Use your camera regularly and often to keep on top of its operation so that when you get into a difficult situation, it will be old hat. Keep an eye on your light when you are on your adventures. By looking for angles, shapes, and the light that works with them, you are ready for shots like 8-27.

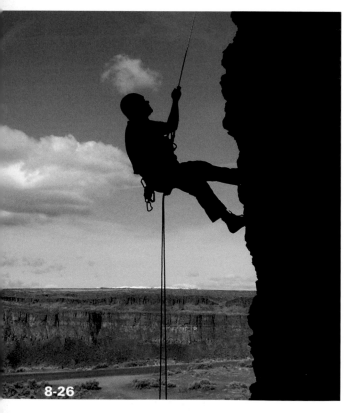

8-26

8-27

ABOUT THIS PHOTO *A digital camera in a pouch close to the body makes for a quick shot when hanging from a cliff. The brightness of the daylight and darkness of the climber create a dynamic silhouette. 1/430 sec., f/5.6 ISO 100. Photo by Jarod Trow.*

ABOUT THIS PHOTO *A quickly setting sun creates a perfect situation to show a dynamic landscape with the bluest of skies. Exposure set to 1/500 sec. at f/8 at ISO 200. Photo by Jarod Trow.*

Assignment

Capturing the Personality of a Community

Your assignment is to take street photography. Find a location that allows you to be relatively unnoticed, yet able to view people as they go about their normal activities. You don't want to use a flash, because it is distracting to your subjects and prevents you from getting the most candid shots. Choose a photo that displays interesting lighting conditions. For example, you might be able to get a silhouette of a person or show the sun or a street light hitting your subject's face in an unusual way.

To complete this assignment, I chose this image of a couple walking through an art museum. The light in this place is simply amazing. With of all the sunlight, there are bright highlights everywhere. The building is white too, so all the harsh sunlight is filled in by the light reflecting all over everywhere. This couple was simply walking across the space and provided a perfect focus for the shot. I used a spotmeter to take my initial reading and then overexposed the scene further to increase the brightness. I took this image at an exposure of 1/60 second at f/5 at ISO 200 using a Nikkor 20-35 f/2.8 wide-angle zoom.

Don't forget to go to www.pwsbooks.com when you complete this assignment so you can share your best photo and see what other readers have come up with for this assignment. You can also post and read comments, encouraging suggestions, and feedback.

STILL LIFE AND MACRO LIGHTING

You face special challenges when lighting objects that are close-up and still-life groupings. Many of these challenges have to do with light quality and quantity, as with most subjects. But with macro photographs, the challenge grows as the subjects get smaller.

However, when shooting some small, nonmoving subjects, lighting can become simple, because you are able to better control the light. This could mean anything from pulling a drape open or closed, to using a reflector or strobe, to bringing a lamp in from another room. In some cases, still life and macro shots entail putting your camera on a tripod. This can be both to make certain the composition is perfect and because it is often necessary to use long shutter speeds. This chapter delves into some basics of design for still-life photography as well as offering insight into lighting those close-ups and macro shots.

CAPTURING GREAT LIGHT IN YOUR EVERYDAY LIFE

Take a look around your home, your office, and the places that you go often; great photos and great light are everywhere. In many cases, your familiarity with the subjects can make you overlook very interesting photos. This can happen both inside your house or office, just the same as the city or town that you live in. That is why traveling is so fun; it is all new and different.

These everyday things are still-life compositions. They don't have to be totally still, because what they do show is character and, of course, life. Sometimes, a still life is just created by happenstance: Someone put something somewhere, and the composition is just right. A still life need be neither large nor small, but it might be interesting to look deeper into the scene and deeper into your life and see just what photographic delights are hidden when you start to look at things very closely.

Looking at the same old things might seem boring, but trying to see them differently can be very interesting. The light is always changing, so keep looking at things, move them around, change your perspective, and get closer. You can find a vast array of new subjects to shoot right in front of you. Getting low lets the camera see the gradation of the light on the wall, from bright to dark as it gets darker closer to the ceiling. Moving the camera or the chair to capture a little bit of reflection brightens the slats of the chair and darkens the edges, giving those lines more contrast and drama.

No matter what time of day or what the weather is, light interplaying with color and texture is all around. The nice part of shooting close to home is that you can visit and revisit places easily and see how things change depending on the time of day. On overcast days, the colors may be more muted, and looking closer you might notice that some very nice contrast exists because of the soft light. In 9-1, the post of the stair rail has some very interesting detail, and the lights and darks give this very flat subject a lot of dimension.

Take time to look at the colors and textures as you look deeper into your environment. Observing the contrast of the subject can help to determine how to shoot something. Less contrast provided by more indirect light can really be optimal for small details and textures, as in 9-2.

A small, but definite, difference exists between indirect and soft light as this photo was taken in shade, but a hard light source is definitely nearby as evidenced by the dark shadows and the direction and contrast to the light.

9-1

ABOUT THIS PHOTO *Using a 105mm f/2.8 Micro Nikkor lens allows you to crop close to a subject easily. 1/60 second at f/8 at ISO 100.*

9-2

PRINCIPLES OF DESIGN

Using some of the elements of design in photographs is useful to help create interesting and dynamic photographs. These elements are also great building blocks with which to build your artistic sense. Photographs that have good design principles often simply look right, or better than ones that do not.

Now that you have worked so hard on finding and creating good-looking light, it is time to look a little deeper into how the composition of a photograph works.

■ **Emphasis.** The focus or subject of the image is the emphasis. It can be larger, but in photography, you can also use depth of field to help define the emphasis.

■ **Balance.** By placing one large item against several small ones, you can create balance; even using negative space (where there is nothing) on the other side of where there is something helps create balance.

■ **Repetition.** By repeating something in the image, you can make the scene more active. Repeating something also can create a pattern.

- **Rhythm.** When intervals between elements are similar in size or length and then are used to create organized movement within the image.

- **Proportion.** The image has more unity when the elements appear to have similar proportion. Using different lenses, you can create unreal proportion to create stronger emphasis.

- **Movement.** Using compositional elements to allow the viewer's eye to flow freely within the image or to direct the eye toward the emphasis.

- **Contrast.** Juxtaposing different elements against each other, dark and light, soft and hard, vertical and horizontal, and so on.

This is obviously a very abbreviated directory of these principles. When you are trying to create better photographs, evaluate these principles within your compositions. Look at other people's photographs as well and see how the elements work within the photographs that you like.

Repetition is often used to create dynamic photographs of many different things. Lighting can help create repetition, because the light helps define the shape of the subjects being repeated. In 9-3, the object being repeated is the bodies of the fish, but if you squint your eyes and look at the image, you see the lines of light and black created by the highlights on the belly of the fishes and the shadows as the dark backs of the fish go away from the light. The fish head is there for emphasis.

9-3

ABOUT THIS PHOTO *This image was exposed at 1/60 second at f/5.6 at ISO 100 with a 28-70mm f/2.8 lens. The main light came through the awning into the fishmonger's booth, and the highlight on the main fish came from a tungsten work light.*

Using the contrast of subject matter within a photograph brings balance into the composition. Dissimilar subjects together, even when intertwined, can bring excitement and even irony into a photograph. In 9-4, a number of contrasts are

evident, hard and soft, dark and light. Both the contrast of the soft shapes of the flower and the hard edge of the jewelry, and the dark edges and shape of the bracelet wrapping around the white glow of the flower create a very interesting image.

The lighting accentuates the contrast, shape, line, and balance. The medium background that gradates into dark sets off both of the subjects. The light is a mix of tungsten spotlights and available window and skylights. The light is generally indirect, but not too soft. The light is hard enough to show definition in the flowers but not enough that there are any black shadows. This mixed light comes from the source, the skylights letting hard light into the room, but not really anywhere close to the subject.

ABOUT THIS PHOTO *A close-up image with a shallow depth of field isolates these subjects from a very blurred background. 1/80 second at f/6.3 at ISO 1600.*

Sometimes, not only can a common item become a very interesting abstract, but interesting lighting can also set it apart even further. High-key lighting is generally lighting with a white or light colored subject in front of a white or light-colored background. This type of lighting is often done in a studio setting with studio strobes making the scene very bright. In 9-5, the scene is simply very overexposed. But the overexposure actually makes the photograph work because if the image was exposed normally, it would look just like any other shower head in any other bathroom. The showerhead has very interesting nozzles, which made for a cool rhythm, and their angle makes the image feel as though it has movement. Again, the shallow depth of field helps to focus the eyes on just a part of the subject, and the out-of-focus parts give shape to and build on the rhythm.

The light came from a studio strobe that was simply overpowering. This light created a scene so bright that there is no black whatsoever. The light is very hard, but it bounces all over and everywhere creating its own fill light on every side of the showerhead. I did say earlier in the book that overexposure in a photograph would result in trouble as it is nearly impossible to overcome in the computer as all of the detail would be too blown out, and the scene would have too much contrast. Well, you have to know the rules to break the rules. Overexposing by about 5 stops can cause very large problems in a regular scene, but it can accentuate a scene that is already interesting and abstract.

A low-key image happens when more contrast and drama are in the image. Usually, low-key images have a darker subject over a darker background. The light for low-key photography is more of a dramatic side or backlight, although

ABOUT THIS PHOTO *This exposure was set at 1/40 second at f/4.5 at ISO 100 using a Micro Nikkor 105mm f/2.8 lens. The camera was exposed in manual mode. The proper exposure with the strobe might have been 1/125 second at f/11.*

9-5

having a bright subject among a dark scene also is considered low-key. Using an ordinary on-camera flash to light up the lid of an ordinary crock pot creates the unusual photograph in 9-6. The texture of the condensation on the inside of the lid and brightness of the handle against the darkness of the inner wall of the cooker have great contrast and balance. Having the lid just above the center of the frame and cutting just into the darkness also makes the handle pop out of the scene, giving it further dimension.

ABOUT THIS PHOTO *The strobe was on top of the camera but bounced into the ceiling. The light on the ceiling and cabinets creates the bright highlight on the handle. 1/60 second at f/5.6 at ISO 400.*

9-6

Using the contrast of color, especially when the colors are red, blue, and yellow, brings even more excitement and movement to a photograph. This is one reason that so many photographers are so moved by the American Southwest. The rich red rocks against the cobalt blue skies make for very dramatic images.

Interesting lighting can easily make the most banal of subjects beautiful and dynamic. Find shadows and lines and use them to create tension and contrast in a scene that might otherwise be overlooked. By incorporating the interesting lines of shadows from dramatic backlight with the simplicity brought in by a new snowfall, even an old chain link fence can become an exciting photograph, as in 9-7. This simple image of a very ordinary subject can be a great design study. Take a minute to digest this image and then take a look at the image dissected into the design principles in the following list.

- **Balance.** Many short lines against what appears to be just a few very long lines.

- **Contrast.** The warmth of the snow on the other side of the fence against the cool blue of the snow with the fence's shadow.

- **Repetition.** The fence posts and the shadows going on and on.

- **Rhythm.** The posts and the shadows create an angled line that becomes ever more obtuse.

- **Movement.** The lines of the posts and the shadows bring the eye that junction at the ground that makes the eye look back and forth and on the next junction of line.

- **Unity.** All of these things bring the photograph into one strong composition.

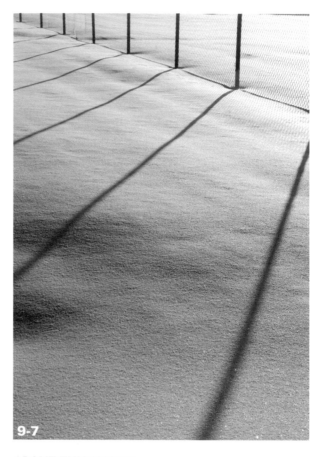

9-7

ABOUT THIS PHOTO *This image photographed at a focal length of 55mm, which is slightly telephoto and is a length that virtually every photographer has. The exposure was 1/100 second at f/11 at ISO 100 with a +2/3 exposure compensation.*

Using these principles along with the ability to see what the light is doing in any scene can help you to be a better photographer. Look critically at the scene, and then when you bring the camera to your eye begin to look around inside your viewfinder, at the top, bottom and sides and see what is in the background, what is the subject. Zoom in, zoom out, tilt the camera, get lower, and get on your toes — each of these things changes the photograph. Do these things until you have the image that you want, and then keep shooting.

LIGHTING FOR CLOSE-UP AND MACRO PHOTOGRAPHY

With each chapter in this book, the challenge has been to look more critically at the light and the scene to determine how the light works best in the scene and how, as a photographer, you can make it better for your subject. In this chapter, the challenge has come from more of the artistic side of photography and how to simply look more deeply into everyday life to create photographs with the light. The next challenge is to look even deeper for close-up photographs.

True macro photography happens when the image on the sensor is the same size or bigger than the subject being photographed. This is determined by the ratio of 1:1, meaning that image size on the sensor is equal to the subject size. Getting even closer would make the ratio of image to subject 2:1, meaning the image is twice as big as the subject. Getting to 1:1 requires either a special lens — a *macro* or *micro* lens — or some sort of additional accessory to the lens or camera that allows these extreme close-ups.

Most zoom lenses have a macro setting or some sort of macro capability. This allows the photographer to get very close to the subject, but probably not actually to the macro level. Macro zooms usually allow a photographer to get close enough for a 1:4 image size-to-subject size ratio. This means that the image on the sensor is about 1/4 the size of the actual subject. This is actually excellent for good close-up photography.

The challenge of lighting such close subjects is often that the camera becomes part of or a distraction to the lighting. It may cast a shadow, and certainly moving in too close totally changes the strobe situation. The angle does not allow for any

light to get there, and the light generally overexposes the scene. The other issue with close-up photography is that the depth of field becomes extremely small. In most cases when the camera is at its minimum focus distance, it is virtually impossible to hold the camera still and keep the focus where you want it. When the subject is at an angle to the camera as opposed to being square or flat to the camera, it is even easier to see the shallow depth of field, as in 9-8.

9-8

ABOUT THIS PHOTO *This image was taken with a Micro Nikkor105mm f/2.8 lens at an exposure of 1/45 second at f/4.5 at ISO 200. Notice how the plane of focus cuts through the image, showing exactly how shallow the depth of field is.*

idea To show just how hard it is to even compose at the minimum focus distance, try this: set the camera to manual focus and turn the focusing ring to the closest focus setting. If you have a zoom lens, zoom the lens to its longest focal length. Find a simple subject, such as your keys or this book, and move the camera in and out until the subject becomes in focus. Don't turn the focusing ring, just move in and out, so that you can see how shallow the depth of field is and at that focus distance, how jumpy the image looks in the viewfinder.

DEALING WITH DEPTH OF FIELD

To get enough light on the subject in most basic macro settings, the best way is to get your camera on a tripod and use some longer shutter speeds than normal. At the very least, the speeds are going to be longer than it is reasonable to hand-hold the camera. The closer that a lens is focused, the more shallow the depth of field is, so at very close focus there is minimal depth of field. Additionally, at the close focus distances when shooting in macro, the ability to hold the camera steady is drastically reduced.

When you are shooting any sort of wide scene, with more of a wide-angle lens, often you are focusing the lens at its farthest focus distance, usually called *infinity*. Infinity focus is the distance where everything beyond that distance is totally in focus. This is how disposable cameras work: The little plastic lens is created to have an infinity focus of about 4 feet, so that most things you would shoot are already in focus. The farther away the subject, the more depth of field you have. Close focus is the opposite. The closer you get, the less depth of field you have. So when you

ABOUT THIS PHOTO *This image was photographed at 1/40 second at f/8 at ISO 100 with a Micro Nikkor 105mm f/2.8 lens. The lens was set to its closest focus setting, and then the camera was moved into focus using a tripod.*

ABOUT THIS PHOTO *Increasing the aperture of the exposure to 1/6 second at f/22 at ISO 100 increases the depth of field by a factor of 2, but it took almost three f-stops to do it.*

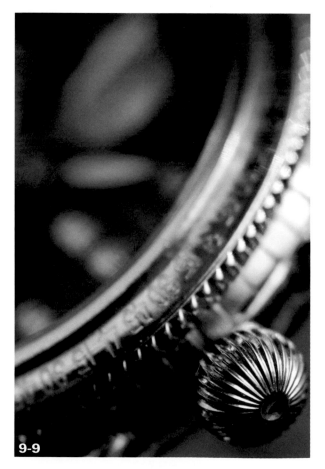

9-9

9-10

focus close, even with a very small aperture, the depth of field stays very small.

The stop watch in 9-9, 9-10, and 9-11 is shown with increasingly small apertures and increasing depth of fields. Notice in the first image that the depth of field is really limited to just the crown of the watch, and even the bezel is soft. The depth of field here is probably 5 millimeters with an aperture of f/8. When the f-stop is set to f/22, the depth of field gets substantially greater, probably

as much as 10mm. Even at f/51, in 9-11, the depth of field is less that 1 inch.

In many cases, the lack of depth of field actually helps the image. It helps in a similar way to how shallow depth of field works with portraits. The main parts of the image are sharp and well defined giving them importance, and some of the less important things fall away and become soft as in 9-12.

ABOUT THIS PHOTO *This image was exposed at 1/100 second at f/6.3 at ISO 100. The shallow depth of field keeps the toes and parts of the body in focus, while parts of the legs go soft. Photo by Holly Jordan.*

ABOUT THIS PHOTO *Even at near the maximum aperture of f/51, with a shutter speed of 1 second at ISO 100, the depth of field increases by about 50 percent, and it took 2 1/3 f-stops more to get there.*

9-11

9-12

CREATING LIGHT FOR MACRO SITUATIONS

Getting so close to the subject can create very abstract kinds of photos. Lighting this close is challenging in many situations, because the camera is so close to the subject that it is hard to even get the light in between the subject and the front of the lens. One way to get light on to a subject is to get the light near some sort of hard light source, such as near a window or in the shade near the edge of the sunlight. If additional highlights are needed to give a little life to the subject, place a small white reflector or white card in the light reflecting some highlights back onto the subject as in 9-13.

Using a reflector when a hard, direct light is involved is just as important with close-up subjects as it is with portraits. The contrast of hard sunlight is just as difficult to deal with. In 9-14 and 9-15, a sea urchin shell is placed in bright sunlight to show the challenges of the contrast. Using Aperture Priority automatic on both images, the aperture stays the same, and only the shutter changes with any light change.

In 9-14, the bumps on the little shell are very bright, and they have little to no detail on the bright side of the bumps. The shaded side of the urchin shell begins to get dark and sort of murky. By bringing in a white card close to the edge of the shell, the entire exposure goes up. This allows the bright side to have more detail, as the additional light fills in the shaded area. The light on the dark side of the urchin shell still falls off and darkens, but with far more pleasant results.

The exciting part of macro photography is seeing things that are ordinary but getting so close to them that they become abstract and out of context and, thus, extraordinary. In many cases, the lighting may be the thing that draws you to these subjects. Some object has a glint of reflection, color, or texture that lures you into photographing it. The bigger challenge may be just taking the time and effort to get the tripod out and shoot what is already something very interesting to you. Using the ambient light that is already enticing you to shoot, just start getting close. If you are still having trouble getting the light to the subject with a reflector and the like, it may be time to use the strobe.

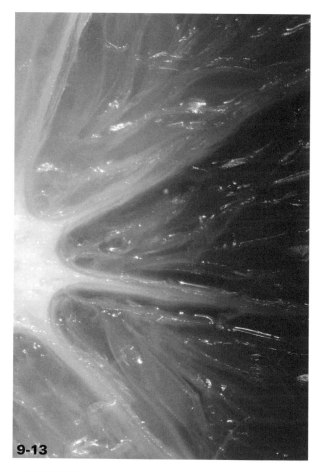

9-13

ABOUT THIS PHOTO *This image was taken with an exposure of 1/4 second at f/51 at ISO 100. The orange was placed just outside of an incoming ray of bright sunlight, and a small flexible reflector was placed in the light creating the highlights.*

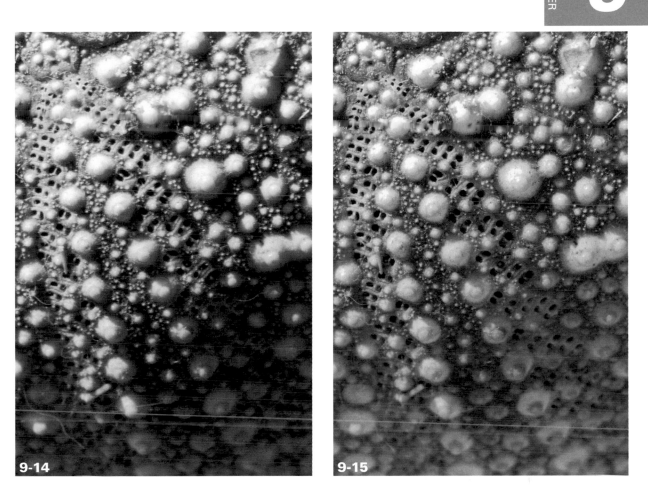

9-14

9-15

ABOUT THESE PHOTOS *The exposure in 9-14 is 1.5 second at f/51 at ISO 100. The meter averages the bright highlights and the dark shadows, with the largest problem being the highlights are washed out. In 9-15, the exposure is .8 second at f/51 at ISO 100. The extra fill light brings the entire exposure up nearly 1 full f-stop, which in effect darkens the highlights, with the shorter shutter speed.*

To use a strobe to shoot macro subjects, it probably is necessary to either bounce the light off of something else or get the flash off of the camera. As discussed earlier in this chapter, on-camera flash is not the best thing for macro subjects. The flash tends to go right over a subject so close and generally overexposes the subject because of how close it is. Turning the strobe to the side and bouncing the light into a collapsible white reflector makes the light relatively broad and not too harsh. The light still has direction when bounced

from such a hard light source, but the reflector really evens the light out more, making the subject look more natural.

tip It may be necessary to get some cleaning materials out when shooting so close. When you get close to things, many times the patina of old, worn things is very interesting; other times it just looks dirty. One of the biggest problems is dust. A tiny speck of dust may look huge in your image. Be careful with using canned air as sometimes the propellant can freeze the thing you are trying to dust off.

FINDING GREAT LIGHT FOR FLOWERS

Shooting flowers and plants is often the reason some photographers pick up a camera in the first place. The color, delicate shape, and textures make flowers a natural draw for photographers. Using any of the styles of lighting on a flower can make great photos, but looking at things differently helps to create different and interesting images. Backlighting a flower makes it appear to glow as the light passes through the thin membrane that is the petal. In 9-16, the light comes through the petal and actually creates a tiny soft box of light that helps to illuminate the yellow, lower part of the flower. Careful focus at f/8 makes sure that the central part of the flower is sharp, and the softness at the top actually helps it to appear more ghostly and ethereal.

Using soft, overcast light can help the flowers look more layered against each other, without the shadows of the different flowers getting in the way. Make sure when shooting flowers in an overcast situation that the white balance is set to cloudy or shady to keep the color and saturation of the flower looking correct. Setting the compensation to overexpose also keeps the flowers from looking dreary and dark. A meter reading done with the center-weighted meter keeps the flowers bright and makes sure that background tones don't affect the exposure.

When shooting other fauna, it really looks fantastic when backlit. The light comes through the thinness of the leaves and just appears to glow. Catching some of the dew still on the leaves is always a bonus, but water drops can be augmented by a squirt from a spray bottle if you feel that the photo needs that extra dimension. Getting the light behind the leaf as in 9-17 probably means shooting very early or very late in the day as that

is when the light can best come through at such an angle. As it gets later in the day, shooting through the leaves entails getting underneath the leaves, which is sometimes a challenge.

Finding flowers with just a tiny bit of direct light, such as on a hazy morning, is a great time to capture the natural color and drama. Attempting to use more selective focus to place the emphasis on one particular part of the flower is easy with the lack of depth of field when using close focus.

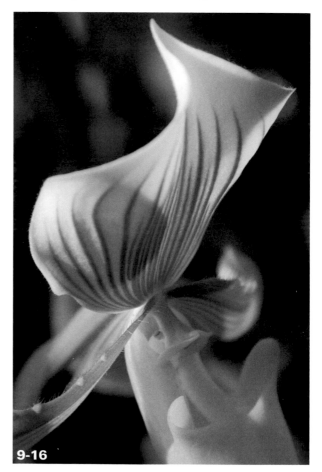

9-16

ABOUT THIS PHOTO *The exposure of 1/160 second at f/8 at ISO 125 with a Nikon 18-200mm f/3.5-5.6 lens allows for a motion stopping shutter speed needed because of the breeze. The backlight in this scene really makes this flower glow.*

9-17

ABOUT THIS PHOTO *Since shooting light coming through something that is green and yellow will be green and yellow, maintaining your white balance at daylight may give you the most accurate color. Exposure set at 1/180 second at f/9 at ISO 200.*

WORKING WITH MACRO MODE

If you simply have a macro mode or close focus capabilities on your lens, getting quite so close may not be an option, but that shouldn't stop you from exploring the world of macro type images. Using the close focus ability of most zoom lenses should yield great results, but keep in mind some of the things discussed earlier. The depth of field is still diminished due to when the lens is focused to its closest setting, and the propensity for camera shake is greater when focused so close.

Images that challenge the viewer with an abstract or unusual viewpoint are exciting. Having people look at a photo saying, "what is that?" will inevitably be followed with a "how did you do that?" Finding great images in those details is easy especially when you think about design principles and keep your macro rules of thumb in mind.

Finding simple lines and textures by getting close is important, but even more, make sure that the light accentuates those things. This often means having the subject lit from behind. In 9-18, the backlight not only makes the thin edges and spikes of the plant glow. The backlight also helps create a sense of layers, and the different tones of the leaves all pull together to unify the texture, line, and light of the image.

9-18

ABOUT THIS PHOTO *It was critical to have the one sharp spine in focus with an exposure of 1/40 second at f/2.8 at ISO 200 when shooting underneath the aloe.*

When you are indoors with a lot of tungsten spot-lights, the light often creates a lot of hard reflections and highlights in the scene. Making sure that the white balance is set to tungsten to combat too much of a warm cast often helps. Glass and other reflective objects are difficult work with because of those bright reflections.

When subjects are backlit and have no inherent translucence, the only way to fill in the shadows is to bring in a reflector. A small white collapsible reflector does wonders in just adding a bit of color and lightness to the shadow side of the subject, as in 9-19. In this case the backlight is so strong, there is still a loss of detail in the rim light of the shell, but that is mostly because the shell is reflecting the light from the window. This reflection is every bit as bright at the source of the light.

9-19

ABOUT THIS PHOTO *A 18-200mm f/3.5-5.6 lens is used to create the image of the shell. The exposure is set at 1/125 second at f/5.6 at ISO 400, with the white balance set to daylight.*

USING THE MACRO MODE ON A COMPACT DIGITAL

The macro mode on a compact digital camera is selected by pressing the button with the flower on it, although each camera is different. In many cases, this allows the camera to focus very close to the subject, but the tradeoff is that the lens is usually only able to do its macro setting when the lens is set to wide angle. This wide-angle macro gives an entirely different feel to the look of the macro photos. Using a telephoto lens to do macro photography takes the tiniest slice of the scene, while the look when using a wide macro lens is much more of a perspective change than a true macro photograph, because you see so much of the scene.

Any other light but full sun in the middle of the day is generally preferable, yet because of the brilliant white of the helmet against the blue in 9-20, this abstract takes one step back to figure out what this really is. The lesson here is that any light can create interesting photographs, so shoot anytime of day or night, because you never know when you might shoot a real winner. Moving in close to the white helmet really helps with creating the abstraction as the wide angle forces the perspective of the scene.

Using the advantage of the wide-angle macro makes the creation of repetition easier, because you can get more into the image. For example, sitting in a car may not be the best place to find good light, but thinking about it, windows all around are letting in natural light, and with the roof in place there is a natural bit of shade. In 9-21, the soft open shade gives a perfect exposure to the map, and the windows create very bright highlights on the shiny binding rings. In fact, the contrast of those rings is the thing that creates the most interest and texture in the image.

9-20

9-21

Getting so close is definitely appealing, and being able to see the layers of paper inside the holes helps to show the definition in the photograph.

One of the other great advantages of the compact digital camera is the ability to not have the camera to your face to be able to see what the lens sees. With the live view LCD on compact digital cameras, the traditional viewfinder on those cameras is virtually obsolete, and getting extreme angles is far easier. This further allows the creativity of the photographer to flourish by working with unusual perspective and angles. Getting extremely low to a subject is nearly impossible with a digital SLR because it would mean getting your chest and chin right up to the subject, and, in many cases, that would be virtually impossible.

The fluorescent light of a subway stop creates amazing reflections on the metal work of the benches. The shapes of the holes reflect the light on the lip of each and every hole making for very interesting pattern and shape in 9-22. Additionally, the bright reflection and the dark of the inside rim of the hole make for really interesting contrast.

When the light source is tungsten, the warmth of the light almost always comes through. In 9-22, the hard, cold fluorescents help to make that photo what it is because that light source creates those highlights and shadows. In contrast, the warmth of the subject in 9-23 is perfectly matched with the light source. The reflections seen are off the tiniest strands of fabric, which

9-22

9-23

gives the fabric a slight sheen, but even more, as the light reflects off the colors, the image is more about the texture and color of the image. Being able to get so close to the fabric helps to create a better sense of just what this fabric is all about. The viewer can feel this yarn and the texture that is woven into it.

The wide-angle view of the compact digital camera's macro forces the perspective and proportion of the shot. For example, in 9-24 when using some daylight as the main light of the scene, it was not until the light comes across the bridge of the cat's nose that it is soft enough to work. The light hitting the hidden side of the scene would be far too bright and harsh. The image is really all about getting so close to the subject and creating a photograph that is really unimaginable. Getting so close to the subject, but getting more than the tiny sliver that most macro lenses give you opens up a new world when using compact digital cameras. Using a wide angle as a macro changes all the rules because of the strange proportions created with the wide-angle lens. Take advantage of the tools that you have, because they can help any photographer to make exciting and different images.

9-24

ABOUT THIS PHOTO *Using the macro mode with the camera at its widest setting, you can get tremendously close to the subject. Exposure is set at 1/1000 second at f/2.8 at ISO 200.*

TAKING PRODUCT PHOTOS

Whether you are shooting products for online auctions, a church fundraiser, or a professional catalog, the biggest goal is usually to focus on the product with minimal distractions. This does not necessarily mean that the subject has to be photographed in front of a white or black background, but doing so puts all the emphasis on the subject and eliminates issues like colors clashing.

When you don't have access to an elaborate studio full of lighting equipment and backgrounds, you have many ways to shoot great product shots right in your own home. The biggest thing to think about is to keep it simple. Simple backgrounds, simple layout, and simple lighting are going to give the best results. When trying to just get a quick shot, you can just organize your items on a plain background like a table or counter top and aim your camera-mounted strobe at the ceiling to get nice even bounced light. Use your zoom lens to crop as many extraneous details from the shot as possible.

> **tip** For a minimal amount of money, you can get what is commonly called a *light tent*. These are collapsible nylon domes into which you can put your small products. They are made of thin translucent material that allows the light to come in nice and diffused and allows for photos with minimal shadows no matter where the light comes from as the light bounces all around the tent.

You don't have to use a strobe to create simple product shots. Light tents and domes are very flexible, and you can even use household lamps, clip lamps, or halogen work lamps to illuminate the subjects inside of these simple devices. In 9-25 the ball is lit with a lamp on either side of a light tent. If you are going to use the light tent with tungsten or halogen bulbs, be sure to select your white balance correctly. If there is no overwhelming color to the scene, use Auto white balance.

9-25

ABOUT THIS PHOTO *Remember to select the proper white balance whenever you change the light source for the light tent. This image was exposed at 1/25 sec. at f/5.6. and used the AWB to correct for the warmth of the light.*

Assignment

Using Light to Make Something Special from Common Objects

Find an object around your house that has the potential to become a special image with the right light. Photograph a house plant that has great shape and different colors of green. With sun coming through the window and striking the leaves or stalk, it could make a wonderful photograph. You might have an old bicycle in your garage that, if propped up against a tree or a brick wall, would be a great subject and exude all kinds of personality in a photo. You could direct the light to reflect off the chrome of the bike or show shadows coming off the bike. It's up to you.

I take a lot of still-life photographs. As you develop your eye, you'll start to find interesting features in everyday objects. This image was taken with a compact digital set to macro in the wide-angle setting. The interest of the light mostly comes from the reflection off of the aluminum that comes from a window in the office. I didn't want to use the flash as I thought it would be too bright for the rest of the scene, so I used ISO 200 to get a little faster shutter speed in the darkness of my office and used exposure compensation of –1 to make the black very black and the silver very muted. The lens is literally just an inch or two from the subject. The exposure here is set to 1/60 second at f/2.8.

Don't forget to go to www.pwsbooks.com when you complete this assignment so you can share your best photo and see what other readers have come up with for this assignment. You can also post and read comments, encouraging suggestions, and feedback.

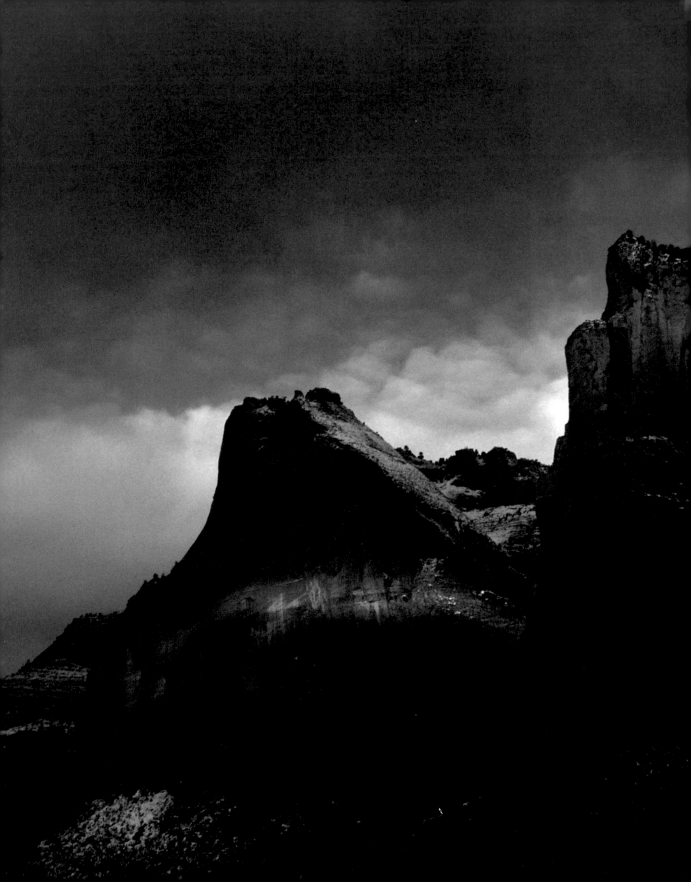

CHAPTER

10

MASTERING NIGHT AND LOW LIGHT PHOTOGRAPHY

Now that all the different angles and textures and directions and styles of lighting have been discussed, it is time to talk about shooting when there is no light. Really, plenty of light is often available; it just takes a while to get enough of it to make a photograph. There are special challenges in photographing low-light situations, and the long shutter speed is just one of them. This chapter explores ways to get the best exposures when the light is low or seems to be missing completely.

YOUR BEST FRIEND, THE TRIPOD

Although not all low-light photographs are made while using a tripod, most of them are. In order to get the best results — meaning steady, sharp and solid images — a tripod must be used. Tripods need not be expensive, but they should be sturdy enough to hold the camera still in a slight breeze. With the size of digital cameras getting smaller and smaller, this is ever more important as the camera's weight might not help to hold the tripod still.

A couple of additional things help keep the camera from blurring. The first thing is making sure that all of the leg extensions are nice and tight. If your tripod uses a twisting type lock, then make sure that you twist it sufficiently. If it has one of the many kinds of lever style locks for the legs, keep the nuts and bolts properly tensioned so that the tripod stays upright and solid even when there is some weight placed on it. Most tripods even come with the proper sized little wrench to keep everything tight. Keep that wrench in your camera bag, and when you are waiting for a sunset or the like, take a minute to tighten your tripod.

Getting some additional weight on the tripod also helps to keep it rock solid. Some professional photographers may go as far as hanging a sandbag or two from the tripod in order to keep everything still. Sandbags may be overkill for most, but hanging your camera bag from the tripod to weight it down does the same thing, without requiring a bunch of sandbags.

Using the strongest tripod in the world is all for nothing if your hand moves the camera every time you touch the shutter release. Most every digital camera has some sort of socket for a cable release or remote trigger. In a pinch, you can also use the camera's self-timer in place of a cable release. If you set it to longer, it actually may mean less vibration on the camera than a cable release. Some of the more advanced digital cameras even have the option of locking the mirror in the up position before firing the shutter to eliminate all vibration. For extreme critical sharpness, the mirror-up function can be vital.

CAPTURING SKYLINES

When photographing cities at night, you might be amazed at the brightness of the city lights, how they affect the meter, and just how much light the camera is able to pick up. In most cases at night to get the appropriate level of darkness in a scene, you need to underexpose at least slightly, as in 10-1. When shooting a city at night, though, with the brightness of the headlights, the streetlights, and the lights from the buildings, you may even be able to just use the straight meter reading and one of the auto modes.

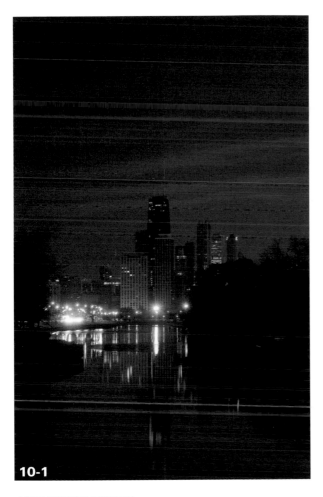

10-1

ABOUT THIS PHOTO *By using an exposure of 8 seconds at f/8 at ISO 100, the skyline is very distinct against this sky, which is just beginning to see some morning color.*

Using the automatic modes and the exposure compensation might actually be better than using manual as a learning tool for people who are still working on mastering exposure. That may seem counter intuitive, but unless you are someone who writes down what the meter reading said and then what the manual exposure was, there is no way to determine exactly how you worked with or against the meter reading when you go to looking at the camera data. When you set the camera up in manual mode, it only records the exposure data; it doesn't tell you what the meter said. In Aperture Priority, for example, when you see the exposure data plus the exposure compensation, you know exactly what the exposure was compared to what the meter was telling you to do.

Mastering your exposures by looking at the camera data in Photoshop Elements or Bridge works only if you actually look at and compare the photograph and determine what works and what doesn't.

Because of the brightness of the city lights, there are two times of day when shooting the sky seems to work best — when it is cloudy and after dusk or way before dawn. The reason that those times are better is because being able to actually see some texture and color in the sky goes a long way toward separating the buildings from the sky. If you shoot very early or quite late after sunset, while there is a tiny bit of light still in the sky, it will still be apparent that you are photographing at night, but the sky tells a better story. Shooting when it is very cloudy also makes for an interesting sky because of the light pollution. The glow of the city lights reflecting back from the city creates an eerie glow in the sky, and it makes something more of the sky than having it just go black, as in 10-2.

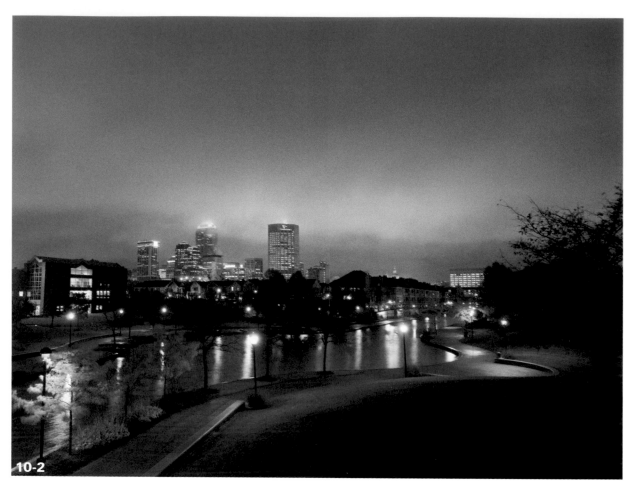

ABOUT THIS PHOTO *Not only does the stormy weather put texture in the sky, but the wetness on the surfaces also increases the richness and reflections and color on the ground. The exposure here was 1.5 seconds at f/5.6 at ISO 200.*

Even when there is just a small bit of texture in the sky as in 10-3, it is still better than just all black. Just like shooting a landscape in the day, attempting to put something in the sky to give it drama and dimension is exactly the same when the sun is shining elsewhere. Compositionally, shooting skylines at night and landscapes is similar. Placing something in the foreground for emphasis and scale makes for a more interesting photograph.

Some might ask, why can't you see the stars with such long exposures? The answer is that the city lights still provide a massive amount of light as compared to the small amount of light that the sun puts out. The exposures simply aren't long enough to capture the starlight, and if they were, the city exposure would be totally washed out.

ABOUT THIS PHOTO *The exposure here was 6 seconds at f/7.1 at ISO 125 with exposure compensation set at −1. The small bit of sky still adds quite a bit to the sky-line, and setting the white balance to tungsten works to make the scene look clean.*

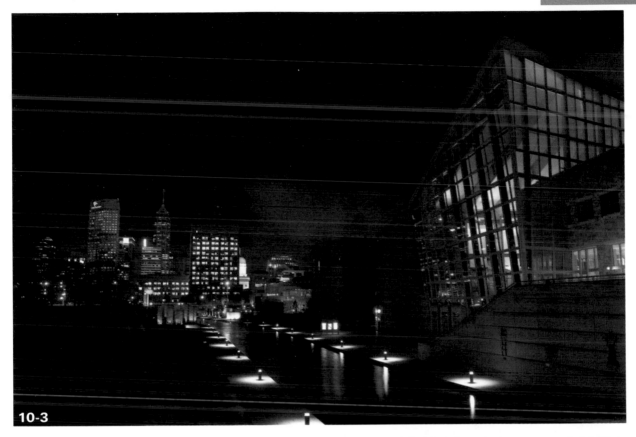

10-3

TAKING PHOTOS AT DUSK

Although discussed in earlier chapters somewhat, some things specific to lower light are important enough to go over differently.

When just a tiny bit of sunlight is available, using the spotmeter is important to get the right expo-sure of the small patches of sunlight, as in 10-4. Using the other metering functions can make for a very washed out looking image as the averaging meters average all that dark with the small amount of bright. To get the correct exposure using a center-weighted or evaluative meter, you need to use some underexposure, either manually or with the exposure compensation.

10-4

ABOUT THIS PHOTO *Getting the spotmeter reading on the tiny bit of sunlight nails the exposure. Still a lot of sun is hitting that tiny spot as the exposure here is 1/180 second at f/7.1 at ISO 200.*

When shooting a more urban shot, you have a lot of city lights, and the color is great at dusk because the ambient light is still there to give some definition to the buildings, but you can still see the man-made lighting scheme. This time is a favorite for a lot of architectural photographers and people who are trying to balance the light of the scene and the light of the sky. Sunsets are often hastened by inclement weather as the light gets lower much sooner, as in 10-5. This may be an advantage in shooting because the sunset will stay much the same for a longer period of time instead of going rapidly from bright daylight to dark nighttime.

SHOOTING IN THE AFTERGLOW

Often, quite a bit of light is still left in the sky long after the sunlight has left the scene. This time is called the *afterglow* and is still a great time to shoot some low-light shots. Many times this light comes from the glow of the reflected light coming off of the still lit clouds. Many times the light in the afterglow has its own light quality. It is not hard, yet there are rich shadows, and it is not soft light, but the tones definitely have a soft texture. In 10-6, the sky is blue, and there is definition in the clouds, but the light hitting the balanced rock is still very directional, even though the sun has been below the horizon for a while.

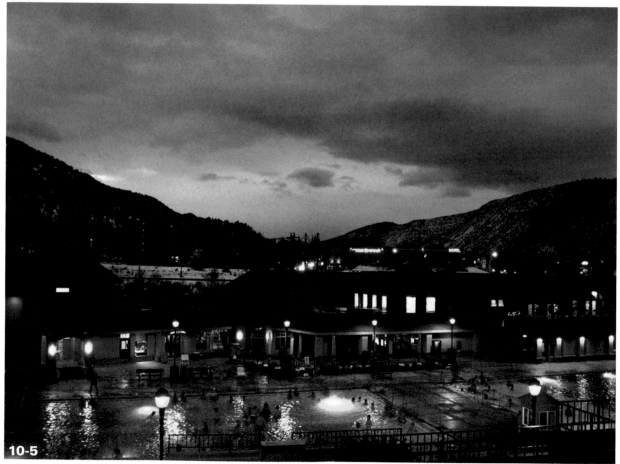

ABOUT THIS PHOTO *Usually, the camera can't deal with the disparity in light indoors and light outside. For short periods of time, those lights can be balanced, usually at dusk. This image is exposed at 1/13 second at f/4 at ISO 200.*

ABOUT THIS PHOTO
By comparing a sunset chart and the camera data with the image file, this image was taken about 20 minutes after the sunset. The exposure was 4 seconds at f/8 at ISO 200.

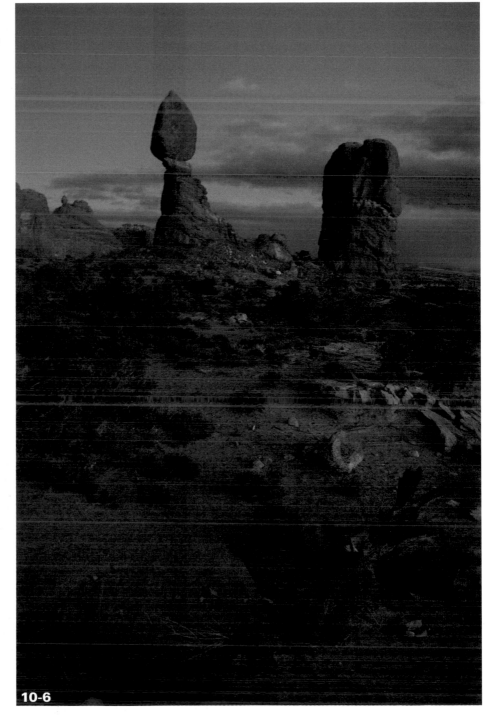

10-6

There isn't really a name for the time long before the sunrise, but this pre-sunrise is very much like the light of the afterglow. Earlier in the day, when almost no light is in the sky, the reflections of the city lights almost perfectly balance the light in the sky. To just look at the scene might make the scene appear far too dark, but letting enough light into the camera with a long shutter speed can cause the scene to be bright and rich with color. Long exposures not only let in a lot of light, but because the sensor is on for so long, they can also create additional noise in the image. If you are going to all the trouble to do long exposures, make sure that your ISO is as low as possible.

Shooting water at dawn and dusk can also make for exceptional lighting. Much like shooting a creek or river, shooting long exposures of waves moving across a body of water adds a slight glow and smoothness to the water. The water is constantly moving, and the little white caps and the reflections off of the water are constantly moving and oscillating; yet, because of the low light level and small aperture any whites are muted and just add to the softness of the water, as in 10-7.

HOW LONG IS LONG? You have may have noticed that the longest exposures in most of these shots go for about 30 seconds. That is largely because that is the longest setting that most digital cameras have. Using a cable release makes it possible to take photographs with substantially longer shutter speeds — many minutes to many hours. This can be done with the camera set to B, which stands for Bulb. This setting allows the camera to expose as long as the release button is pressed. Don't worry about your thumb for a several-hour exposure as both mechanical and electronic cable releases have a lock feature that allows for the button to be pressed and then locked until the exposure is done and then unlocked.

Older cameras also have a T setting, which stands for Time. This works just like the B setting, except that you press the shutter release to start the exposure and press it again to end it. This has largely gone by the wayside in digital cameras in favor of the B setting.

So if 30 seconds is too short of an exposure for your scene, how do you know how long to have the shutter open? The easiest way is to think about the exposure not in how many seconds, but in how many minutes. So a 30-second exposure is a one-half minute exposure. To make it twice as bright, the exposure needs to go to one minute, which would be a 1 f-stop increase in exposure. To increase another 1 f-stop, the exposure would be two minutes, and to increase 2 stops from 1 minute would be a four-minute exposure. It is a geometric progression.

Using such long exposures uses a lot of battery power. The sensor must stay powered up for all of those minutes. Make sure that your batteries are charged up before you head out to do a lot of long-exposure photography or risk not getting the shot you are trying to capture.

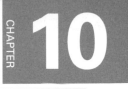

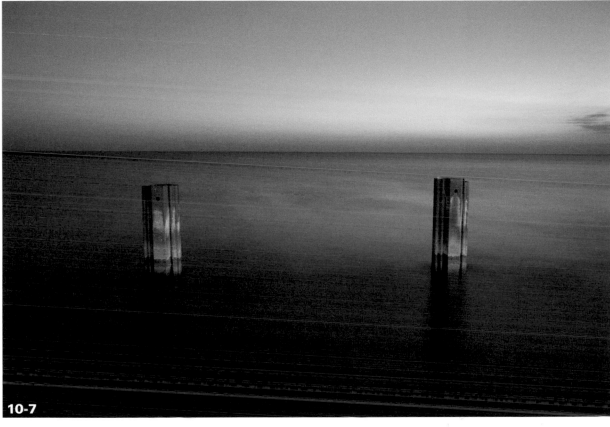

10-7

ABOUT THIS PHOTO *This image was taken at an exposure of 30 seconds at f/4 at ISO 100. The city lights give the pilings enough of an amber glow, complementing the blue of the lake long before the sun rises.*

It is also possible to shoot a scene when the afterglow has almost totally faded and the scene is lit with just a small bit of ambient light still in the sky and the light of a full moon. This necessitates long shutter speeds and large apertures to get enough light into the camera. Shooting during the twilight can actually create a scene that still appears to be nearly daylight. Because the meter is still telling the camera to make the exposure grey, making it look just like daylight as in 10-8 because of the long exposure.

SHOOTING SUNSETS AND SILHOUETTES

In most cases shooting a sunset and silhouettes actually entails shortening the exposure. When shooting in low light, it usually is a low contrast, such as in 10-8. That long exposure was with the light hitting the scene matching the light coming from the sky. When shooting more toward the sunset and with the sky still bright, a silhouette is created when underexposing the scene, making the shadows darker.

253

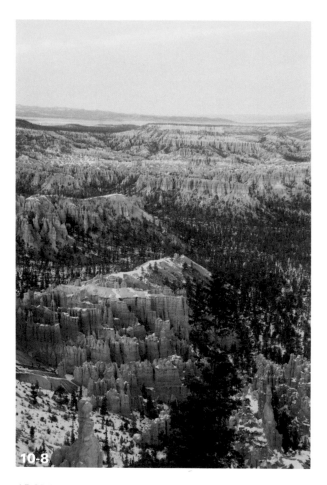

ABOUT THIS PHOTO *Nearly after the sunset, and probably two hours after this valley dropped into shadow, using an exposure of 30 seconds at f/8 at ISO 100 the scene is almost indistinguishable from a daylight scene.*

Some digital cameras actually have silhouette settings. Silhouettes can easily be created by getting a meter reading off of the brightest part of the scene and then setting your exposure from there, and in many cases, underexposing from that bright part. When shooting a sunset, or dusk scene, the brightest area of the scene is the sky and it easily creates a silhouette when things are placed in front of that sky, as in 10-9.

ABOUT THIS PHOTO *Although being able to see all of the detail in this scene would make for an exposure of several seconds, shooting at 1/20 second at f/11 at ISO 200 creates a very dynamic silhouette.*

Even in just slightly diminished light, the opportunity for a silhouette is there by using the contrast of the scene. Getting low and getting any sort of dark object against a brighter subject and then underexposing the scene makes a silhouette. This can even be done with moonlight hitting the clouds. One very interesting thing to do is to work with your white balance to force a particular feel into the scene. In 10-10, setting the white balance to tungsten outside on a gloomy dark day makes an already blue feeling scene to look blue literally.

Sunsets are not necessarily considered true low-light situations, but when shooting sunsets and silhouettes, you are essentially shooting layers of shadows. Unlike a scene in which the sun's light is virtually gone, ample contrast exists to maximize the levels of the shadows, especially when the scene is backlit. When shooting into the end of the sunset, the layers of the background become ever more apparent, such as the mountains and trees in 10-11.

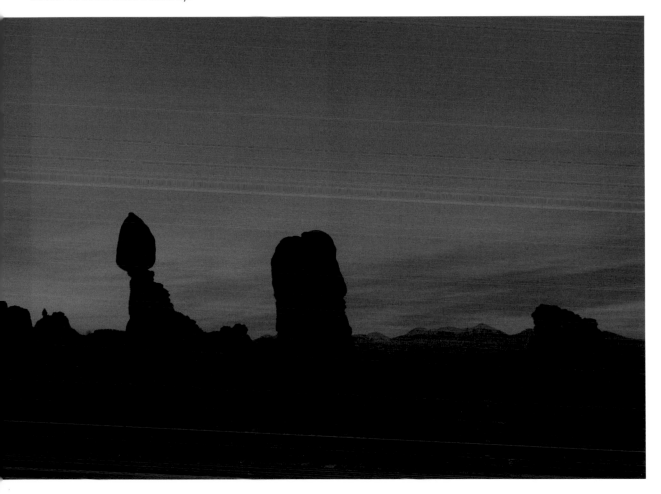

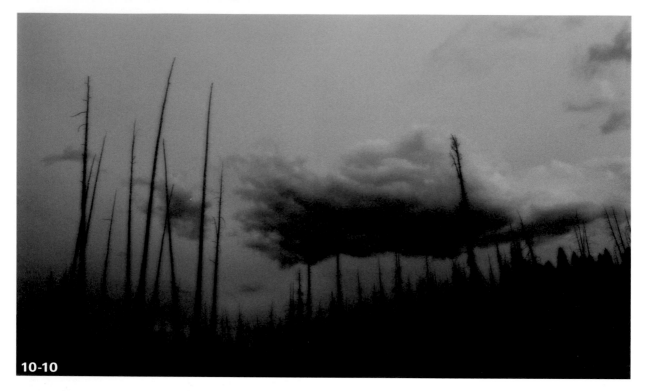

10-10

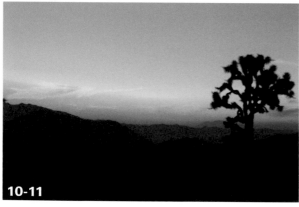

10-11

ABOUT THIS PHOTO *The last light of the day makes a silhouette of the Joshua tree and layers of mountains in the background. The exposure here was 1/125 sec. at f/2.8 at ISO 200.*

CREATING SOFT, MOODY LIGHT WITH LOW LIGHT

Softness in a photograph can come from the light source itself, the subject, or the atmospheric conditions of the scene. Atmospheric conditions would be fog, haze, or smoke. The material in the air diffuses the light and the contrast of the scene and gives the light something to reflect off of, creating rays of light in the haze wherever there is a direct light source. Most notably, this happens when the sunlight filters through lifting fog. This effect also is seen a lot in movies and television where there are flashlights. In 10-12, all of the light comes from the light of the firemen's

flashlights cutting through the smoke and the haze. Not only does this make the actual light rays more visible, but it also spreads the light out, making it broader.

Sometimes, the subject and the light combine to make a photograph very soft. Anytime that a light source is diffused, a lamp shade, an umbrella, a soft box, a translucent reflector, or even fingers over a flashlight, the light becomes softer as the rays of light spread out, bounce

around and reflect against the diffuser. This means much of the light is lost, and only a little bit is active in creating the exposure. Having such a small light or low level of light usually makes for a dark scene. There just isn't enough light to brighten anything, but just because the scene is dark, that doesn't mean that the scene has a lot of contrast. No real highlights are on the face of the girl in 10-13, and the shadows there are very soft and diffused.

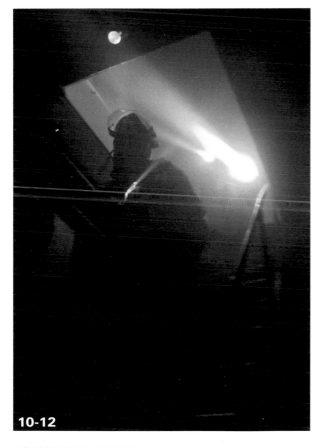

10-12

ABOUT THIS PHOTO *Beams of light make for dramatic lines within the image as the flashlights shine through the smoke. The exposure here is set at 1/6 second at f/4.5 at ISO 1600. Photo by Jarod Trow.*

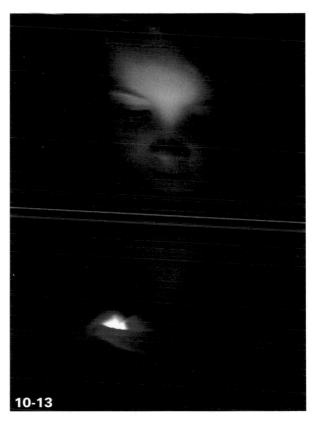

10-13

ABOUT THIS PHOTO *It doesn't even matter what the source of this light is, because it is so small and soft, all you really see is the softness of the light on the little girl's face. The exposure here is 1 second at f/2.8 at ISO 400. Photo by Holly Jordan.*

TAKING ADVANTAGE OF ADDITIONAL LIGHT SOURCES IN LOW LIGHT

Low-light images are often made even better with the addition of some sort of light for the subject or as the subject, to help build some interest or emphasis in the image. This additional light can take the form of a strobe or incandescent, or the light can be from more esoteric sources like headlights from a car or from a sparkler.

Mixing strobes with incandescent light was mentioned in Chapter 4. This is a common and easy way of using additional light sources to put emphasis on a subject in a low-light scene. When the light gets very low, the strobe makes up the bulk of the light for the subject, but to get the low lights in the background to expose, a longer shutter speed needs to be used. When a slow shutter speed is used in conjunction with a flash to make the image, it is called *slow sync* or *dragging the shutter*. In 10-14, the camera is set on a tripod to maintain sharpness with the slow shutter speed.

10-14

ABOUT THIS PHOTO *Using a slow sync, the flash fires at a shutter speed of 1/20 second which lets the background lights burn in while the flash perfectly exposes the subject. The exposure here is 1/20 second at f/2.8 at ISO 200.*

Flash can be used to augment even a distant low-light scene by adding some light in a place where there otherwise may be just darkness or a silhouette. Shooting long exposures often means that the apertures are also small, letting very little light in. By taking a strobe unit off the top of the camera, you can angle the light so it is at more of an angle, more of a crosslight. With a long exposure, you also don't even need a sync cord or wireless trigger; you can just fire the strobe manually with the test button. If the aperture is so small (high number f-stop), it may take several hits with the flash to build up much of an exposure. Using the strobe like this makes for a much more subtle effect, as seen in 10-15.

USING REAR SYNC IN LOW LIGHT IMAGES

Rear Sync or *2nd Curtain sync* refer to firing of the strobe at the end of the exposure instead of the beginning of it. What happens is that the first blade of the shutter opens to begin the exposure, light builds on the sensor creating the exposure, and just before the second blade comes down to end the exposure, the strobe goes off. This does two things: It freezes the subject at the end of movement and gives the subject a *trailing blur* as some of the exposure is behind a moving object.

One great thing about using strobes with the rear curtain strobe in a low-light situation is that you can also use the lights as a design element within the image. A long exposure creates time to move the camera and zoom the lens during the exposure, and with the rear curtain sync, the subject still is properly exposed and frozen by the strobe. Zooming the lens during the exposure makes the lights into trailing light rays or beams, as in 10-16. This is an effect that can add a little life to an image that otherwise may be a little bit staid, but it should be used judiciously.

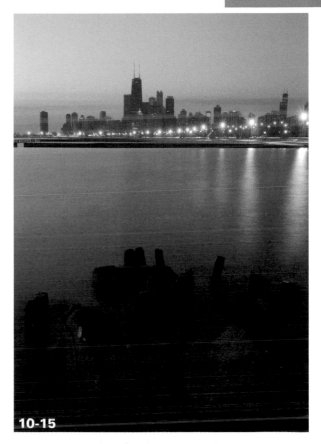

10-15

ABOUT THIS PHOTO *With the camera locked on the tripod and a very long exposure, firing the strobe manually four or five times gives the rocks just a little bit of definition. The exposure was 25 seconds at f/100 at ISO 100.*

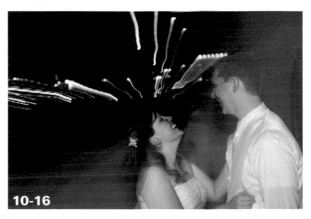

10-16

ABOUT THIS PHOTO *Zooming the lens during the exposure is something you can do only with a long exposure. This exposure is set at 1/5 sec. at f/4.5 at ISO 800. The high ISO helps the background lights stay bright.*

One thing about strobes in general is that because the light happens so fast, the flash of light freezes the motion in the image. This is particularly important when the action is happening quickly. Using this ability with the rear sync can make for very dynamic images. When the scene has some light, it helps to register the fast-moving object as in 10-17, and when there are lights on the subject, such as a car with all its lights on, the trails behind the subject add a lot to the effect.

MATCHING LONG EXPOSURES WITH FLASH

The second thing that rear curtain sync does is to fill in the amount of light that the exposure needs after the long exposure. For shooting more static things, using rear curtain sync really helps to better balance the light of the long exposure with the strobe because the computer and the meter have already figured out how much light was need for the exposure; the computer adds enough strobe to finish the exposure, as seen in 10-18.

When the light is just right, regular strobes don't even need to be used. Although this section is about flash, think about different kinds of flash...like the flashers on your vehicle. In a 30-second exposure, how many times might those lights flash, each time building up some exposure on the sensor, even though they might barely register in your brain? See 10-19.

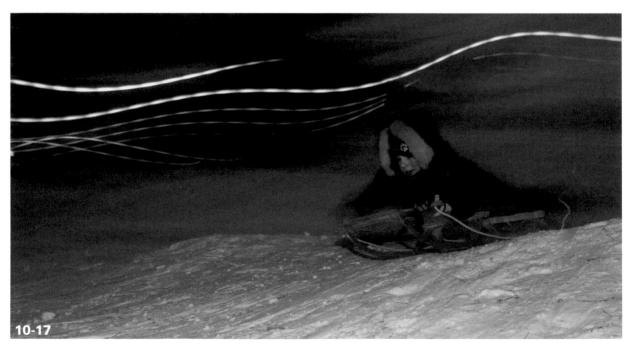

10-17

ABOUT THIS PHOTO *Sometimes being off of the tripod helps, too. The exposure here is 1/4 second at f/2.8 at ISO 400, and with the inconsistency in panning, the lights in the background appear as wavy racing stripes.*

ABOUT THIS PHOTO *Using the rear curtain sync made the strobe fire just enough light into the tree to give it a nice glow without overpowering the light on the rocks. The exposure here was 1/30 second at f/8 at ISO 100.*

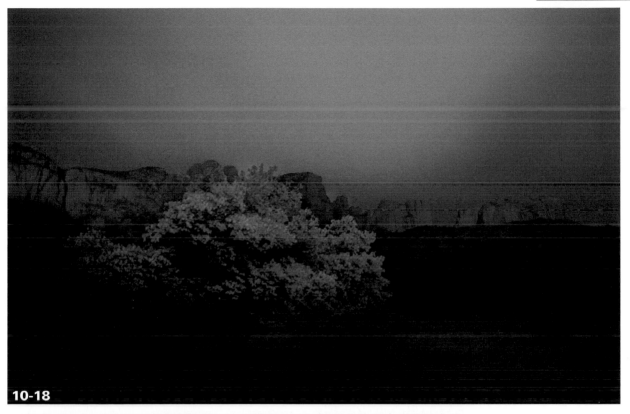

10-18

10-19

ABOUT THIS PHOTO
The exposure here was set in order to capture the cliff face in the background. The car lights hitting the trees were a total bonus. The exposure was 30 seconds at f/4.8 at ISO 200 with exposure compensation at +1.

Even the flash on a compact digital can help to liven up a scene by forcing the flash to fire. In a landscape scenario, the flash on a compact digital just does not put out that much light, but when a subject is in shadow and there is still a bit of glow after the sunset hitting the rest of the landscape, it can make more of the scene than just a silhouette. Using the flash to brighten the bush in 10-20 helps to separate it as the subject from the far away arch and overall adds balance by bringing a stronger subject to work with the strength of the arches.

CAPTURING THE MOTION OF LIGHTS

You can make light move through a photograph in so many ways that it is hard to just focus on a few. Cityscapes are really great places to look at the lights and work with many different types and colors of light. Unlike a straight landscape, though, by placing the lights from moving cars somehow in the scene, the lights of the cars add a huge sense of frenzy and activity in the place, as in 10-21. Even the motion of the leaves in the sky helps to increase the layers and add to the dynamic feel of a city.

Use the longest shutter speed that you can, but try not to have an aperture smaller than f/16 or so. The smaller the aperture, the darker the lights of the cars will be. This might be okay if there is substantial traffic, because the lights from the headlights will build up exposure. If there are only a few vehicles, then stay with the wider apertures. On the other hand, if the shot shows cars leaving, and you see more taillights, you may need even faster aperture as taillights are far dimmer than headlights.

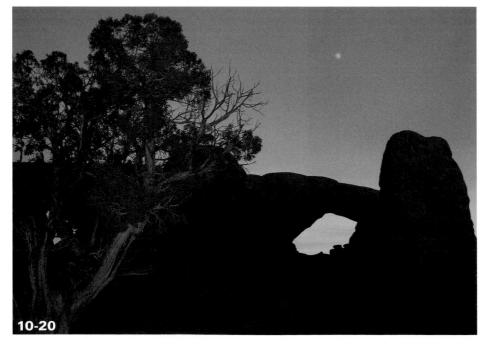

ABOUT THIS PHOTO
To make sure the colors would stay rich and not wash out, the exposure compensation was set to 1/100 second at f/2.8 at ISO 100. The flash puts out just what is needed to balance the exposure with the background.

10-20

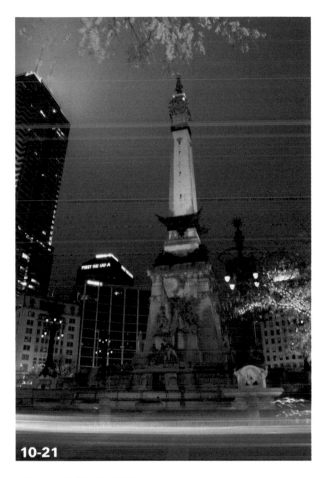

10-21

ABOUT THIS PHOTO *After you stake out your scene, make sure it is at angle to capture the movement of the lights through the scene. The exposure for this image is 4 seconds at f/14 at ISO 200.*

Sparklers burn very hot, and at the core, the light of a sparkler is very bright, but it takes a long exposure to get all trails of all the sparks at they come off of the stick. Using a long exposure, you can get a feel for the excitement that kids get when they first light sparklers, seeing the long trails jumping out from the sparkler and falling to the ground, as in 10-22.

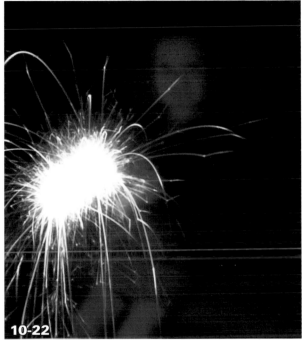

10-22

ABOUT THIS PHOTO *Sparklers need long exposures, but they do burn hot, so it is possible to use a reasonable aperture. The exposure here was 4 seconds at f/7.6 at ISO 100. Photo by Holly Jordan.*

FASTER LENSES? Photographers often throw out the terms *fast lenses* or *faster apertures*. This refers to the fact that some lenses have different maximum apertures, allowing for different shutter speeds at a given light level. For example, the zoom that comes with a digital SLR almost certainly has a maximum aperture of f/3.5 or f/4 at the wide setting of the zoom and f/4.5 or f/5.6 at the telephoto end. A more professional zoom lens has a maximum aperture of f/2.8 all the way through the zoom range. The lens with the maximum aperture is called a faster lens because it allows for a faster shutter speed at the same given amount of light when the aperture is wide open.

LONG EXPOSURES FOR CELEBRATIONS

Shooting fireworks is its own art form, posing several challenges. Difficult to begin with because you have to set up the camera in the dark; you also have to focus on a black sky and try to get an exposure while the camera is pointed at that black sky. The challenges never end. So here are five rules of thumb for shooting fireworks.

- **Rule 1 — Set the camera to f/8 or f/11.** Use f/8 if you want to see some color in the sky, and the light show is relatively small. Use f/11 if you want more of a black sky, and the fireworks are at a very major celebration, like the Independence Day Fireworks in Boston or Washington, D.C. Bigger cities simply have bigger and brighter fireworks.

- **Rule 2 — Set the rest of your exposure correctly.** Use ISO 100. Your aperture and the ISO are making the entire exposure.

- **Rule 3 — Set the shutter to B, bulb, or time.** Choose the setting on your camera that allows you to open and close the shutter at your desire.

- **Rule 4 — Put your camera on a tripod and use a cable release.** These two items are intertwined, so they count as one rule! A cable release is not absolutely necessary, but it is very hard to photograph fireworks successfully without one.

- **Rule 5 — Set the camera's focus manually.** A switch somewhere on your camera or the lens allows you to manually focus and leave it

there. You can probably just look at the lens barrel and set the focus to infinity. After your first exposure, check the focus on the LCD screen. Most digital cameras have the function to zoom into your image and check critical focus. Use it on the first one so that all the rest of your shots are in focus.

Once you've done these five items, watch and listen for the launch of the fireworks. A certain pace will start to evolve as the show proceeds. You can open the shutter before the launch because there is little to nothing in the sky to create an exposure until the shell is launched and explodes. Keep the shutter open until it has burned out to get the full effect of each shell. This may be difficult during the finale. Shooting more than one explosion at a time often results in overexposure as the light just builds up on the sensor.

Keeping some part of the environment in the scene helps to define the photo and gives it further definition, scale, and sense of place. Whether it is a local park with your neighbors or the Brooklyn Bridge in the scene, shoot at least a few with some elements of the environment, as in 10-23.

Now for more abstract fireworks shots, don't hesitate to break any and all of those rules of thumb. For example, try breaking Rule 4 — and handhold your camera. Try to time the bursts, but otherwise you can create some really interesting shots by just trying different things, as seen in 10-24.

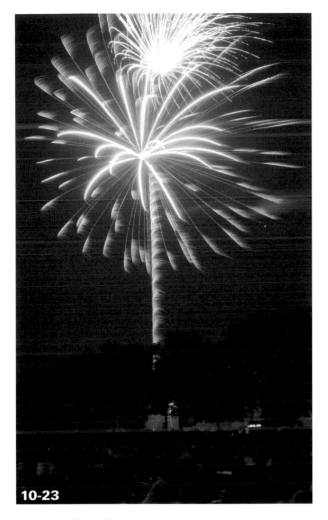

10-23

ABOUT THIS PHOTO *Keeping the shutter open for the entire burst is important; otherwise, you can't fully capture the shape of the burst. The exposure of this image is 8.4 seconds at f/8 at ISO 100.*

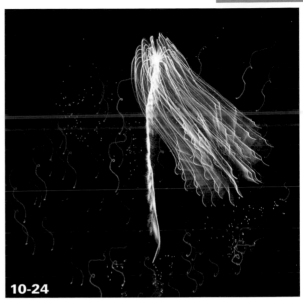

10-24

ABOUT THIS PHOTO *This is a handheld fireworks shot, and it has such a cool feel to it. The exposure is 4 seconds at f/7.6 at ISO 100.*

Carnivals and fairs are also very interesting places to capture the motion of lights. Shooting carnivals and the like is very similar to shooting fireworks, but because the lights on rides are so much brighter and more repetitive, you probably need to stop down some more. In case you want to experiment a little, you might start with checking on an exposure using the evaluative meter with Aperture Priority and the exposure compensation set to –2/3.

The biggest thing you want to look for in shooting rides is to capture the sense of motion. In order to do this, try to get the longest shutter speed possible. After you have your exposure set up with a long shutter and small aperture, the biggest problem is waiting for the rides to start and stop and trying to get multiple rises going at the same time, as in 10-25.

To help increase the feel of motion, tension, and activity, try tilting the camera slightly. When doing it slightly, it needs to be enough that it looks purposeful, 10–15 degrees or more; otherwise, if it is too slight of an angle, it just looks like you made a mistake. This can also help to fill the frame with light better when other things are happening with the light in the scene, such as the blur of the people at the bottom of 10-26.

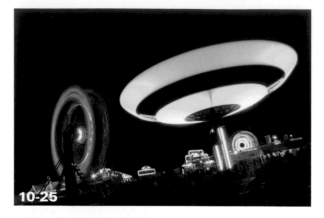

ABOUT THIS PHOTO *Getting all three of the rides going at the same time was quite a lengthy process. The exposure was set in manual at 13 seconds at f/22 at ISO 100.*

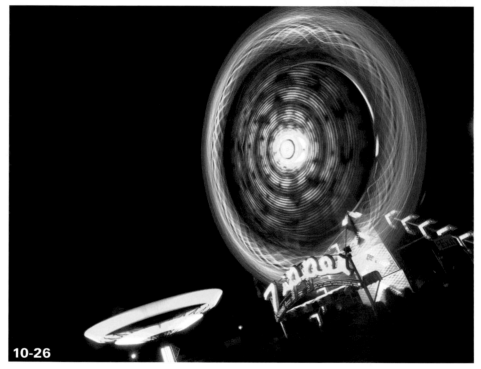

ABOUT THIS PHOTO
The texture of the Zipper is very interesting with all of the tiny lines of light, both in circles and in wavy lines. The exposure here was 10 seconds at f/16 at ISO 100.

Assignment

Finding Light in the Night

Take a nighttime picture using light from a streetlight, moonlight, car lights, or any other available light. If you have a dSLR, set your camera to Shutter Priority so that you can control how long the shutter stays open. If you have a point-and-shoot, you may need to set the camera to nighttime format on the camera's automatic settings. You probably want to use a tripod or set your camera on a hard surface to accommodate the long exposure. Take a picture of traffic going by, or an object under a streetlight, or anything that inspires you.

I really enjoy taking pictures of car lights in the night, with their headlights streaking across the image in brilliant colors. Sometimes the photo becomes abstract in nature. I took the photo for this assignment where there were hardly any streetlights to flood the scene with too much light. To keep the scene dark overall, I set the exposure compensation to –1/3 with an exposure of 1/6 second at f/2.8 at ISO 200. I took it at twilight, so there was still some light in the sky. The lights on the tree in the corner gave a colorful focus to the picture, and the trailing lines of the taillights help give the scene a sense of activity and vibrancy.

Don't forget to go to www.pwsbooks.com when you complete this assignment so you can share your best photo and see what other readers have come up with for this assignment. You can also post and read comments, encouraging suggestions, and feedback.

GLOSSARY

aperture The lens aperture is a moving diaphragm within the barrel of the lens. It controls how much light passes through the lens and into the camera. See also *f-stop*.

Aperture Priority In Aperture Priority (A or Av), the photographer selects the aperture desired, and the camera sets the shutter speed as needed.

backlight A subject that is backlit is lit from behind.

color temperature See *Kelvin*.

contrast range The ratio between the darkness of shadows and the white of the highlights is known as the contrast range.

crosslight See *sidelight*.

directional light The direction the light comes from. See also *backlight*, *sidelight*, and *top light*.

filters Filters are pieces of glass or optical resin that you place in front of the lens to affect the image in the camera. Filters come in three basic types: gels, screw-in filters, and slide-on filters. See also *gels*, *screw-in filter*, and *slide-on filter*.

flash sync speed The flash sync speed is the fastest shutter speed at which the flash can fire and still capture a complete image. In most cases, the fastest shutter speed that can be used with a strobe is around 1/125 or 1/250, but consult your owner's manual to make certain. Digital cameras with built-in flashes and dedicated accessory flash generally do not fire if the exposure is incorrect for their operation.

f-stop The designation for each step in the aperture is called the f-stop. The smaller the f-stop or f-number, the larger the actual opening of the aperture, and the higher numbered f-stops designate smaller apertures, letting in less light. The f-number is the ratio of focal length to effective aperture diameter.

gels Very thin pieces of resin that you place in a holder in front of the lens. Gels are generally used for color correction. Gels can come in small increments of effect to precisely change or correct your image.

Golden Hours of Light Better labeled the golden moments of light, this time occurs when the angle of the sun starts to get into those few degrees of sunlight just above the horizon. It takes only a few moments before everything starts to slip into shadow. The time is called *golden* mostly because the light is so warm that it takes on a golden or amber tone. The color and the low, long shadows make these golden moments such an exciting time to shoot.

graduated neutral density filter This filter is immensely helpful in landscape photography, particularly during sunrise and sunset. The bottom of this filter is clear, the top is a neutral grey, and the middle is a smooth gradation between the two. The grey part, the neutral density, simply lets less light in. This filter is used to darken a bright sky, bringing the exposure closer to that of a shaded foreground.

high key High key lighting is lighting with a white or light-colored subject in front of a white or light-colored background. See also *low key*.

incandescent light Light from tungsten light bulbs is the most common source of light in most homes. This very warm source of light can be used in a lot of photographic situations, but incandescent lights are limited because of their relative low light output.

ISO ISO is an acronym for International Organization for Standardization, which is a body that sets international and commercial standards. In digital photography, the ISO is the measure of the digital sensor's light sensitivity. Digital sensitivity correlates to film speed in traditional cameras. Digital cameras can have film speeds from

50 through 3200. The standard ISO settings that you use most of the time are 100, 200, and 400.

JPG/JPEG JPEG (labeled as .jpg) stands for Joint Photographic Experts Group, which is the name of the committee that wrote the standard. JPEGs are compressed image files and are considered lossy in that they get rid of some of the image data, according to specific parameters when they are compressed, and use advanced algorithms to decompress or open the files.

Kelvin The color of light is measured in Kelvin (K), named after the nineteenth century physicist William Thomson, 1st Baron Kelvin. The Kelvin unit is based on energy absolutes; therefore, 0K is the temperature at which all energy is lost. To put this in perspective, 0K is the equivalent of −459.69°F. In the light spectrum, 5500K is white, and higher color temperatures are blue and are cooler in appearance; lower temperature colors, like yellow, orange, and red, are warmer in appearance.

light quality Light quality is generally defined as how hard or soft the light is, meaning how quickly the transition from light to shadow is. Bright sunlight is hard light, but an overcast day generally has soft light. Hard light comes from small, point light sources, and soft light comes from broad, diffused sources. The light quality sets the mood of a shot.

low key A low-key image happens when more contrast and drama are in the image. Usually, but not always, this entails a darker subject over a darker background. In a low-key image, the light that actually lit the subject would be more of a dramatic side or backlight. See also *high key*.

macro photography True macro photography happens when the image on the sensor is equal to or bigger than the subject that is being photographed. The ratio of 1:1 means image size on the sensor is equal to the subject size. Getting closer would make the ratio of the image to the subject 2:1, meaning the image is twice as big as the subject. As the ratio goes up, the size of the image on the sensor continues to go up, getting ever closer to the subject.

metering The Evaluative, Segmented, or Matrix meter (the name depends on the camera maker) is a meter that takes different parts of the scene and measures each one and computes or averages the exposure of the scene. This type of meter is very accurate for most situations and is the default for most cameras.

panning In some cases, shooting fast-moving subjects with a fast shutter speed is less than optimal. This could be because the background is not very interesting or just to get a better sense of motion. Panning is a technique in which the photographer slows the shutter speed of the camera to between 1/30 to 1/4 of a second; the camera is then moved along with the subject. The effect is that there is a blurred background, while the subject remains relatively sharp.

polarizing filter A polarizer is used for taming reflections and glare on glass, water, and foliage. It can also darken the sky and increase color saturation. No other filter can do these things. The polarizer does all this by aligning light waves as they come into the lens so that they come in from only one direction.

RAW Whether you use a Nikon, Canon, Leica, Panasonic, Sony, or another brand of dSLR camera, the question of using RAW or JPEG often comes up. RAW files are the proprietary files of each camera manufacturer, and they contain *all* the data of the image photographed. See also *JPG/JPEG*.

Rear Sync Rear Sync or 2nd Curtain sync are two names for the same thing — the firing of the strobe at the end of the exposure instead of the beginning of it. The first blade of the shutter opens to begin the exposure; light builds on the sensor creating the exposure; and just before the second blade comes down to the end of the exposure, the strobe goes off. This does two things — it freezes the subject at the end of its movement and gives the subject a trailing blur.

screw-in filter Circular filters with metal threads that screw into the front of the lenses. Generally, these are glass and can be used for UV elimination, black and white effects, light polarization, and some color correction. See also *polarizing filter*.

Shutter Priority Shutter Priority (S) allows the photographer to select a shutter speed and the camera to match the exposure to the aperture.

shutter speed Your camera's shutter opens and closes just in front of the digital sensor, allowing light in for only as much time as needed to create the exposure. With each full change of the shutter dial, the shutter is open for twice as much, or half as much time. Shutter speeds can be as fast as 1/8000 second or as slow as many hours, but in most real-world photography, the shutter is open for just a fraction of a second. For instance, a standard daylight exposure might be 1/125 second at f/11 using ISO 100.

sidelight Light coming from the side of the scene is called sidelight, which is also referred to as crosslight. It emphasizes shape and texture in an image.

slide-on filter Usually square in shape, this filter slides into a holder that screws into the lens threads. Slide-in filters are usually for image effects, such as changing the overall color of the image, to softening, to adding the look of fog or motion to the image. The most commonly used slide-on filter is the graduated neutral density. See also *graduated neutral density filter*.

SLR SLR is an acronym for Single Lens Reflex, which means that the light from the image comes through the lens and bounces off a mirror in front of the shutter into the viewfinder until the shutter release is pressed. At that time, the mirror flips up; the shutter opens, exposing the digital sensor and then closes; and the mirror flips back down.

spotmeter Unlike the averaging or multi-segment meter, which averages the scene to get the right exposure, the spotmeter allows you to select a very small part of the scene and find the exposure for just that area. This technique is particularly useful when you need to find the exposure of your subject and it is surrounded by large amounts of light or dark.

top light A subject lit from above is lit with top lighting. However, top or front lighting has a tendency to look flat and uninteresting.

trailing blur Caused by Rear Sync (2nd Curtain), it is the appearance of the exposure behind a moving object.

TTL (Through the Lens) A type of metering for both ambient and flash exposures. TTL metering uses a meter inside the camera to measure the light after it passes through the lens. This is very accurate metering and is on virtually every digital SLR.

white balance The white balance function of the camera optimizes the color of the image to ensure that white objects in the photo appear white. It does this by compensating for the differences in color temperature of different light sources.

black and white images
 high contrast and, 179–180
 overcast lighting and, 186
 street photography and, 204–205
blinking, 138
blur
 showing motion with, 153–158
 techniques for creating water, 164
bounce flash as light source, 44–45
Bridge, about, 146, 247
built-in flash, 40–42

C

cable release, 53, 246
cables for cameras, 202
camera bags, 197
camera shake
 bracing body to prevent, 211–212
 cable release to prevent, 246
 camera image stabilization, 158–159
 eliminating, 95
cameras. *See* compact digital cameras; dSLR
 cameras; protecting cameras
candid shots
 taking, 143
 taking while traveling, 204–205
 tips for, 133–136
canned air, 235
carnival rides, 265–266
Cartier-Bresson, Henri, 134
center-weighted metering, 37
chargers for batteries, 202
cleaning items before shooting, 235
close-ups. *See also* macro photography
 depth of field and, 231, 232–233
 lighting for, 231–242
 selecting subjects for, 224–226
 tripods for, 51
 using Macro mode for, 237–238

clouds
 drama added by, 84–86
 sunset and, 77–80
 using soft light to create moods, 81–84
cold weather, 203, 218
color. *See also* color temperature
 adjusting before dawn and after sunset, 76–77
 afterglow and landscape, 250
 compensating for sunsets and clouds, 78–80
 contrasting in still-life images, 230
 diffused light, 102
 found in light, 24–25
 interesting contrast with, 230
 overcast lighting and white balance, 83
 varieties of landscape, 174
 white balance and complementary, 13–14
color cast, 16
color temperature
 adjusting settings to balance tones, 12
 balancing from multiple sources, 115
 defined, 10
 emphasizing in macro photos, 240–241
 fog and, 190–191
 incandescent light and, 109, 111
 measuring in Kelvin, 10–11, 271
 seeing colors, 11–13
 white balance and, 10, 13–14
compact digital cameras
 advantages of, 30–31
 built-in flashes for, 40–42
 digital stabilizers in, 159
 exposure compensation with, 31–33
 illustrated, 31
 Macro mode for, 238–241
 megapixels for, 35
 memory cards for, 35
 photographing kids with, 153, 154
 scene modes, 33
 setting for long exposures, 252
 wide-angle macros, 238, 241

continued

wide-angle macros, 238, 241
windbreaks, 200
window light
 creating mood with, 117
 direct, 100–102
 qualities of, 99
 using, 95, 96
windows
 diffused lighting with, 102–103
 shooting interiors with light from, 104–106
wireless flash syncing, 142

X
XD (Extreme Digital) memory, 200

Z
zoom lenses
 aperture of, 263
 macro capabilities of, 231
 selecting for sporting events, 152–153
 using rear curtain sync with, 259

 PHOTOWORKSHOP.COM

Complete Your Learning Experience

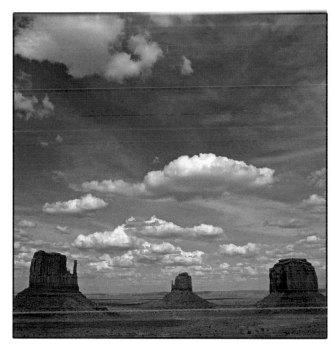

This book series is just part of your photography education.

Take full advantage of this unique opportunity to interact with other photographers from around the world. Now, visit Photoworkshop.com where you can:

- Upload Your Chapter Assignments
- Have Your Images Critiqued
- Rate the Images of Others
- Share Your Progress
- And Much More!

Develop your talent.

Go behind the lens with Wiley's Photo Workshop series, and learn the basics of how to shoot great photos from the start! Each full–color book provides clear instructions, ample photography examples, and end–of–chapter assignments that you can upload to pwsbooks.com for input from others.

978-0-470-11433-9 978-0-470-11876-4 978-0-470-11436-0

978-0-470-14785-6 978-0-470-11435-3 978-0-470-11955-6

For a complete list of Photo Workshop books, visit **photoworkshop.com**. This online resource is committed to providing an education in photography, where the quest for knowledge is fueled by inspiration.

Available wherever books are sold.

WILEY
Now you know.